HEADWATERS

HEADWATERS
A Journey on Alabama Rivers

PHOTOGRAPHS BY *Beth Maynor Young*

TEXT BY *John C. Hall*

WITH A FOREWORD BY *Rick Middleton*

THE UNIVERSITY OF ALABAMA PRESS

TUSCALOOSA

Copyright © 2009
The University of Alabama Press
Tuscaloosa, Alabama 35487-0380

Manufactured in China

Publication supported in part by Watershed Identity Foundation

Designed by Robin McDonald
Typeset in Arno Pro

∞

The paper on which this book is printed meets the minimum requirements of
American National Standard for Information Sciences-Permanence of Paper for
Printed Library Materials, ANSI Z39.48-1984.

Library of Congress Cataloging-in-Publication Data

Young, Beth Maynor.
 Headwaters : A journey on Alabama rivers / photographs by Beth Maynor
Young ; text by John C. Hall ; with a foreword by Rick Middleton.
 p. cm.
 ISBN 978-0-8173-1630-3 (cloth : alk. paper) -- ISBN 978-0-8173-8102-8
(electronic) 1. Rivers--Alabama--Pictorial works. 2. Rivers--Alabama. 3.
Alabama--Pictorial works. 4. Alabama--Description and travel. 5. Alabama--
History, Local. I. Hall, John C., 1945--II. Title.
 F332.A17Y68 2009
 976.10096'93--dc22

 2008018256

DEDICATION

FOR ALL OF THE PEOPLE: advocates, scientists, teachers, paddlers, fishermen, and agencies; who are working to secure a future for these waters, that our children and grandchildren and great grandchildren may enjoy and be inspired by the mystery of rivers.

CONTENTS

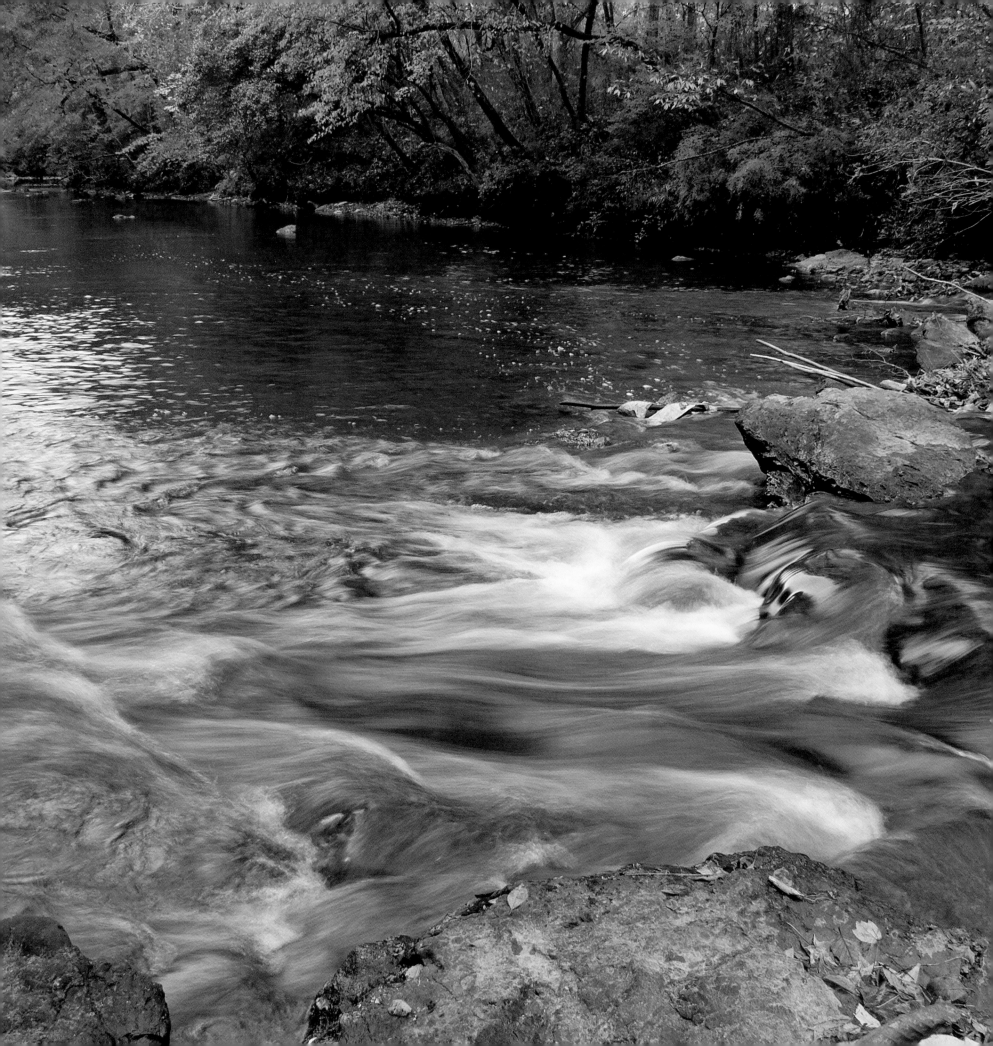

FOREWORD

WHEN I WAS TWENTY-SEVEN, my wife, Chita, and I moved from Birmingham to Montgomery to start our lives together, and I began my environmental career. My job with Alabama's attorney general provided the unique opportunity to travel to every corner of the state, more often than not to learn firsthand about a valuable natural area or resource and to head off a looming threat. Soon we were spending our weekends and vacations going from one newly discovered place to the next as our curiosity was piqued and our knowledge grew.

I began to see the world through a different lens. I gradually came to appreciate the extraordinary richness and variety of Alabama's landscapes, plants, and animals, and the essential bond between people and nature. A sense of place became more to me than family, friends, and culture. I also began to understand my connection to the Southern environment, and to my future.

So time has passed, and I am still exploring and still learning little by little. It has taken me a lifetime, it seems, to understand the forces at work and the connections to be made. Then along comes *Headwaters*—the deceptively simple story of the River of Alabama as it emerges in seeps and springs in the north Alabama highlands and flows through time and the landscape to the Gulf of Mexico. By tracing the course of a typical Alabama waterway, this fascinating book delivers the entire breadth of Alabama's land, water, people, history, and geology in one powerful package. Photographer Beth Young and author John Hall combine their talents to tell a story that is as beautiful and moving as it is interesting and accessible. Together they take us from the broadest vistas to the most intricate details, and through the ages of creation to yesterday's walk in the woods.

I first met Beth Young in the late 1980s, when she was putting her boundless energy to maximum effect to help launch the Cahaba River Society, Alabama's first river conservation organization. Beth's enthusiasm was contagious, and her stunning images of my hometown river opened my eyes to the natural treasure in my own backyard. It was the power and beauty of Beth's Cahaba lilies that awakened an entire city and state to the need to protect our rivers and streams, through law, land protection, and love. I now have "Beth's Lilies" on my walls both at work and home, and every day they remind me of my awakening to the river and of the gifted and delightful photographer who helped me see it.

I'm certain that the photographs in *Headwaters* will have a similar effect on the reader. Beth is a spirit of the river. She sees and feels things that are beyond the capacity of mere mortals, but then kindly allows us in on the secret through her work. Each of her images standing alone is beautiful, but taken together in this book they convey a profound message about a special place and the compelling need to protect it.

If Beth is of the river, then John Hall is of the land. An expert on earth science and natural history, John provides the Geology 101 course I never had in college, and offers it up in four simple, readable lessons. Following the River of Alabama from top to bottom, and from old (300 million years or so!) to new, John explains the forces that have shaped the river as he takes us from the headwaters, through the uplands, over the fall line, into the coastal plain, and out to its exit into the gulf. As the journey proceeds, John weaves a fascinating tale of biology, history, folklore, culture, and conservation, all with a proper Alabama accent.

John's narrative and Beth's pictures speak to us in exceptionally close harmony. Part 3, on the fall line, offers a case in point. Taking us through time from the ancient separation of the continent, to the impact of early settlement patterns, to the emergence of an economy whose pollutants threaten the very survival of the lilies found only in the rushing waters of the fall line shoals, the words and images work together to deliver lessons that are clear and memorable.

This fine book serves as a powerful reminder of the unique and marvelous creation that is Alabama. It is pure and true. It simplifies the complex and gets at the heart of our connection to nature and place. In many ways, this book achieves between its covers what I have spent a career trying to accomplish. It engenders pride and hope and makes a compelling case for why conservation of Alabama's extraordinary places and diversity of life deserves our full attention and best efforts. Most of all, it offers the gift of discovering and knowing a wonderful place, for which we should all be grateful.

—Rick Middleton

Executive Director, Southern Environmental Law Center

Opposite page: **Weogufka Creek, a tributary of Hatchet Creek, drains Coosa River Wildlife Management Area uplands. The preservation of this beautiful area is another example of the continuing partnership between the the Alabama Nature Conservancy and the Alabama Department of Conservation's Forever Wild program.**

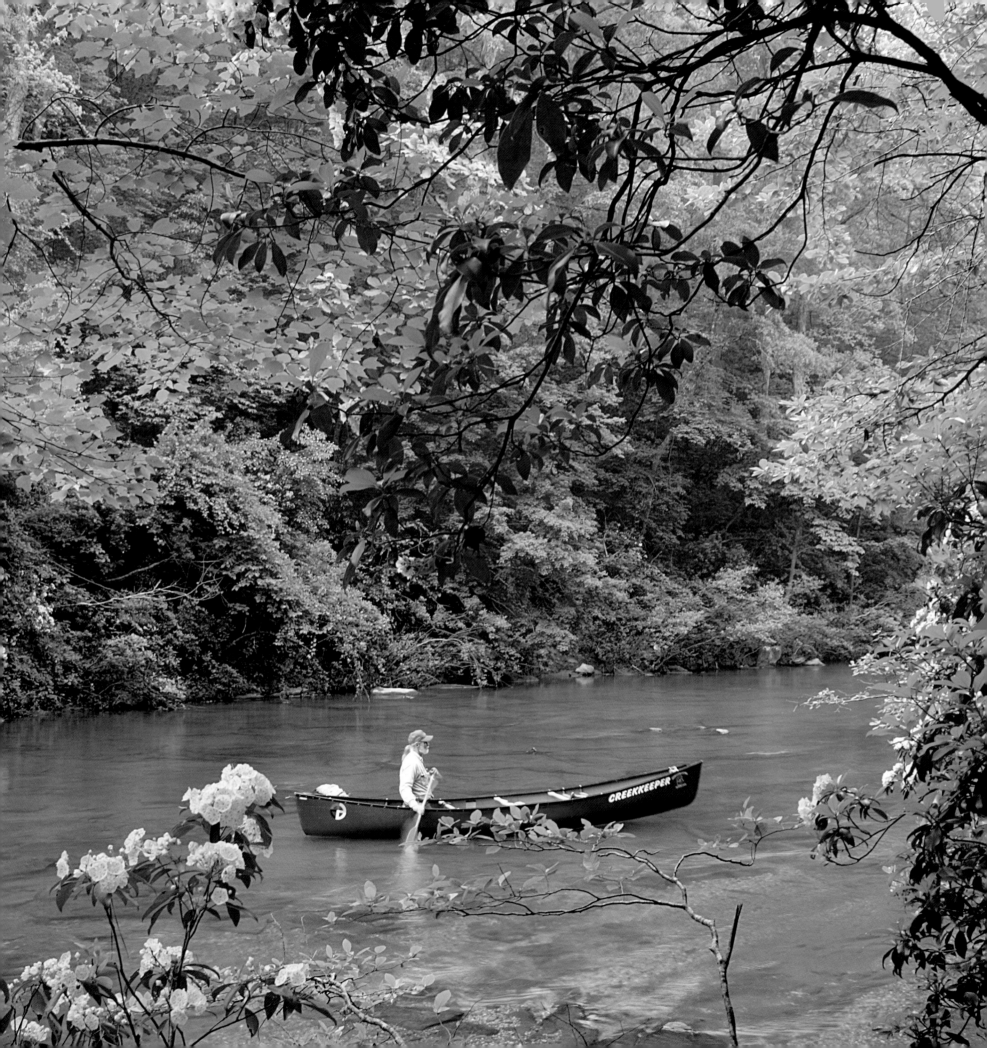

ACKNOWLEDGMENTS

T HE *HEADWATERS* BOOK HAS BEEN A LABOR OF LOVE, and it would not be possible without the help of some wonderful people who have shared their resources, knowledge, time, enthusiasm and love for Alabama's rivers.

Environmental and conservation efforts have been supported for many decades by Bill and Fay Ireland. In the Spring of 2000 they made a significant contribution to the newly formed Watershed Identity Foundation. This became the seed money for the rivers project.

While this book pays homage to the beauty and diversity of Alabama's rivers, it also is a tribute to Bill Ireland. We deeply appreciate everything he has done to support the many people working on environmental and conservation programs in our state. He is truly one of this generation's conservation heroes.

Even noble tasks do not come free, and we are delighted to thank our donors for their assistance: Brent and Delilah Belcher, Britt and Judy Butler, Dodie and Corbin Day and Jemison Investment Co., David Donaldson and Vulcan Materials, Nannette Sheaffer and Red Mountain Bank, Wendy Smith and the World Wildlife Fund's Southeast Rivers and Streams Program, through their partnership with The Coca-Cola Company, and Leslie and Elton Stephens Jr.

We would also like to thank the board of the Watershed Identity Foundation, Bob Tate, James Lowery, Pat Byington and Katie Smith Jackson, for their vision and support.

We also owe a debt to Melissa Ryan, friend and Deputy Director and Senior Editor, Photography and Design for *Nature Conservancy Magazine*, who spent four cold days in January helping to organize the photography into an orderly pattern and story.

During all of the photography, I (Beth) had someone with me, sharing each mile, hiking sand and gravel bars, paddling the canoe, and exploring the mysteries around each bend. I wish to thank all of the following people for their help and their love of rivers: Nelson Brooke, Charles Carroll, Alan Cressler, Mac Dean, Tommy Dodd, Paul Freeman, Linwood French, Jim Godwin, Randy Haddock, the late Shane Hulsey, Francine and Bruce Hutchinson, Paul Johnson, Mark and Maggie Johnston, Jim Lacefield, Bill Maynor, Spence Maynor, Brad McLane, Randy Mecredy, Chris Oberholster, Ben Thompson, David Patterson, John Wathen, and my dog Mason.

But they are only a few of the friends, guides and mentors who helped us down the stream. Others, too, have worked hard to protect these rivers and their lives and friendship are a continuing inspiration: Bill Adams, Herbert Boschung, Ian Brown, Richard and Nancy Cobb, Jeff Danter, Larry Davenport, Don Elder, Ben Ferguson, Eugene Futato, Larry Godfrey, Paul and Libby Hartsfield, Dan Holiman, Sam Howell, Guy Hubbs, Dan Irvin, Wendy Jackson, Rhett Johnson, Douglas Jones, Brian Keener, Susan Moates, Frank Paruka, Jack Perkins, the late Malcolm Pierson, Sonny Resha, Craig Remington, Andy Rindsberg, Tom Rogers, Weezie Smith, Beth Stewart, Joab Thomas, Francis Tucker, Charles Williams, and Jim Williams.

Rick Middleton, founder of the Southern Environmental Law Center who, in addition to being a friend, provides legal support for environmental organizations all over the south. The staff of The University of Alabama Press has been a joy to work with and their enthusiasm and ideas have been invaluable. Robin McDonald, who knows how to make a book, has taken the words and the images from two folks who didn't and has created something special.

John is grateful to the Hall women—his mother Barbara, who got him interested in natural history; Marilyn, who patiently put up with thirty years of erratic curiosity; and Rosa, who endured the birth of the text.

And last but not least, Beth would like to thank her patient and encouraging husband, Frank, for his devotion and support, as well as understanding the passion that compels her to spend time exploring these beautiful rivers.

Opposite Page: **John Wathen, Hurricane Creekkeeper, patrols his beat. He is an effective and highly recognized member of the national Waterkeeper Alliance, which shines the light of publicity on polluters.** *Page i:* **Proud lord of all it surveys, a Tennessee River great blue heron stands, ever ready for a fish.** *Pages ii–iii:* **Mountain laurel accompanies a Coosa tributary as it flows over granite bedrock.** *Pages iv–v:* **Hatchet Creek's lily shoals at their best. For a brief time each morning— hard to predict and not always to be counted on—the mists rise. We always count ourselves lucky to see it again.** *Pages vi–vii:* **Patterson Falls in wet weather. Sand mountain is so dry that in late summer, this falls is reduced to a tickle, but in wet weather, it is easy to see how Bryant Creek has cut it's canyon.**

INTRODUCTION

THE GREAT RIVER OF ALABAMA

W E ALL READ VARIOUS CLAIMS AND STATISTICS, most of them even true, as to Alabama's incredible riverine resources. They all agree that Alabama is among the best-watered regions of the continent. It has more rivers, more species of fish and mollusks, and more geographic variety than practically anywhere else in North America. Whatever the various rankings by its boosters, the state is in fact a world hot spot of temperate zone diversity.

Alabama's rivers have certainly not escaped the notice of the state's inhabitants. In prehistoric times Native American towns filled the river bottoms, where spring floods kept their cornfields fertile. Alabama's rivers appear on the Great Seal of the state, and most of Alabama's major towns are located on them. Historically, Alabama's commerce and transportation was based on rivers, and even the location of its various capitals had to do with river politics.

Historically, perhaps because of our overabundance of blessings, we haven't paid enough attention to our rivers, preferring to view them as industrial appendages to be dammed, bridged, and ignored, and, when we wanted to get rid of something nasty, conveniently downhill. In recent decades this has changed in at least two important ways: clean water, once thought to be limitless, has become a valuable resource subject to covetousness and regulation, and rivers have emerged as focal points of beauty and recreation for an increasingly urban population. Fortunately, Alabama has more of them than other places do.

This resurgence of interest in rivers is encouraging, because now there are actually a lot of folks who share our feelings about them. The interest is so marked that it has been termed the River Movement. Today in Alabama there are several major and numerous smaller river conservation organizations actively seeking their preservation. Entire watersheds have organized to celebrate their history and to tout their recreation and tourist potential. Opposition to careless development is front-page news and is taken seriously by a growing number of people.

We have been on (or in) most of the rivers, usually accompanied by people who are, thankfully, more knowledgeable than ourselves, and we are overjoyed to share our love of them with you. We want to explore what makes rivers special places to visit, what makes them similar and different, changing and timeless. It is more fun to discover their delights by serendipity--to come around the bend and say, "Wow! Look at that!"

So we have decided to treat Alabama's many rivers of reality as a single stream of imagination that we call the River of Alabama, or the Great River. The River of Alabama's mythical headwaters trickle out of Appalachian highlands, its fabled upper reaches tumble amongst the rocky Alabama uplands, and its mystical midcourse crashes across the fall line to form a slow and legendary coastal plain river. Even though several of our rivers' headwaters rise along the Chunnenuggee Hills, well below the fall line, their tiny springs and seepages are like those in the mountains, and they flow and grow and sparkle like the others. We include them all in the Great River.

The book follows the Great River as it flows down to the sea, from oozing seepages to roaring rapids, from slow to swirling, clear to green, small to large. Sometimes the

Above: **The State Seal of Alabama, showing Alabama's main rivers. The Chattahoochee River is shown but not labeled. The state's unmatched abundance of rivers figured large in antebellum Alabama. To its later regret, the state chose to develop steamboat transportation instead of railroads.**

Above: **Morning on the Escatawpa. Clean water, thoughtfully managed, will preserve stable and diverse streams and quality experiences for generations. Clean drinking water, hunting, fishing, picnics, float trips, birding, swimming, and photography—everybody wins.**

River of Alabama is rocky, sometimes its banks are sandy, and sometimes it is a blackwater stream, crystal clear, or mysteriously green. Sometimes it is bright and rapid, or like an enormous impounded lake covered in duckweed. But flow it does, in broad valleys and narrow canyons, through plains and sloughs, finally traversing a great and magical swamp to a marshy estuary and a fantastic union with the Gulf of Mexico.

To wholly concentrate on the river's water and ignore its context would be a mistake. Like Bedrich Smetana's Moldau, the River of Alabama seeps from tiny springs. It flows past mountains and woodlands, plants and animals, fish fries and weddings, fortresses and cotton landings, Indian villages and historic river towns, and legendary bluffs and rapids. We must stop and consider its inhabitants, its smell and its light, its enclosing forests, its rocks and valleys, and the way it makes us feel. We will wonder at its great age and its relentless power. We'll listen to its poets and its correspondents. We'll kneel to check out its niggling (and wiggling) details—snakes, snails, lilies, and crawdads. We'll pause to gape at its beauty and bemoan our poor stewardship of its gifts. We'll talk a little more about geology than is customary, because we don't want people to miss some of the real surprises in their descent of the Great River. In fact, our varied geology is the very key to our diversity.

So pretend we are on a canoe trip. Sometimes we will drift with our thoughts, and sometimes we will stop and regard waypoints and bright details. Like the best of field trips, we make no claim to an organized narrative, though we will begin chapters with a couple of the more complicated bits. But mostly we will take the wonders as they come, generally from high ground to low, small streams to big, creeks shallow enough to explore on our hands and knees, wading and boating down the Great River until we finally pull out on Piñeda's lonely beach.

We believe the river is important. Each of us owns a piece of it, and it is right that our favorite spot should haunt us as we go about our lives, as we do our work, consider development, make laws, and care for our land. Rivers should interrupt our road trips to the extent that we should never pass over a stream without wondering, "What is the name of that creek?" "Where can I put in to float that?" "I wonder if I can fly-fish that?" Or, more sadly, "Why don't I have my camera?"

We hope that folks will share our general sense of concern about these beautiful streams, and our vague sense that we should pay more attention to conservation issues while there is still time to influence them. How can we live with ourselves now that we know better and don't stop to help?

But mostly we want you to share our sense of hope—that the rivers can survive our stupidities long enough for us to come to our senses and let them recover. And we hope that you will share with us the pride of stewardship when you see a part of the river that is still (or again!) healthy and natural.

So pull down the canoe, slip it into the headwaters, and let's go to the gulf.

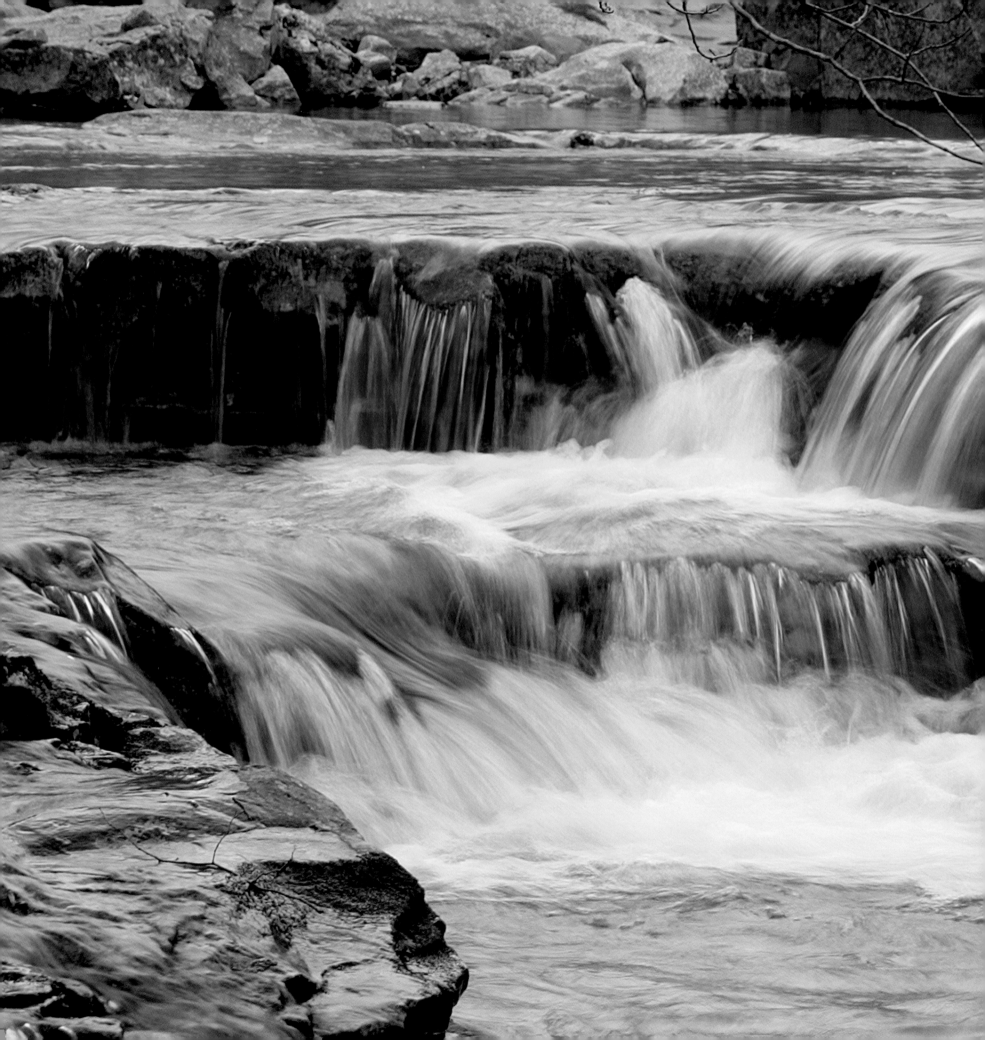

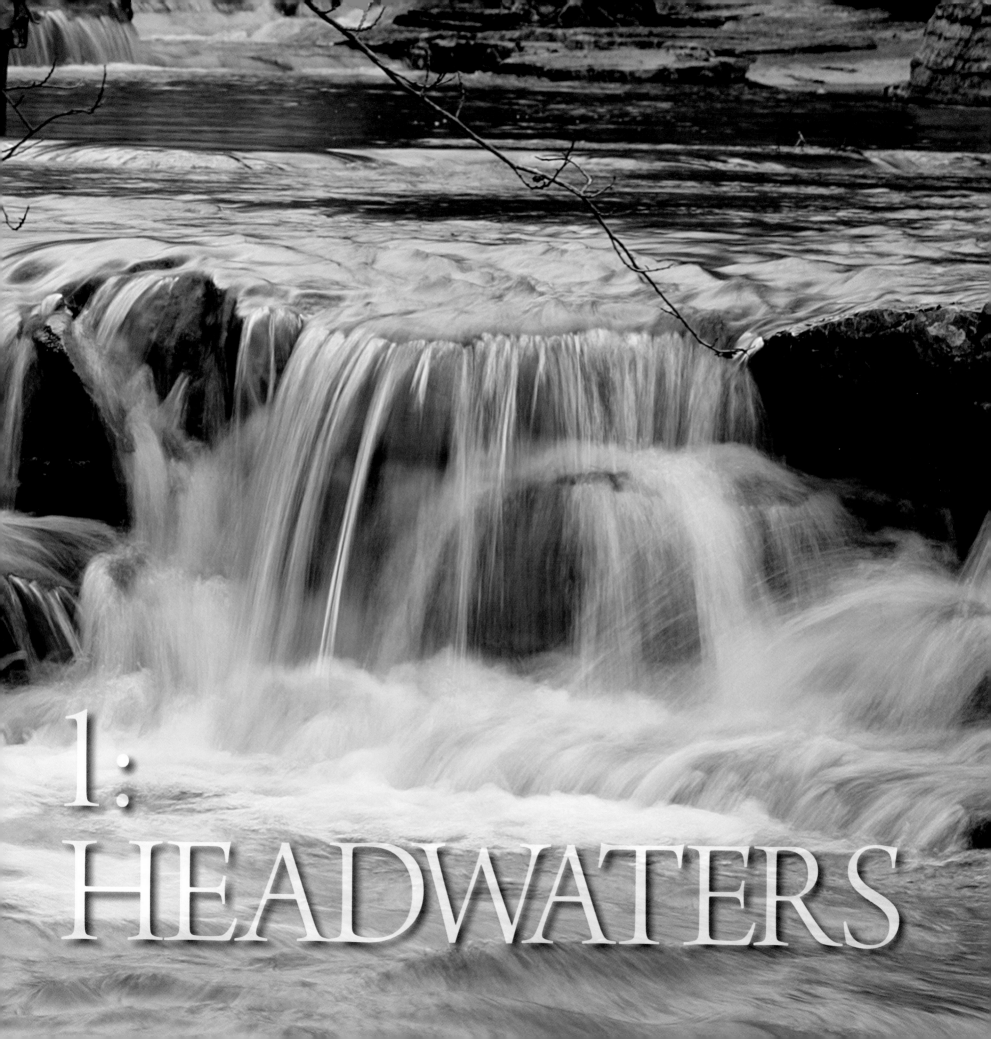

1:
HEADWATERS

I N TERMS OF ITS LANDSCAPE, Alabama is two states: an old northern half and a much younger southern half. Most of the Great River of Alabama has its origins in the Alabama uplands, the legacy of an ancient geological instance when the collision of continents formed the supercontinent Pangea. The most obvious result of this episode was the uplift of the Appalachian Mountains and its foothills to the west, including much of present-day north and east Alabama. It is in these uplands that the rain sinks into the earth and emerges as the seeps and springs that get the Great River flowing.

The headwaters are an intimate land. Headwater streams are small, the landscape is mostly steep, and here and there it is dazzlingly beautiful. This is the land of waterfalls and cobbled streams, narrow valleys and stony ridges; dramatic rocky profiles, canyons, and defiles; small coves and broad gulfs—Lethe Brook, Locust and Sipsey Forks, Stephens Gap Cave.

To see all of this, we have to walk. The little springs and seepages are too small for boats. This is a good time to explore the flanks of Cheaha Mountain, the green gulfs of the Bankhead Wilderness, and little seeps along the walls of Little River Canyon. You can also see the headwaters in south Alabama, along the southern flanks of the great arcing *cuestas*—the Chunnenuggee Hills that border the outer edge of the Black Belt, the Grampian Hills of Monroe County, the steepheads along the Florida line, and the Buhrstone and Tallahatta Hills along the Hatchetigbee Anticline in southwest Alabama. Some of these springs, like Blue Spring in Covington County, are sizable and provide single-point sources for streams.

It is from these headwaters that the Great River arises. They are covered with moss, or ferns, or pitcher plants. The water wells out of the ground, for it is along these slopes that the normally buried water table intersects the surface. At Cheaha, walk the Chinnabee Silent Trail from Turnipseed to the top of the mountain. Follow the little

JERICHO CASCADE

Previous pages: Hurricane Creek, on the trail to the Walls of Jericho, Jackson County, Alabama

It is best to listen to the river when it isn't too high. Tune out the general rush and roar of the water, and concentrate on the individual sounds. Assign them vocal parts—soprano, alto, tenor, baritone, bass; or even instruments—strings, woodwinds, or percussion. Sit quietly and try to sort them out. You may wind up looking for the physical source of certain sounds—What *is* making that high note? Seeking your favorite nocturne, you can go and sit by your magic spot, but every night, and in every season, it's a different song.

stream up on the flank of the mountain to where the little trickles run down and it smells like damp earth and mint and *Galax*.

These nameless little tributaries are legion. It is tempting to think that streams flow because it has been raining somewhere upstream, but in fact the daily flow of streams is due to groundwater. Rain that runs off into streams just causes high water and does little good. This is why conservationists of all stripes bemoan urban sprawl, the careless clearing of woodlands, and the ditching and paving of the landscape. You have to slow the rainwater down long enough for it to sink into the soil. Only then will the streams flow all summer long.

Alabama's diversity of plants and animals reflects its soils and its landscape. These, in turn, are reflections of its geology. From time to time, mostly above the fall line, you get to look at the bare bones of the landscape. Not just the odd rock, but the strata, sometimes turned on edge and stripped of earth like the bones of a picked-over carcass.

The forces of nature have affected the Alabama landscape from the very beginning; hence there is no starting point for Alabama geology—although we are about to choose one for convenience. But there was no time when Alabama was shiny, new, and unweathered. As continental collision, mountain building, and rifting slowly altered the landscape, it has been literally a daily race between the constructive forces of uplift and deposition and the destructive influences of weathering and erosion. That Cheaha stands some two thousand feet above Talladega Valley suggests that uplift is still slightly ahead at the moment, but it's losing ground (literally) as the dead hand of gravity tugs at the grains of soil and the river washes them to the gulf.

To understand how Alabama's skeleton came to be, and why her rivers are where they are, we must digress briefly into geology's grand unifying theory—plate tectonics. The earth's surface is fractured like an eggshell into large and small plates, some bearing portions of seafloors, or continents, or both. These pieces are in constant motion, but the movement is very slow, averaging about an inch per year, roughly the speed of fingernail growth. This slow plate-boogie has been going on since the earth's crust began to cool, about four and a half billion years ago.

About 300 million years ago, toward the end of the Coal Age, what is now the southeastern portion of North America was located near the equator. The interior of the continent was eroding, and its sediments were being deposited as a broad coastal plain similar to the one we have now. Alabama was a piece of this coastal plain.

Alabama's grand formative episode occurred when chance brought all the continents together, closing the ancient Atlantic Ocean. In a series of slow but titanic collisions, three continents—Europe, Africa, and South America—struck North America. Beginning in the north and progressing southward, the continents slowly collided with

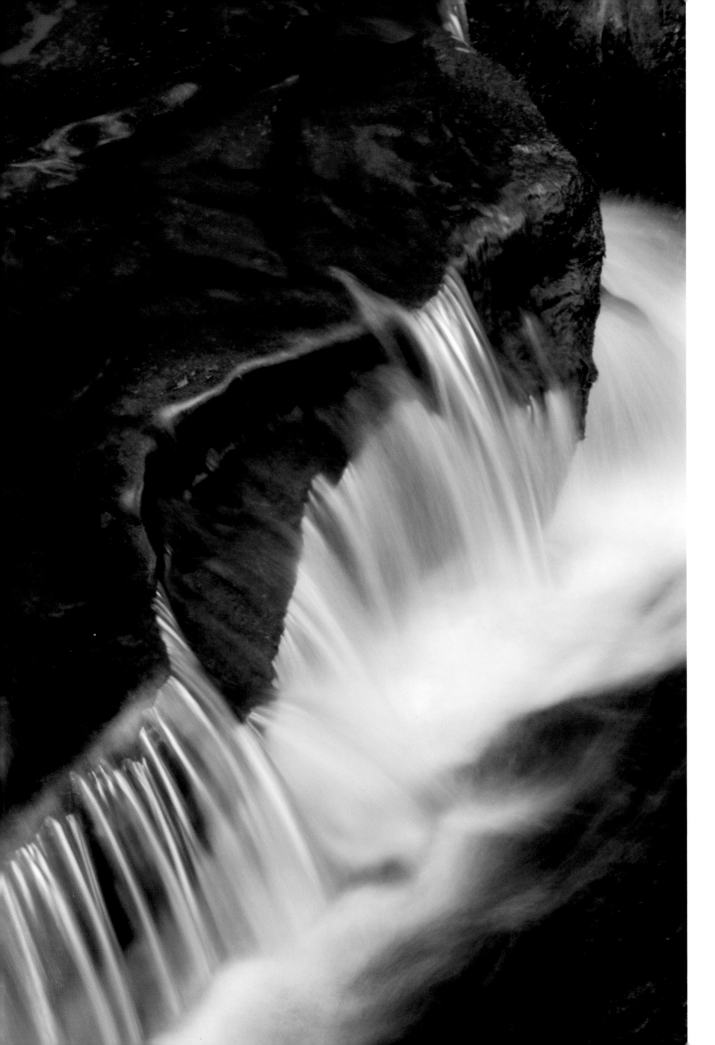

GRANITE FALLS

Ancient Appalachian granite outcrops near Coosa River, Elmore County, Alabama

In Elmore and Chilton Counties you can see the southernmost rocks of the Appalachian Mountains. They were formed during the Pangean collision, perhaps 300 million years ago. Granite, an igneous rock, was formed at great depth when the energy of the collision raised temperatures enough to melt continental rocks; it represents the fiery heart of the collision between Africa and North America.

We wonder at the time and dynamics necessary to erode miles of overlying surface rocks enough that we can gawp at these naked mountain roots. How much rock has been removed so we can see this? Where did it go?

North America and pushed up a great range of mountains. Finally, it was the south's turn. The northwestern quarter of Africa struck the American southeast. Much of the coastal plain was crushed, and the pieces were shoved back up onto the North American continent to form the southern Appalachians, a lofty mountain chain perhaps as high as the Alps.

For 100 million years, the continents were in contact or in close proximity, forming a supercontinent dubbed *Pangea* ("all-earth"). During Pangean times, Alabama was an inland highland, covered in forests and dinosaurs and bisected, northeast to southwest, by the Appalachian mountain range. But in early dinosaur times, some 200 million years ago, Pangea began to break up.

A deep crack, or rift, formed along the mountains, dividing the southern Appalachians. The continents messily wrenched away from America and from each other. Europe got the east coast, and Africa got the southeastern side of the Appalachians. Large fragments of Africa were left behind to form the basement structure of Alabama, Georgia, and Florida. None of these mysterious fragments are visible at the surface and are now completely covered by the modern Gulf Coastal Plain.

While Europe and Africa proceeded eastward toward their present locations, the ancestors of modern Alabama rivers eroded the fractured end of the Appalachian Mountains. The Tennessee River's predecessors gnawed at the north corner. The grandparents of the Warrior and Cahaba Rivers gouged at its broken end, and the ancestors of the Coosa, Tallapoosa, and Chattahoochee Rivers ground away at its southern corner. The eroded bits slowly accumulated in the deep sea-filled rift at the southeastern corner of the now fractured continent.

Finally, in late dinosaur times, about 100 million years ago, the sediments accumulated to the point that they began to be visible along the edge of the sea. From that time until now, layer after layer was added to the coastal plain. Today, everything from the fall line to the sea is made of the accumulated eroded tidbits of the southern Appalachians. Imagine being the Jolly Green Giant and cutting off huge chunks of the coastal plain and stacking them back on top of the Smoky Mountains. One gets an idea of how big the mountains used to be!

There is an additional subtlety at work. Since the Appalachians are eroding and are therefore growing lighter, they and northern Alabama are being buoyed up by the earth's flexible crust and are faintly rising. And since all the materials eroded from the southern and western slopes of the Appalachians are being deposited in the Gulf of Mexico, the

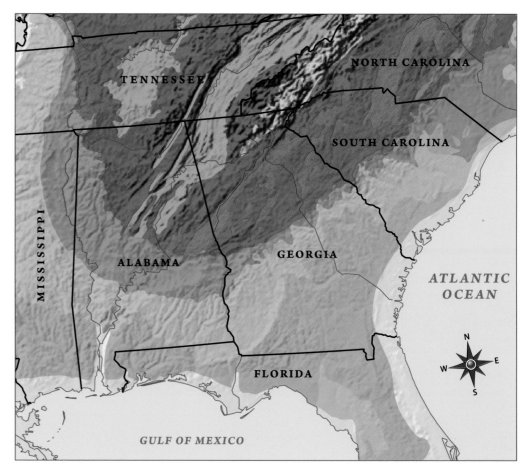

gulf is growing heavier. It is depressing the thin seafloor crust, and southern Alabama is slowly sinking. The upshot of this teeter-totter effect is that the nominally horizontal strata of the coastal plain have actually tilted slightly, dipping to the south at the rate of approximately thirty feet per mile. This is to say that a mile to the south, the surface upon which one is standing is thirty feet deeper in the ground and so forth. This angle is actually fairly steep and accounts for the banded appearance of the geologic map of the coastal plain. This is why we can see the tilted edges of the strata as they dip beneath the younger strata to the south. The edges of the hardest layers don't erode as fast and are preserved as lines of hills, or cuestas, arcing across the coastal plain of Alabama and adjacent states. This process continues, and the next layer of the coastal plain is being formed along the Alabama coast today.

Thus, the skeleton of the state is slowly rising and eroding to the north and east, but slowly sinking and depositing in the south and west. The imperceptibly slow hand of geological change is still acting upon the land, although in some places, along the coast and in the river valleys, we can almost see changes happening. This is well viewed from a canoe. The rocks tower above you—the very grain of the earth—and the weathered fragments slide beneath your keel. They are hurrying to the gulf to become part of the beach.

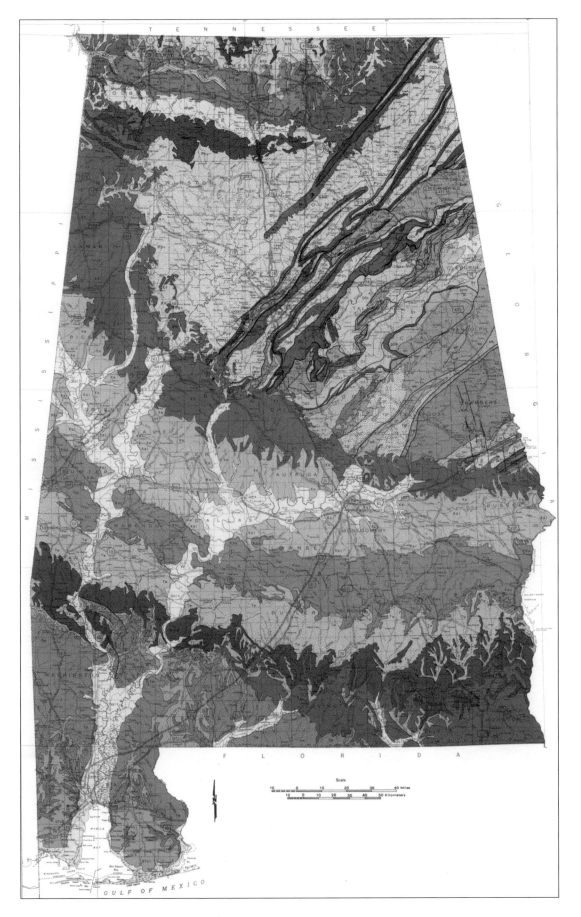

GEOLOGIC MAP OF THE SOUTHEAST (page 4)

The colors represent the age of the rocks, with those pushed up from depth by the force of the collision being the oldest. The red and bright green Appalachian Mountains represent the collision zone, and the landscape becomes progressively less damaged to the west. The matching rocks on the east side of the collision are not to be seen, having departed with Africa at the rifting of Pangea.

Then, after a lengthy pause, the coastal plain (green, brown, and gold) began to be deposited along the seaward edge of the remaining North American continent. The rocks of the mountains and the old continent are very ancient (older than 300 million years) and comparatively hard. The rocks of the coastal plain are much younger (younger than 100 million years) and comparatively soft. Adapted from a map by The University of Alabama Cartographic Research Laboratory.

GEOLOGIC MAP OF ALABAMA (left)

The colors represent the age of the bedrock. This useful map shows more details of the Alabama geology. The purple edge of the Nashville Dome descends into the Tennessee Valley; the light blue Coal Age rocks of the Cumberland Plateau Province (mostly the famous Pottsville Formation) and the linear grain of the Valley and Ridge Province from Birmingham to Chattanooga are easily seen. In east Alabama, the piedmont—the heart of the collision and the eroded roots of the old Appalachian Mountains—is more complicated.

The Upper Coastal Plain, green and blue, laps up on the edge of the north Alabama highlands. The light blue is the chalky Black Belt; the darker blue, the Chunnenuggee Hills. The layers to the south, beginning with the medium-purple band, are the Lower Coastal Plain, and they become progressively younger as you approach the coast. The cream-colored bands that run across the layers of rock are the recent floodplains of the rivers. The floodplains narrow as the rivers cut through harder layers, and they broaden as they cross softer rocks. Map courtesy of Geological Survey of Alabama.

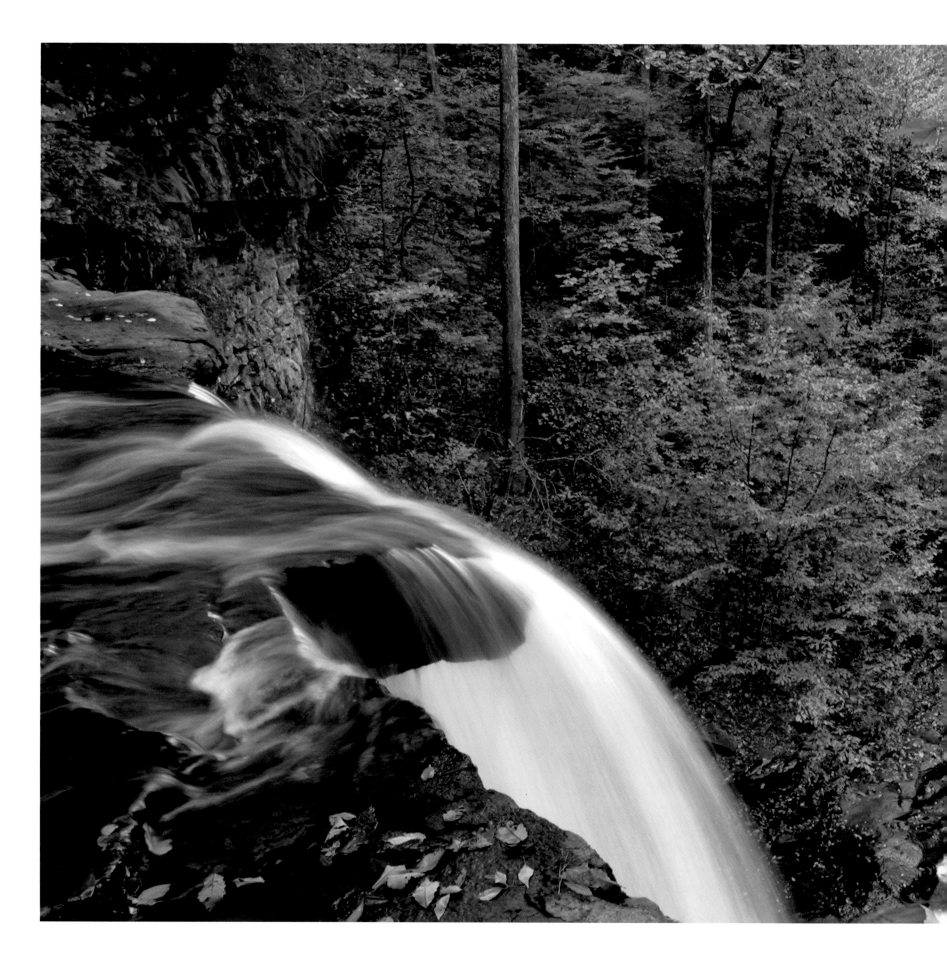

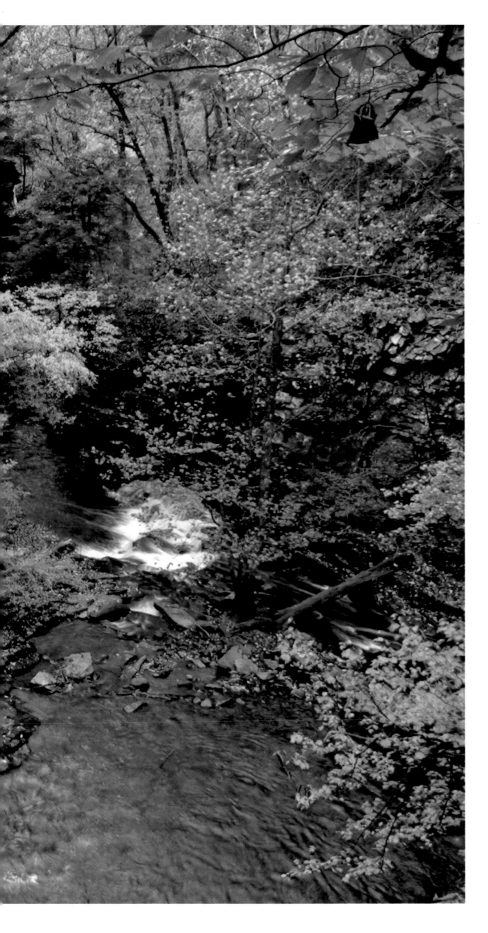

Every valley shall be exalted, and every mountain and hill shall be made low: and the crooked shall be made straight, and the rough places plain.

<div align="right">—Isaiah 40:4</div>

SECOND FALLS

Little Bryant Creek, at Pisgah on Sand Mountain, Jackson County, Alabama

The hard layers of Sand Mountain hold up numerous falls while the plunging water nibbles at their feet. It is a race between eroding water and hard rocks, and momentarily, the mountain seems to be ahead. But erosion is unrelenting, and resistance is futile. All will become sand.

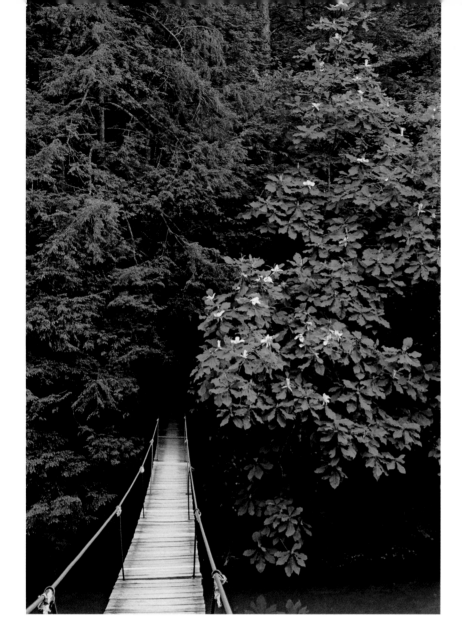

LATE PLEISTOCENE ON THE CUMBERLAND PLATEAU

Above: Hemlock and cowcumber line Clear Creek, Camp McDowell, Winston County, Alabama

A swinging bridge crosses the time barrier and vanishes into the Ice Age Alabama woods. The deep gulfs in the Alabama highlands shelter a relict flora left over from Pleistocene times, when the weather was cooler and damper. Never glaciated, the Deep South was the refuge for northern temperate species pushed south during two million years of glacial ebb and flow. The southern flora was crowded into the Gulf Coast, and northern species covered most of the South. It is interesting to speculate what the present flora of the Southeast would look like if Florida were shorter and the southern flora had nowhere to hide during the glacial advances. Today the ancient cool-weather species such as hemlock, sugar maple, beech, and cowcumber, once again abandoned, still hang on in cool, damp valleys.

COWCUMBER MAGNOLIA

Below: Bigleaf or cowcumber magnolia, *Magnolia macrophylla*, in bloom on Clear Creek, Camp McDowell, Winston County, Alabama

This queen of southern magnolias, with its two-foot leaves and twelve-inch blossoms, amazes newcomers to the Deep South. In late April the tree begins to bloom at the top, and by May the emerging blooms finally work their way down to the lower limbs so we can marvel at them up close. The baseball-size cones are pink, and later, as an encore, out pop brilliant red seeds hanging on little dangles. Cowcumber is a common understory tree of moist slopes and shady streams through much of the state.

Magnolias are an ancient flowering group and have lived in the South since dinosaur times. True North American magnolias are deciduous, and like cowcumber, most have big leaves. But the dazzling evergreen southern magnolia, *Magnolia grandiflora*, is an ancient and natural immigrant from tropical America.

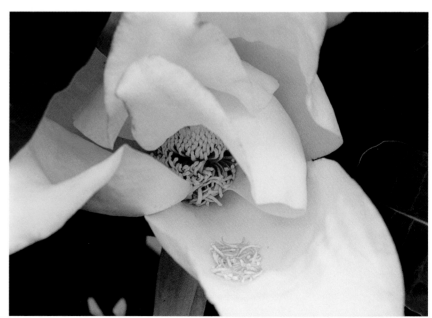

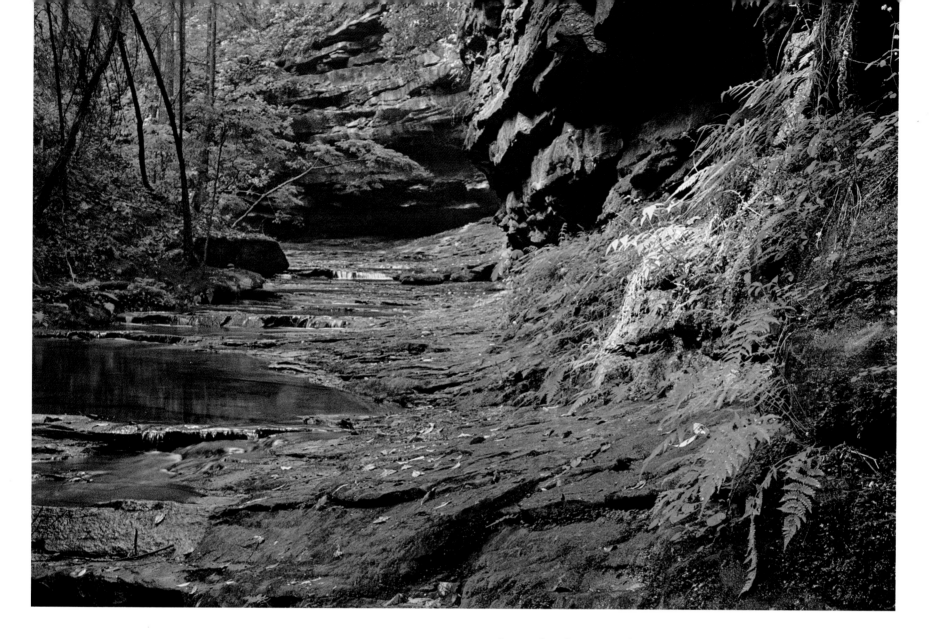

Lethe Brook is the stream of forgetfulness. A place where one goes and becomes so involved in the beauty of the place that one becomes lost. At least that is the way I think of it. But in mythology it is in Hades and not at Camp McDowell.

—Mark Johnson

LETHE BROOK

Ferns and wildflowers along groundwater seepages, tributary of Clear Creek, Camp McDowell, Winston County, Alabama

Surely the Great River of Alabama must begin in a place like this. Humidity fills the air, and groundwater oozes onto the roots of ferns and mosses. Slowly the trickles gather and begin to flow downhill, five hundred miles, home to the Gulf of Mexico.

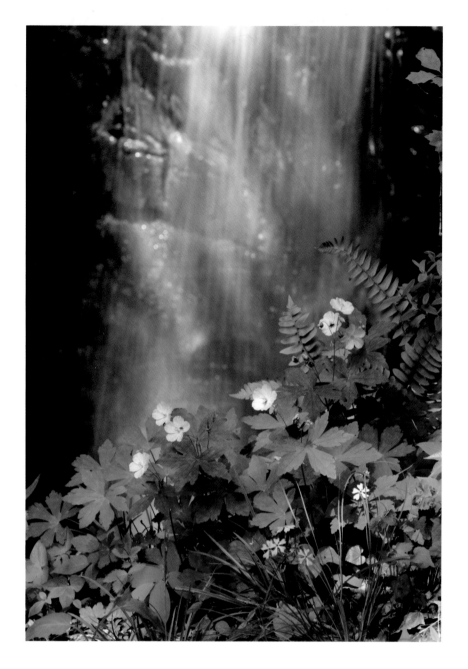

RAINBOW

Phlox and crane's bill geranium at Stephens Gap Cave, Jackson County, Alabama

A little rainbow does its best in the brief sunlit career of this amazing little waterfall. The stream's length is zero. It emerges from the rock above and immediately disappears into a sinkhole. It is fed by rain that collects in a small perched water table on top of the rocky ridge, and in wet season it gushes off the top of the bedrock and vanishes into the netherworld. Limestone areas tend to be very dry, and in late summer this waterfall may disappear. Despite their tender appearance, limestone plants, and animals as well, must be adapted to sometimes harsh conditions.

FALLS AT STEPHENS GAP CAVE

Opposite page: Surface water falls through an open sinkhole into Stephens Gap Cave, Jackson County, Alabama

Limestone areas are often honeycombed with caves and fissures. Such *karst* landscapes have few surface streams, and most drainage is underground. Rich in plants and animals and with an abundance of shelter, these areas have long attracted settlement, and their moist, quiet ambiance still attracts the human spirit.

Rainwater is naturally acid (we're not talking about the acid rain caused by pollution). It dissolves limestone, thus eroding cracks and faults to create voids and caves. In the caves, streams of water course through the fissures to enlarge passageways and form vertical shafts like this one. Eventually the water finds its way down to the water table, where it emerges as springs and seepages to keep the rivers flowing.

Caves have a life cycle attuned to the gradual erosion of the landscape. As the river valleys deepen and the water table slowly drops, the caves become drier. For a while, the slow dripping of water saturated with dissolved lime builds graceful cave formations in the dark grottos. But as the landscape slowly dissolves and the caves continue to dry out, the larger, shallower voids typically collapse, and the region begins to get its characteristic karst appearance of scattered sinkholes and disappearing streams. Much of the Tennessee Valley and parts of southeast Alabama display karst landscapes.

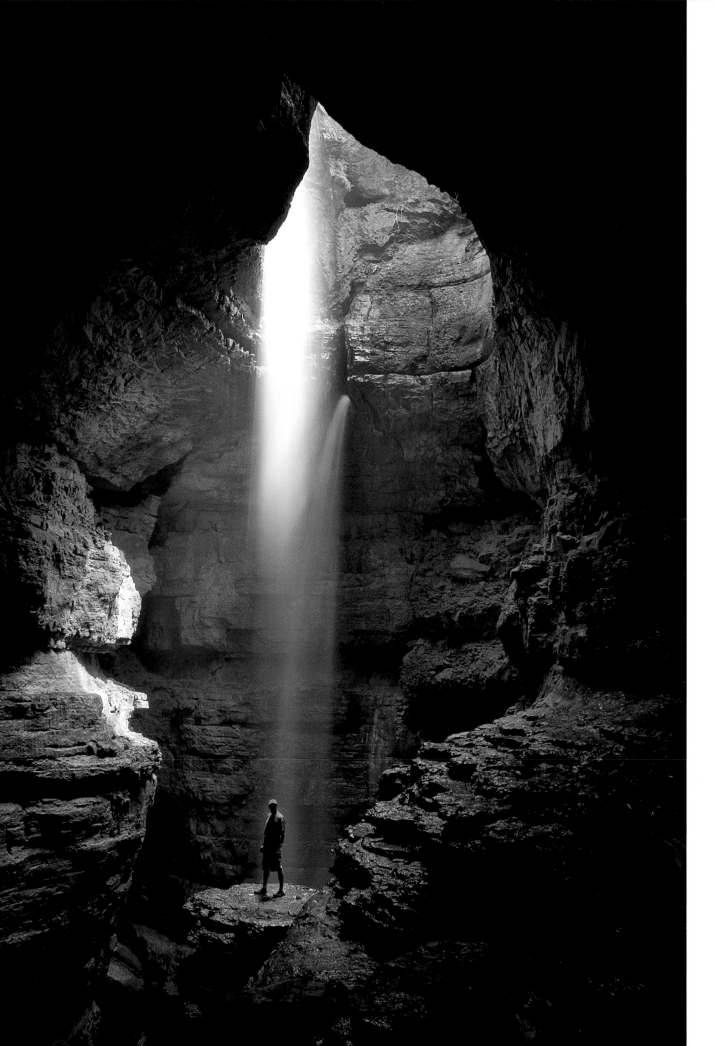

In Xanadu did Kubla Khan
A stately pleasure-dome decree:
Where Alph, the sacred river, ran
Through caverns measureless to man
Down to a sunless sea.

—S. T. Coleridge

In wildness is the preservation of the world.

—H. D. Thoreau

THE FIRST RAVINE ABOVE THE CROTON BLUFF

Small tributary of Black Warrior River flows through Harper's long-undisturbed "Botanical Bonanza," Holt, Tuscaloosa County, Alabama

Roland Harper was an important Geological Survey of Alabama botanist of the early twentieth century. In his classic report of 1920, *A Botanical Bonanza*, he reported an amazing diversity of plants along the bluffs of the Black Warrior River within walking distance of the city of Tuscaloosa. The area shortly became an unattractive industrial district and dropped from public consciousness. In 2005, members of the Alabama Wildflower Society, using Harper's detailed field notes, realized that, by luck, the botanical bonanza had survived without damage. All of the listed flowers were still there, and even views photographed by Harper were still recognizable.

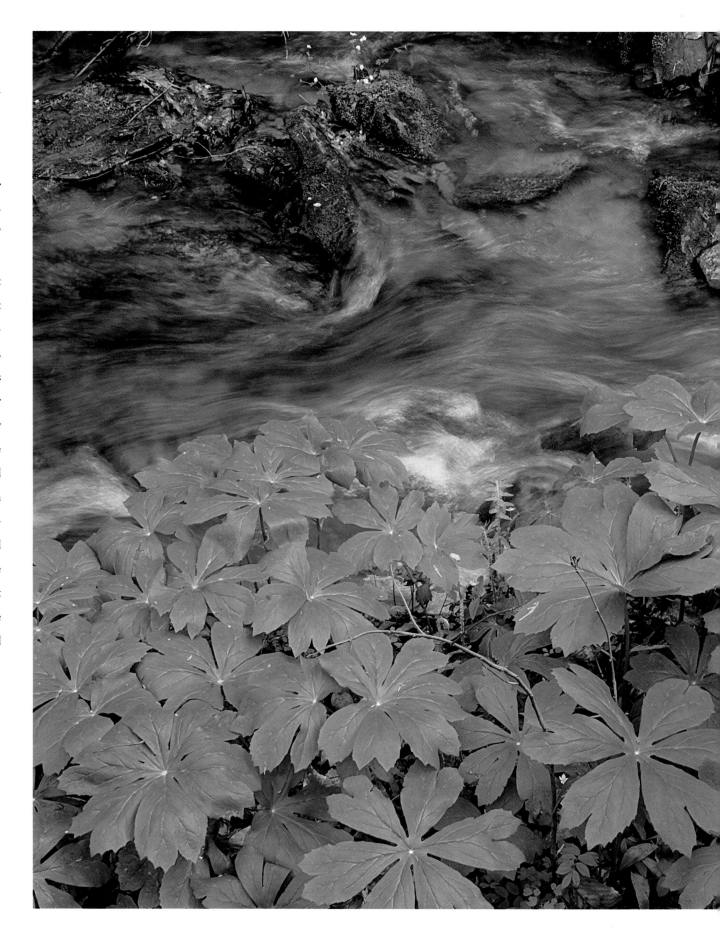

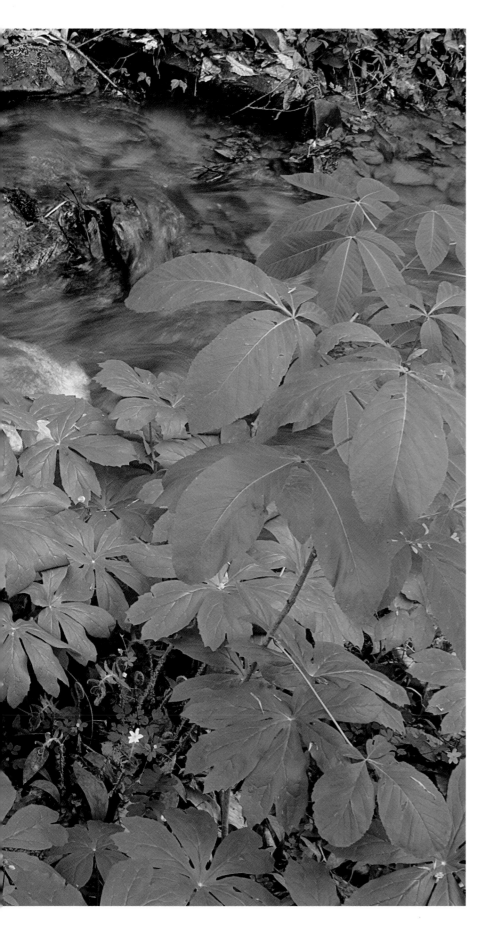

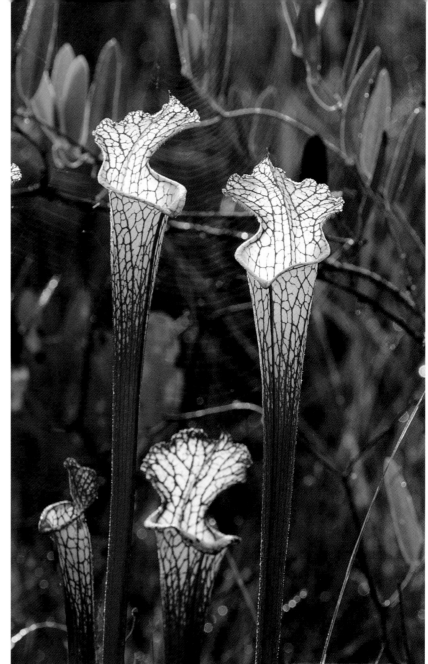

WHITE-TOPPED PITCHER PLANTS

Pitcher plants glow like Japanese lanterns at Splinter Hill Bog, near Stockton, Baldwin County, Alabama

Although in modern times the state's water table has been lowered, here and there the moisture still encounters the surface, and groundwater seeps out to form bogs and small streams. These permanently wet but not quite aquatic conditions invite special plants. Perversely, pitcher plant bogs must dry out enough in season to burn and remove smothering undergrowth. Various species of bizarre pitcher plants, some quite rare, are scattered across the state in bogs from Sand Mountain to the gulf. Splinter Hill Bog, a Nature Conservancy site, is being maintained as a longleaf pine habitat whose controlled burning is also necessary for the pitcher plants.

In front, just under my feet, was the enchanting and amazing crystal fountain which incessantly threw up from dark rocky caverns below, tons of water every minute, forming a basin.

—William Bartram, 1791

BLUE SPRING

Solon-Dixon Forestry Center, Covington and Escambia Counties, Alabama

A number of Alabama streams, mostly in limestone areas, have a single source—a spring. Some of these springs, like Bartram's, are phenomenal—Tuscumbia Spring, Huntsville's Big Spring, and Anniston's Coldwater Spring, for example. These reliable sources of water were well known to the Native Americans and attracted European settlement as well. Some became the focus of communities or individual farmsteads.

The briefest foray onto the Alabama highway map shows more than forty-five communities with the word "spring" in their name. These springs were landmarks in their day. Today, because of the lowered water table, many of them are essentially dry or profoundly reduced in size. Indeed, many residents of these spring towns cannot tell you where the community namesake is.

But the small springs and tiny seepages are the true sources of the River of Alabama. The water table is dependent on the landscape's ability to catch rainwater and allow it to slowly percolate into the ground. The earth absorbs water like a giant bath sponge and reluctantly releases it throughout the year. Then it oozes and weeps, dribbles and flows groundwater. But the more rainfall that flows off across the surface, down ditches and drains, across parking lots and cleared fields, the less enters the water table, the less is available for plants, the less is released for stream flow. Alabama's water table has dramatically shrunk since frontier times and seems slow to recover.

How long has this water been sequestered in the water table before it bubbles into sunlight? If there is not enough, how long will it be until the water table is recharged? If it is polluted, how long must we wait until it is cleansed?

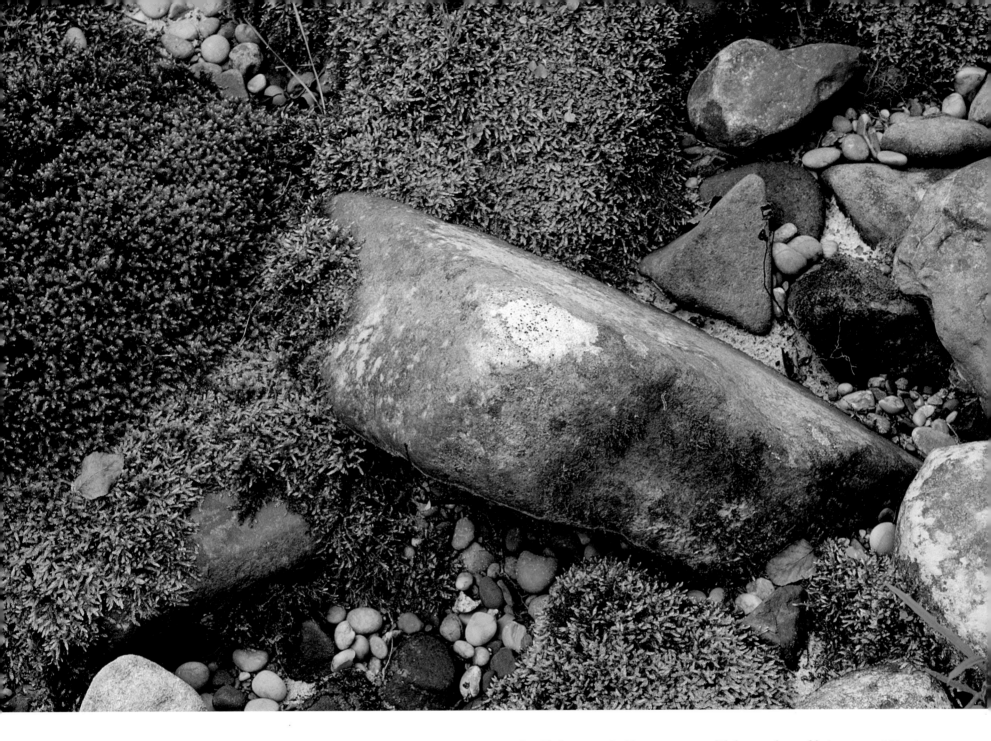

PEBBLES AND MOSS

Ephemeral tributary of Blackwater Creek, north of Jasper, Walker County, Alabama

In the end, even the sharpest rocks become rounded—and covered in moss. The colored pebbles are hard quartzite from deep within the Appalachian Mountains and far downstream from their birthplace. The gray rocks are sandstone, the local product of weathering. They are too heavy for the stream to move very far.

A lot of river questions are time questions. Since rivers commonly go generations without apparent change, we are forced to adopt a geologic time frame rather than a more comfortable human scale. How many years did these rocks tumble in a stream? How many miles did they roll to cease being sharp broken fragments and become round? And how did they get on top of the hills, far from a river strong enough to move them? When did they begin their journey, and where have they been hiding in the meantime?

To a human being, a million years—one hundred times the entirety of recorded history—is an unsatisfactory answer. And it is nearly inconceivable to discover that these rocks are at least three hundred times older than that.

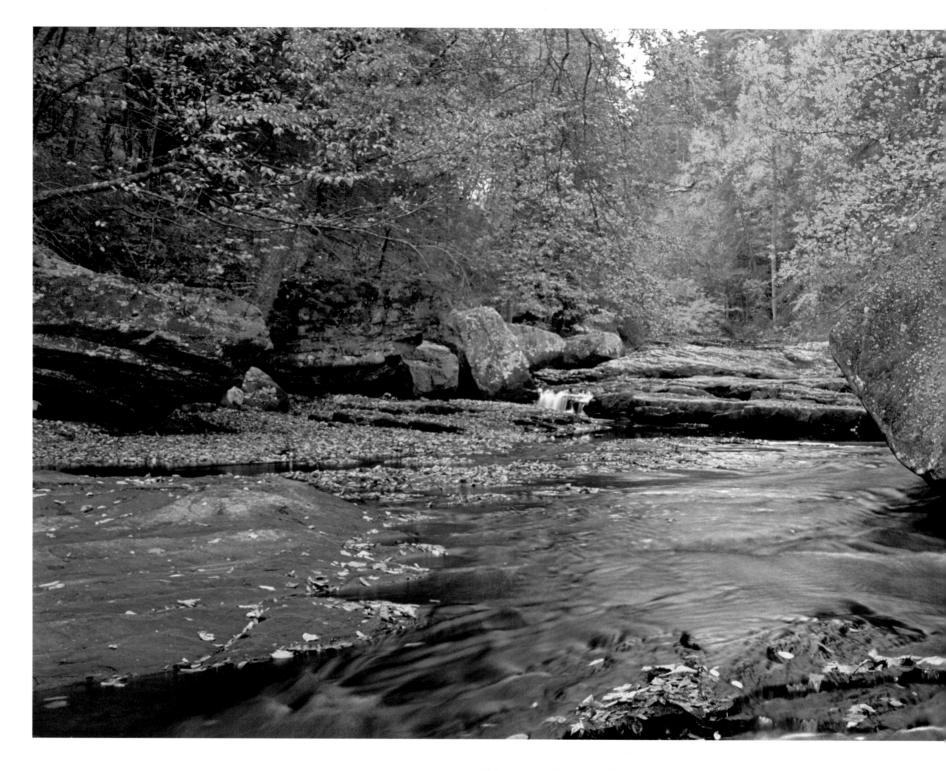

If there is magic on this planet, it is contained in water.

—Loren Eiseley

PISGAH OCTOBER

 Low water and leaves near their peak, Bryant Creek, Pisgah Gorge, Jackson County, Alabama

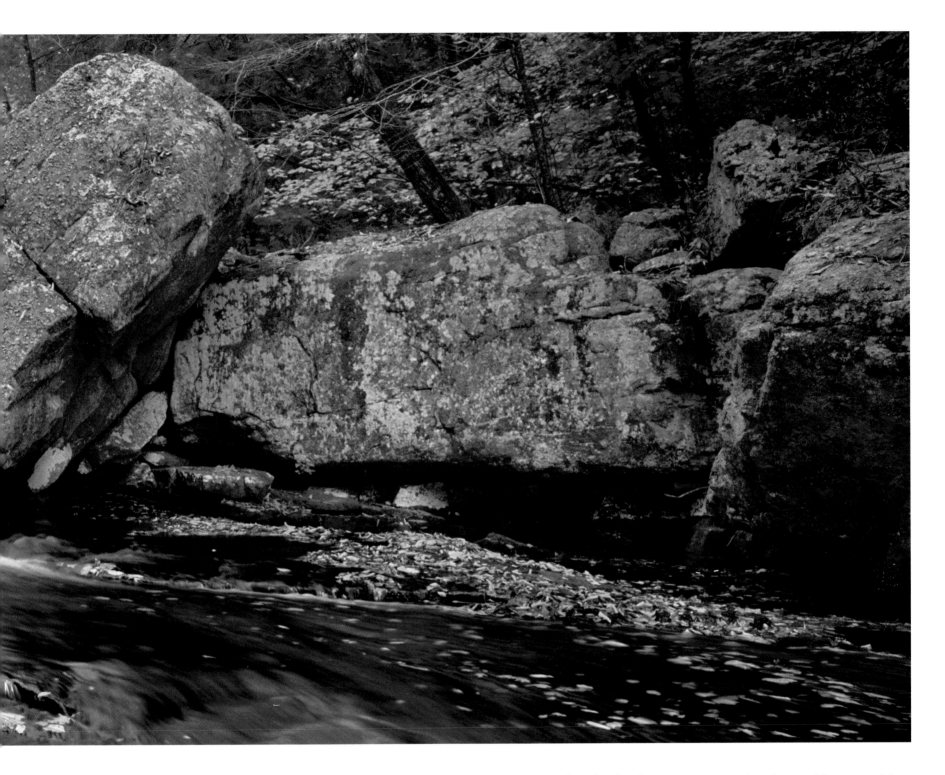

Pisgah Gorge is very narrow and you can hardly walk along the steep banks in the winter, but it is very dry in summer and reveals what is essentially a solid rock bottom. You get to *be* the river, and as you walk along the bed, you can't help but aid erosion by scuffing the rocks with your boots.

From time to time, even the most experienced riverman is simply struck dumb by a sight and must stand openmouthed. Such moments defy analysis—is it the leaves? the water? the figured rocks? The experience is more than the sum of the parts, and these unexpected moments are part of the lure of rivers.

We ask ourselves, Why can't I save this? Why can't I bottle this moment for later —save it for a time in midwinter when I really need a shot of it? Will it still be there next time, or will it be spoiled?

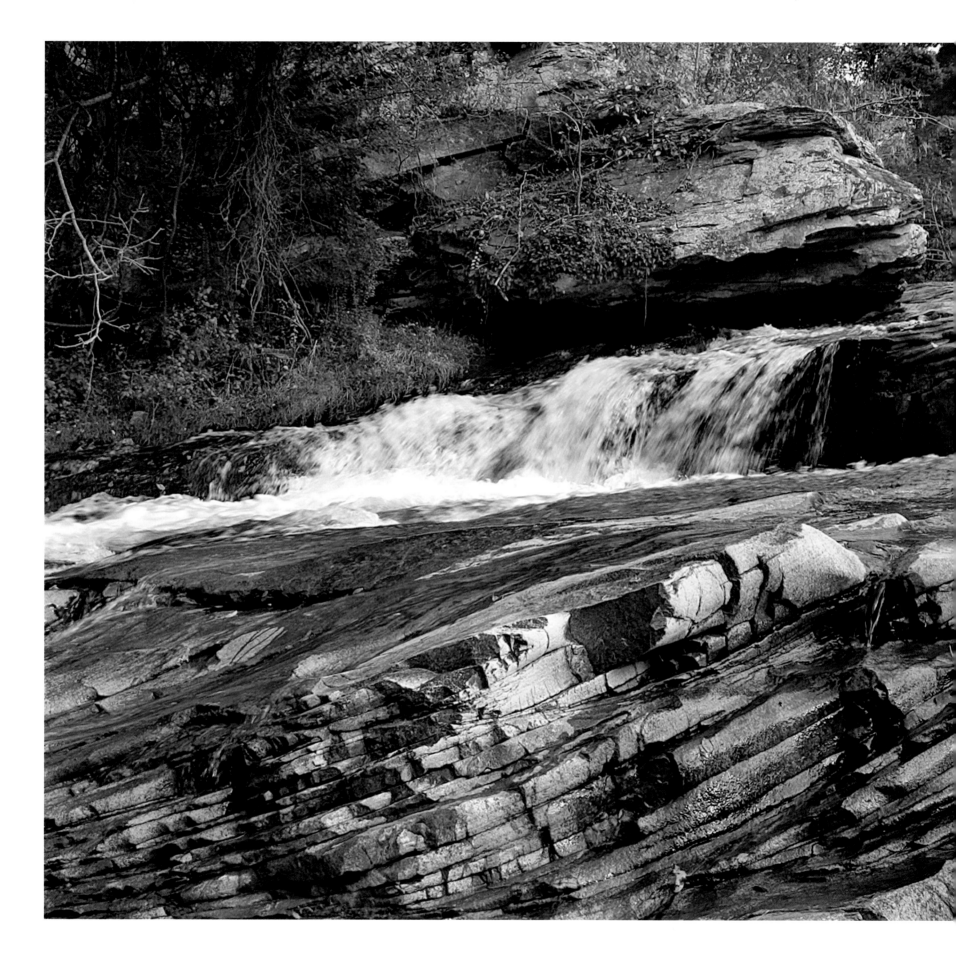

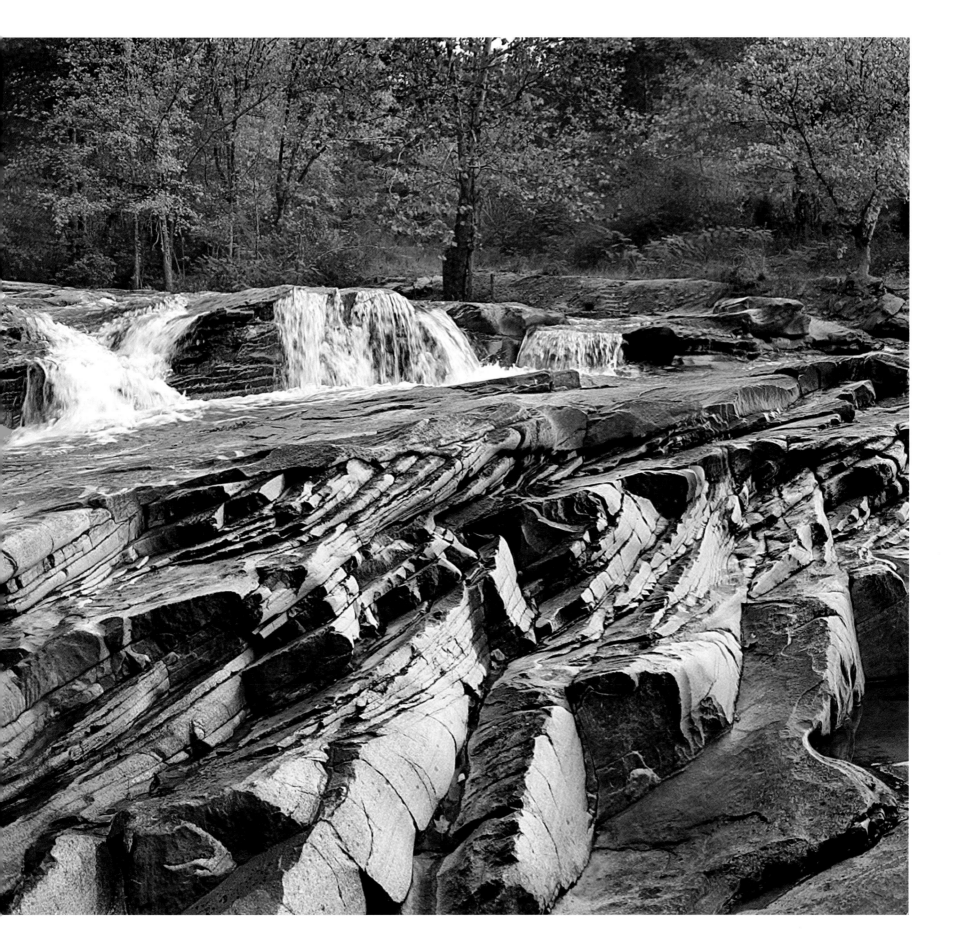

I was born not knowing and have only had a little time to change that here and there.

—Richard Feynman

TURKEY CREEK FALLS

Previous pages: Portion of Turkey Creek preserved by the Freshwater Land Trust near Pinson, Jefferson County, Alabama

Turkey Creek flows over cross-bedded strata. Most of the rocks of the mid-Alabama plateau are Coal Age sandstones and shales deposited along the edge of the ancient Atlantic Ocean hundreds of millions of years ago. We reason that such rocks would be laid down in nearly level layers, so one wonders how to explain these angled strata in otherwise horizontal rocks.

Part of the answer may be found by looking carefully at what is happening in rivers and seas today. In this new age we see cross-bedded sediments being deposited like this on the downstream edges of sandbars in rivers and current channels along the coast. As for 300 million years ago . . . the present is the key to the past.

Leave it as it is ... The ages have been at work on it, and man can only mar it.

—Theodore Roosevelt

DUGGER MOUNTAIN

Looking toward the Dugger Mountain Wilderness Area and Choccolocco Creek, Talladega National Forest, Cleburne County, Alabama

Dugger Mountain is a *thrust fault* fragment, a piece of the earth's surface shoved miles northwest of its rightful place. It is an eroded veteran of the Pangean campaign. It looks especially worn in this light, ancient and slow. Humans have been part of this landscape since the Ice Age, and here we are invited to share what the original Americans must have admired for thousands of years. One would think it has always looked this way, but the rows of planted pines and the field itself shows that the human hand has been laid upon it. Still, who do you suppose first paused here late one fall afternoon to appreciate the view?

Quit thinking about decent land use as solely an economic problem. Examine each question in terms of what is ethically and esthetically right, as well as what is economically expedient. A thing is right when it tends to preserve the integrity, stability, and beauty of the biotic community. It is wrong when it tends otherwise.

—Aldo Leopold

PAINT ROCK RIVER VALLEY

Looking north near Pleasant Grove, Jackson County, Alabama

The Paint Rock River has been called "the most significant river of its size in North America." It drains the Cumberland Plateau with its hardwood forest and has miraculously survived almost undamaged. It has amazing diversity, with unique species of mussels and more freshwater fish species than California.

This landscape seems so instantly comforting, so right. You just know that you could live down there, and the land, the river, and the hills would provide for your needs. Still, if you have the choice, there's not a lot of virtue in subsistence farming—we've been trying to escape that for thousands of years.

Sometimes the shriller voices of environmentalism would suggest that the landscape would be better off without humankind—that maybe there is no rightful place for us. But perhaps there is more to be said for the notion of stewardship, that we can earn our place with intelligent self-control, and that self-interest has its limits.

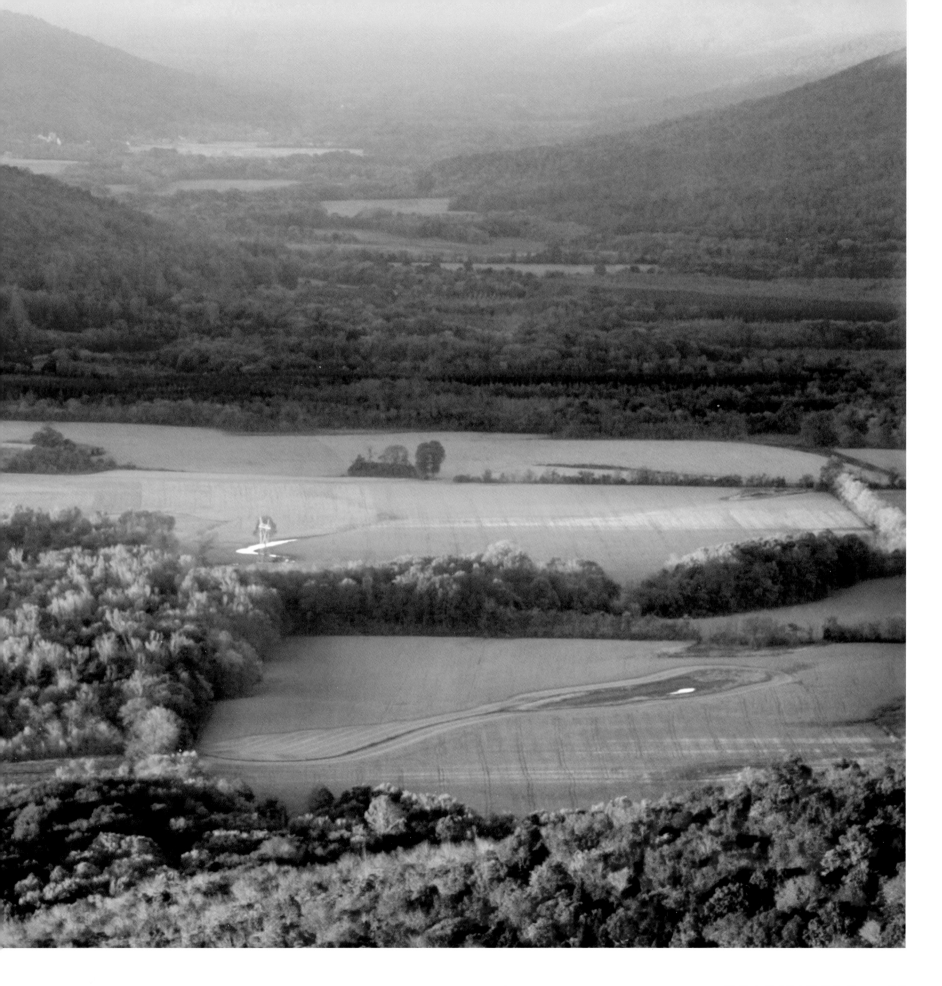

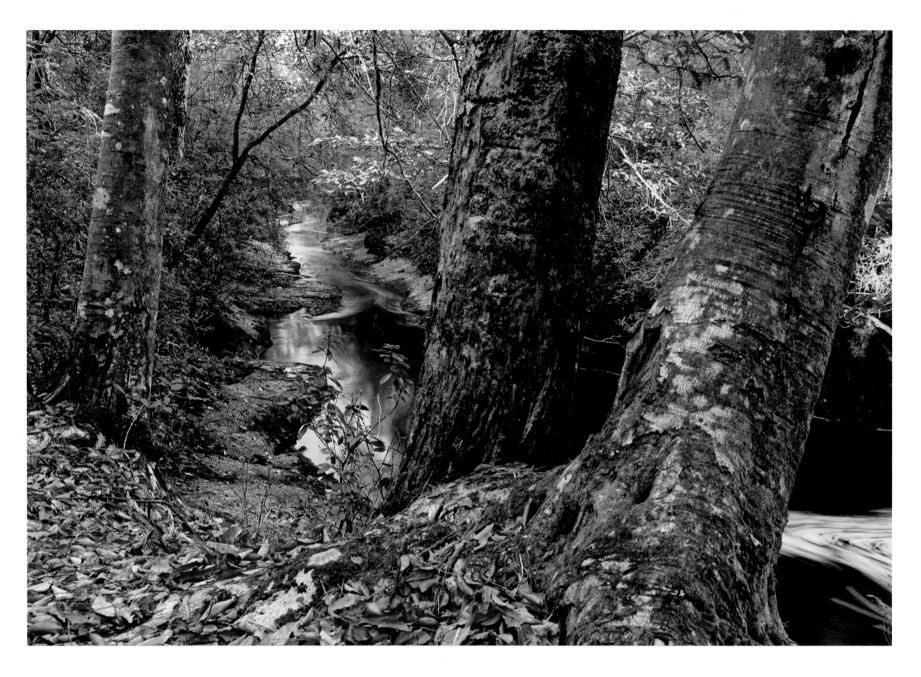

ECONFINA CREEK

Entrenched tributary in high ridge of sandy soil, Bay County, Florida

Toward the coast, hardwoods occasionally brighten the unrelieved landscape of pines. What is this? Beech, horse chestnut, and mountain laurel? Hard to believe we are almost at the beach! Normally we do not associate hardwood vegetation like this with the Lower Coastal Plain pine barrens. But here and there we find such flora on high spots, the ancient remnants of sand dunes and barrier islands left scattered across the landscape by the retreating sea. Locally these places are referred to as *steepheads*, or occasionally by their Muscogean name, *hi-otte*. They often feature streams with fast currents and narrow channels, as if they were above the fall line.

The tea-colored water of coastal rivers, dubbed "blackwater streams," is not polluted, but is full of tannins leached from the vegetation-filled lowlands. The Econfina drainage is preserved as watershed protection for drinking water in Panama City, Florida. Here is an example of how we can have it all—clean water, recreation, and preserved diversity.

creek or one river, fishes that were thought to be extinct and rediscovered, fishes that had never been seen before. There seems no end to them. They are still being discovered at a pace so fast that it is hard to keep up. More undescribed fishes already sit on ichthyologists' desks and in editors' cubicles, waiting their turn to be publicly announced in scientific journals.

Jim Williams, long-time U.S. Geological Survey fish and mussel biologist, was one of the students who helped collect the fishes. His stream was the Tallapoosa, and in the mid-1960s he wandered all over Georgia and Alabama in a pink Ford Falcon with an undergraduate to pull the other end of the seine. "We would make twelve to fifteen col-

Below: **Students from the University of Alabama at Birmingham (UAB) follow biologist Ken Marion on an electro-shocking trip. The electrical apparatus stuns fish, which can be picked up live with a net for study.**

lections a day. Just pull the car over and wade in. We didn't even wear boots. Didn't have them! We were pretty naïve in those days. We were so focused on fishes that we deliberately threw crayfish, turtles, and mussels out of the net and back into the water as trash. Nowadays, we'd love to have that data back!"

Fishes are a good lesson in saving rare and endangered species. It is relatively easy to save widespread fishes with large numbers and extensive habitat. You protect them from capture, impose seasons, or set size limits. Lake fishes are the easiest of all, but stream fishes often generally require habitat that emphasizes tree cover, shade, and rocky bottoms free from silt. This is why a good many stream fishes are in trouble.

But how do we treat a rare fish that is restricted to just one small habitat—say, a single stream or even a single spring? Some Alabama species are not found in large numbers today and never were. Today they are no more endangered than they ever have been, but because of development they are more vulnerable. A single instance of wick-

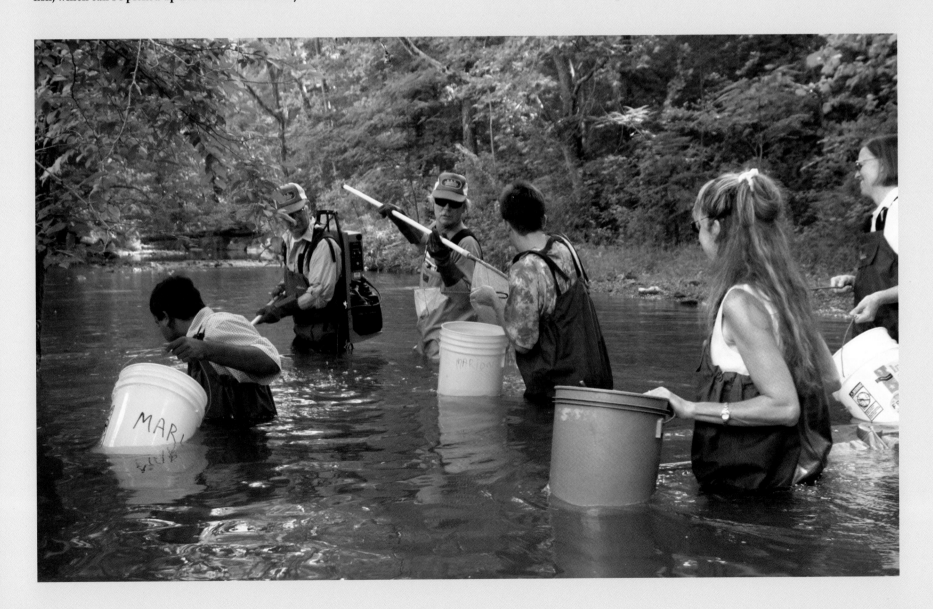

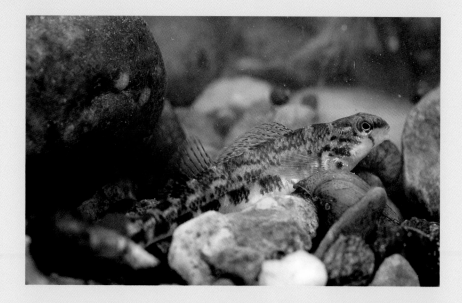

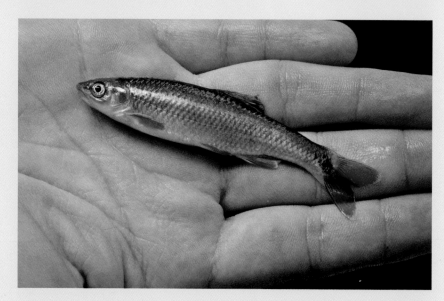

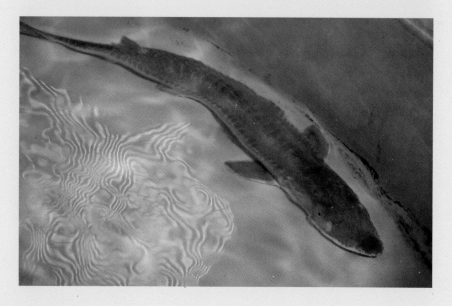

edness or stupidity, a prolonged drought, a chemical spill—there is no redundancy, no backup, and no appeal. A number of these fishes have been translocated to other springs or streams in hope of establishing backup populations. Sometimes it works.

The majority of Alabama species of special concern fall into the "vulnerable habitat" category. The incredible paddlefish, or spoonbill, *Polyodon spathula*, is a big-river species. Now that dams have transformed its gravel-and-sandbar habitat into muddy lakes, it barely hangs on in marginal habitat. The Alabama cavefish, *Speoplatyrhinus poulsoni*, is so unusual that a new genus had to be created for it when it was described in 1974. It is apparently restricted to a single cave, and its numbers are among the fewest of any known species. The pygmy sculpin, *Cottus paulus*, is a tadpole-sized fishlet that is confined to Coldwater Spring and a few hundred feet of spring run near Anniston.

The tiny spring pygmy sunfish, *Elassoma alabamae*, was collected in two Tennessee Valley springs—Cave Spring, Lauderdale County, in 1937, and Pryor Spring, Limestone County, in 1941. Full-grown adults are barely an inch long. It subsequently became eliminated from those springs but unexpectedly reappeared in collections from the swampy Moss Spring in the 1970s. Today it survives only in Moss Spring and downstream in the short Beaverdam Creek that intersects Wheeler Reservoir. It is so tiny and specialized that it appears to be an annual fish—the whole population dies in the winter and is replenished from eggs in the spring. Appalled at its vulnerability, local landowners and state and federal biologists successfully reestablished a second population at Pryor Spring.

Top left: **Alabama Darter, *Etheostoma ramseyi*. Darters in the Southeast have undergone an incredible burst of speciation. There are at least seventy-two species in Alabama. Ichthyologists will tell you that there are still some in hand that haven't yet been scientifically named yet, and there are still others in the wild that haven't revealed themselves. The diversity of darters reflects Alabama's outstanding diversity of geology, geography, and water.** *Above left:* **Tricolor shiner, *Cyprinella trichoistris*. Minnows get no respect. There are scores of varieties, some with gorgeous colors. But the fish people tell about the old days in the Tennessee Valley, where the TVA was sampling fishes in the pre-dam survey. One of their reports dutifully listed specific numbers of bass, bream, and catfish, and "several pounds" of minnows.** *Below left:* **Alabama sturgeon, *Scaphirhynchus suttkusi*, possibly Alabama's rarest fish. Adults are only a couple of feet long. Its rarity suggests there is very little of its gravel–bottom habitat left. The ichthyologists speculate that the chances of finding an Alabama sturgeon are only slightly better than finding an ivory-bill woodpecker.**

Sturgeons, big fish of free-flowing rivers, typify the problems of endangered species that are widespread. The Gulf sturgeon, *Acipenser oxyrinchus desotoi*, is one of the large varieties. These enormous fish, a subspecies of the Atlantic sturgeon, live at sea and every year travel back up freshwater rivers to spawn on the gravel bottoms of the upper ends of the major rivers. They are now eliminated from the Alabama, Tombigbee, and Chattahoochee Rivers because of dams, but they are still present in the smaller coastal drainages where there are no dams to block access and there are still gravelly headwaters.

A much smaller and more slender species, the unique Alabama sturgeon, *Scaphirhynchus suttkusi*, still lives in the big rivers above the dams but has been collected only rarely. Until recently, some claimed it was extinct. This small species does not seem to go to sea and prefers swiftly moving currents on sand and gravel bottoms of big rivers. It has been heavily damaged by the degradation of its habitat, primarily siltation of big-river gravel-bar spawning areas. By the time biologists realized there was a unique sturgeon living in Alabama's rivers, it was almost gone, and few specifics are known of its habits. To compound the problem, because the fish is directly damaged by river-channel activity, boosters of dams and river-channel gravel mining have gone to great lengths to hinder its recognition and rehabilitation.

Again and again, for plants and animals, fish and mollusks, it isn't so much the organism that needs protecting, it's the habitat. Protect the spring, the glade, the gulf, the free-flowing channel, and the rocky shoals; Mother Nature will take care of the fishes.

Below: **Ichthyologist Frank Paruka of the U.S. Fish and Wildlife Service (USFWS) prepares to release a modest-sized Gulf sturgeon into the Blackwater River as part of a USFWS trapping and tagging project.**

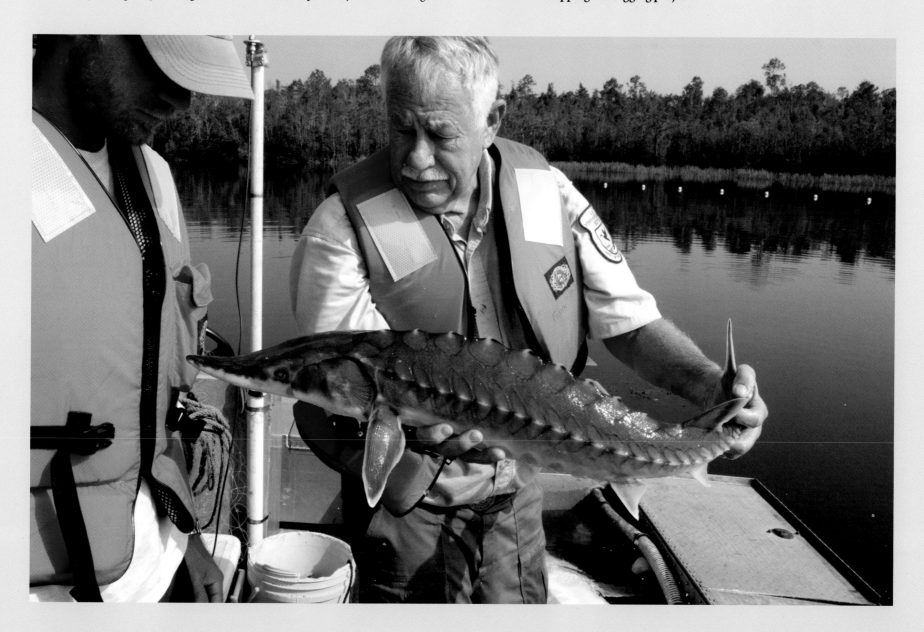

2:
THE ALABAMA
UPLANDS

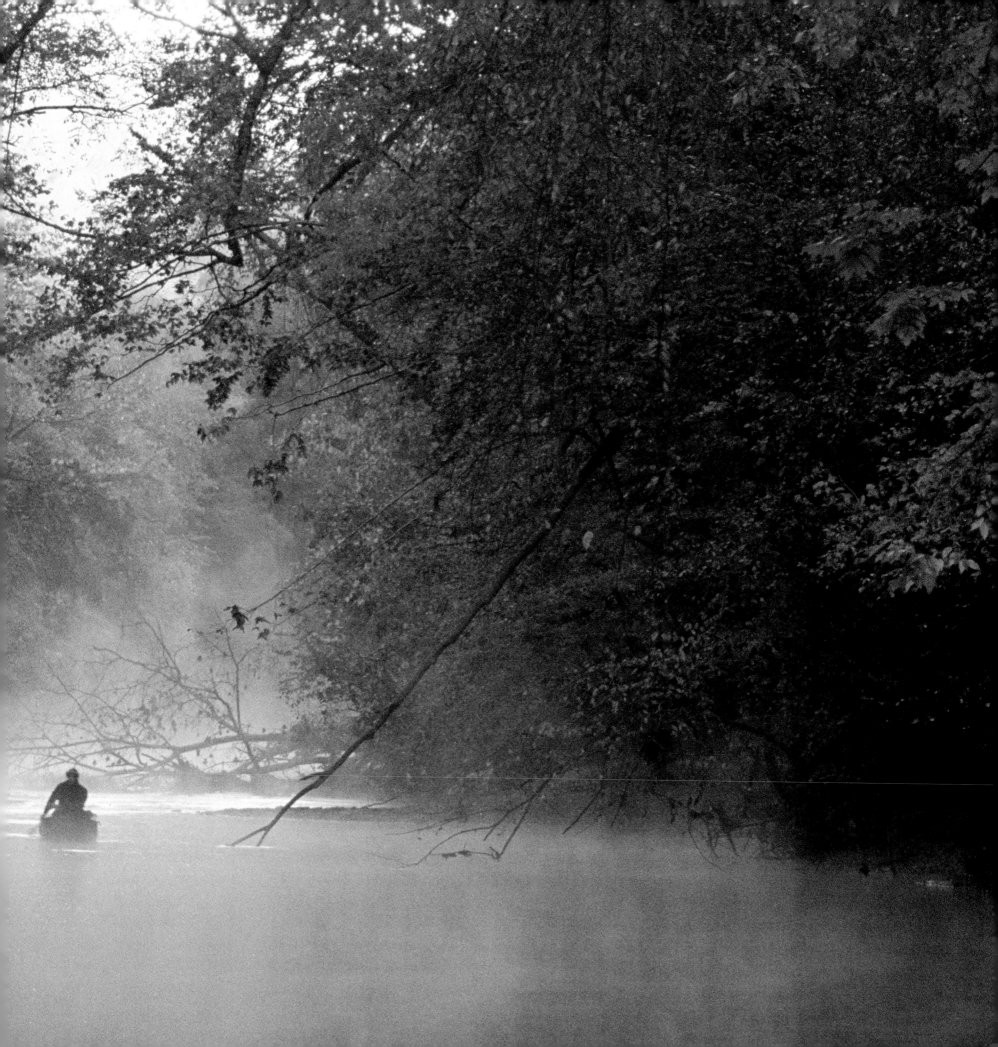

THE GREAT RIVER OF ALABAMA has crept out of its springs and brooks and has formed the rocky, free-flowing rivers of its youth. It flows through a sloped landscape with relatively narrow bottomlands except on the largest streams.

This is the land of our favorite canoe trips—Bear Creek, Cypress Creek, Elk River, Sipsey Fork, Locust Fork, Cahaba River, Cane Creek, Hurricane Creek, Choccolocco Creek, Five Mile Creek, Hatchet Creek, and even the notably improved Valley Creek. This is where the shoals lilies grow, and there are rapids, pools, high cliffs, and rocks to pull out on and sun ourselves while we eat lunch. Along these stretches, you can drift with the current and still make progress.

Yet this is the landscape where floods are less common and more manageable, tempting us to build close to the creeks. The little rivers don't always get their due respect. They are more delicate, easy to break, and we have to watch them more closely. One careless afternoon with a bulldozer, or a thoughtless episode like the Marvel Slab (a homemade dam) on the Cahaba has serious and long-lasting repercussions. Sedimentation from a careless construction project may impact the creek for years.

Upland rivers have rocky valleys and often have rapids and falls, like Pisgah Gorge in Jackson County, Blount County's Cornelius Falls, and High Falls on Talladega Mountain. All but the largest rivers tend to have narrow floodplains. The rivers' characters frequently change as they cross boundaries in the complex geology of old Pangean Alabama. The sudden change of the Cahaba River where it joins with the Little Cahaba —rolling landscape to enormous limestone cliffs—is worth the whole trip from Piper Bridge to Pratt's Ferry.

MISTY CANOE

Previous pages: Sunrise on the Upper Cahaba River, Jefferson County, Alabama

A nice thing about rivers is that they do have limits. They have beginnings and endings and waypoints. But what's in between is always a surprise. Some days aren't as good as others—the weather's too cold, the water's too high, the water's too low, your companions are too loud, the danged boat leaks and your knees are wet, the wind's in your face and the fish aren't biting. But sometimes it's right, and sometimes it's even sublime. And briefly, just for a delicious moment, you're alive, in control and alone. It's the little moments like this that keep you coming back.

The Cahaba is so near downtown Birmingham. It's the source of water for one-quarter of the population of Alabama. It flows through the center of the fastest-growing urban area in the state, and we probably ought to take care of it.

The rocks of northern Alabama are very ancient, a remnant of Pangean Alabama. They predate the rise of the Appalachian Mountains, and any rock you pick up is more than 300 million years old.

The character of the Alabama upland landscape varies greatly from southeast to northwest. Because the continents collided in the east, that side is the most altered, and the effects become progressively less damaging to the landscape as we move westward. The uplands are divided into four great physiographic provinces, each a landscape with a unique geologic history that forms its shape, soil, and character. Following the grain of the geology, the rivers—Chattahoochee, Tallapoosa, Coosa, Cahaba, Black Warrior, and Tennessee—flow markedly parallel as they head to the southwest.

On the east side is the *Piedmont Upland Province*. The twisted and irregular rocks that form the contorted landscape of east Alabama and adjacent Georgia are the greatly eroded and uplifted roots of the southernmost Appalachians, crushed in the great collision that formed Pangea. The mountains are gone, destroyed by millions of years of persistent erosion, but their metamorphic roots, formed by heat and pressure deep in the collision, are still there. Now they have been brought up from considerable depth, bringing with them many of Alabama's valuable minerals—gold, tin, graphite, and mica. The southeastern half of the piedmont is the most altered and is roughly the center of the collision. In some places, such as Alexander City, granites can be found. These igneous rocks indicate temperatures and pressures deep in the mountain roots that were sufficient to melt the original rocks.

The southeastern part of the Alabama piedmont is drained by the Chattahoochee (mostly in Georgia) and the Tallapoosa Rivers. The Tallapoosa apparently has been a mountain stream for a long time. That it doesn't flow through much limestone makes it low in calcium, hence its mollusk fauna has fewer species than the Coosa.

The northwestern half of the piedmont is not as damaged. It is dubbed the *thrust belt* because the landscape is fractured into huge sheets of less-metamorphosed rock, shoved miles northwestward from their original positions and stacked one on top of the other. Their raised and exposed northwestern edges form the series of rocky ridges and mountains in the national forest (think Cheaha) and along Interstate 20 from Georgia to beyond the Coosa River.

The *Valley and Ridge Province* is the profoundly wrinkled area just west of the continental collision point. Here the earth's fabric is fractured and folded into alternating linear mountains and deep valleys. On the flanks of Lookout, Sand, and Red Mountains, we can still see the original sedimentary rocks of pre-Pangean Alabama, bent upward hundreds of feet and heavily eroded to reveal the otherwise deeply buried layers of shale, sandstone, coal, iron ore, and limestone. Some of this evidence is exposed along the Upper Coosa

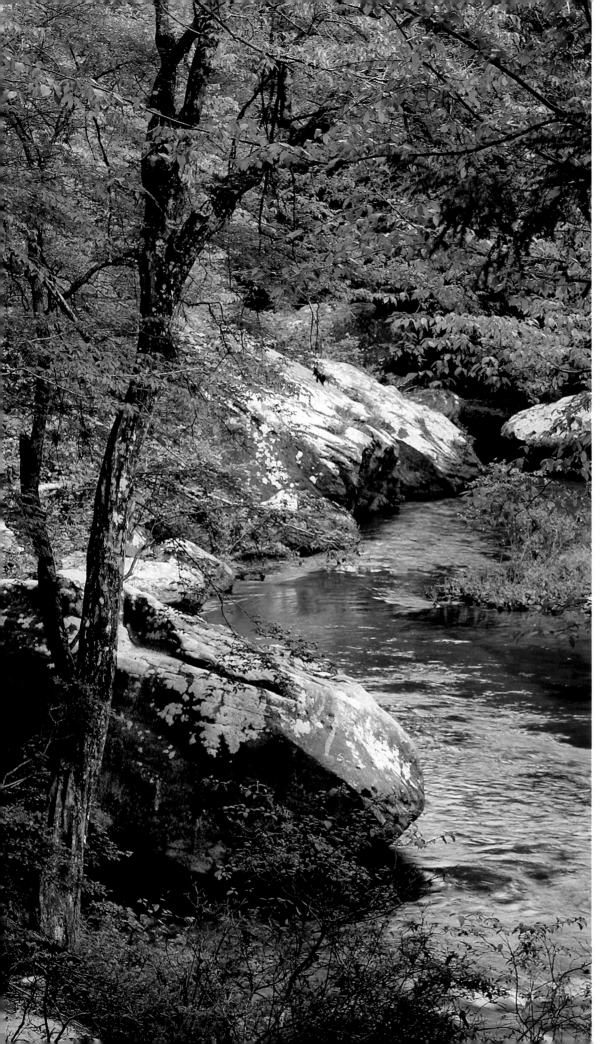

This is the forest primeval.
The murmuring pines and the hemlocks,
Bearded with moss, and in garments green,
indistinct in the twilight,
Stand like Druids of old.

—Henry W. Longfellow, *Evangeline*

HEMLOCKS AND BOULDERS

The river as the first Americans saw it. Sipsey Fork at Thompson Creek, Winston County, Alabama

The human presence in Alabama dates back at least fifteen thousand years. People have always modified the landscape—particularly as they developed agriculture and still more so as cities appeared. Since the eighteenth century the industrial revolution has increasingly damaged the natural landscape until we now despair that we might lose it forever.

Almost none of the Alabama landscape is as it was in frontier times. Even Longfellow's vision of America as the forest primeval, with a few Indians lurking in the shadows, is misleading. The first explorers reported that a great deal of the upland landscape was open savannah or mixed forest, the result of thousands of years of repetitive burning. By early historic times, a large Indian population had cleared much of the drier bottoms for cornfields, and the Europeans, with slaves and steel tools, cleared even more and drained the wetlands. Timbering, with the help of the railroads, destroyed the upland forests. By the early 1900s essentially no old-growth forests survived except in the most difficult and remote places. Even large hardwood forests, like those seen in the Smokies, are only about one hundred years old.

But here and there, particularly in the deep gulfs and canyons, there's maybe a little bit of the old Alabama landscape left. If you look in the right direction and sort of squint, there is hardly a visual clue to place you in the present. Often it is along the streams that we can see the old sights, taste the old flavors, and smell the old smells.

and Cahaba Rivers. The southwestern part of the Valley and Ridge Province includes the massive "Birmingham Anticlinorium." This delightful name denotes the distinctive folded structure that brought up from the depths the three ingredients of iron making—coal, iron ore, and limestone—within a few miles of one another and attracted an iron industry. The Shelby County portion of the Cahaba flows down the eroded southern edge of this ancient structure. In some places you can see the exposed edges of the strata pointing up toward the northwest, toward the vanished center of the fold, now the city of Birmingham. Red Mountain and Shades Mountain are the remains of its southeastern flank.

The distinctive southwest/northeast grain of the valley and ridge landscape can be seen at a glance by the trend of major rivers, railroads, and highways in northeast Alabama. They run up and down the faults and folds of these ancient wrinkles. As we go northeastward up Interstate 59, the limestone valleys become roughly contiguous with a series of valleys that run from Alabama up through Tennessee and the length of Virginia. This area has been termed the Great Valley and is followed by Interstates 75 and 81 all the way to Pennsylvania.

The Coosa River and its ancestors drained the southeast portion of the Valley and Ridge Province (and the north flank of the piedmont's thrust belt). The Coosa flows strongly southwest along these structures until it turns south and makes a dash across the piedmont to Wetumpka. Other parts of the Valley and Ridge Province are drained by the Cahaba and the easternmost tributary of the Black Warrior River, the Locust Fork. To the advantage of the Coosa's famous mollusk fauna (the calcium is important for shell formation), there is a good deal of limestone exposed along the river.

West of the Valley and Ridge Province is the *Cumberland Plateau Province.* This area consists of the relatively undamaged remains of the old Coal Age coastal plain, far

Fall sycamores shine through maple foliage. Windblown, the small maple leaves whisper and big sycamore leaves give a leathery rustle, but come winter, both will fall silent.

enough west of the continental collision that it is less impacted. The rock layers are still horizontal, but are fractured—crazed like a broken windshield. At the surface are huge thicknesses of coal-bearing rocks (originally some six thousand feet), sometimes described by the old British term "coal measures." This is the famous Pottsville Formation—layers of sandstone, shale, and coal laid down in late Coal Age times. In most of the Alabama plateau, this formation is very thick and is important to the landscape of the upper River of Alabama. West of Birmingham, several coal mines are found that are two thousand feet deep or more yet still don't reach the bottom of the Pottsville Formation. The surface of the plateau is eroded into a steep-sloped landscape of narrow river valleys and sharp ridges. It has never been productive farmland, due to the steep terrain and poor soil derived from the Pottsville rocks. The western plateau is drained by tributaries of the Tombigbee—the Sipsey River and Luxapalila and Buttahatchee Creeks. The south portion is drained by the Black Warrior's Mulberry and Sipsey Forks, and the north part is drained by the Tennessee.

But as you go north from the plateau, the Pottsville rocks become thinner and you begin to rise up the flank of the Nashville Dome. Central Tennessee is uplifted, probably by the same tectonic events that formed Pangea. This giant bulge in the earth's surface is centered on Nashville, but its concentric rings of angled and eroded rocks extend into Alabama, where it is called the *Highland Rim Province.*

In Alabama these rocks are mostly the limestone layers that are so typical of the Tennessee Valley with its broad vistas and limestone bluffs. The area is a well-known karst region, a limestone terrain full of caves and sinkholes. Small surface streams are rare (they sink into the fractured limestone), and the landscape is rich in hardwood-covered slopes and cedar glades.

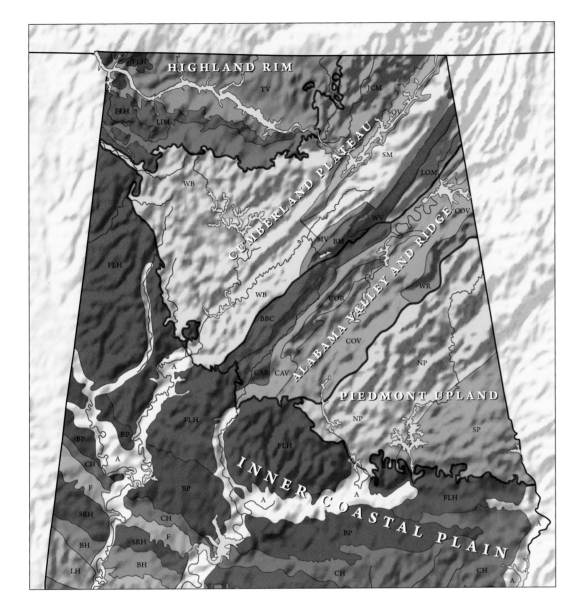

From east to west, Piedmont Upland Province (the contorted and eroded roots of the ancient Appalachians), Valley and Ridge Province (wrinkled and folded by Pangean collision, strong northeast/southwest grain to the landscape), Cumberland Plateau Province (horizontal strata but fractured and eroded), and Highland Rim Province (the edge of the Nashville Dome structure extending south into Alabama). The fall line is where the northern edge of the coastal plain touches the upland provinces. Visible as a dotted line is the buried edge of the old continent, now overlapped by the coastal plain.

Areas of differing Alabama geology erode to form different geographic landscapes. Note the general (but not exact) congruence between this map and the geologic map of Alabama in part 1. It is from this physiographic map that the various local landscape features of the state draw their names, such as the Warrior Basin, Tennessee Valley, Chunnenuggee Hills, Flatwoods, Thrust Belt, Fall Line Hills, and Pine Hills.

There is occasionally some disharmony between the geographic and geologic disciplines. For example, many of the lines of hills (a geographic term) are in fact cuestas (a geologic term). We also use the dramatic geologic term "thrust belt" in reference to the northern Piedmont Upland (geography).

The Tennessee River and its ancestors drained the western side of the southern Appalachians, and you would expect it to flow straight away from the mountains, but the Nashville structure is such an obstacle that the Tennessee makes a detour of several hundred miles into Alabama to get around the dome's southern flank before it abruptly changes direction toward the Ohio River.

Taken as a whole, the geology of old north Alabama is stunningly variable. This is what gives the state its well-deserved reputation for diversity—and we haven't even gotten to the amazing coastal plain yet! North Alabama is so diverse in rock composition that it is almost endlessly variable in soils. In the geologically complex valley and ridge landscape of southeastern Bibb County, tiny pockets of the Ketona dolomite rock layer weather to a high-magnesium soil that hosts at least eight species of plants that grow nowhere else on earth. On the Pottsville bluffs of northwest Alabama, ordinary-looking shales and sandstones weather to unusual soils that host rare plants--for example, the Alabama croton bluffs along the Black Warrior River.

Alabama rocks are so varied in structure that we can contrast Cheaha's two-thousand-foot mountain capped with quartzite with the Pottsville Formation's thick layers of level sandstone that provide caprocks for sheer cliffs and looming bluff shelters. On opposite sides of the state—along Sipsey Fork and Little River—there are canyons so deep and so inaccessible that some of the least-spoiled habitats in the state are to be found there, and the rivers flow through them all.

So there we have north Alabama, the weathered carcass of a 300-million-year-old Pangean landscape, progressively more damaged and eroded as you go from the falls of the Chattahoochee River at Phenix City toward Muscle Shoals. If you look in the overlooked corners, the land is wet and green and still unspoiled.

LITTLE RIVER FALLS

Little River, Little River Canyon National Preserve, Lookout Mountain, DeKalb and Cherokee Counties, Alabama

It is hard not to anthropomorphize streams, because when you speed up the video of time they seem almost alive. They loop, they writhe, they move around. Here the Little River is engaging in its favorite sport, erosion. Streams erode in three directions. The first two are fairly self-evident—streams erode the bed of the channel, which makes the valley deeper, and streams cut at their banks and the valley broadens.

But rivers also erode uphill toward their headwaters. At this place a hard layer of rock supports the falls, but the water gnaws at its edge and undercuts it in the pool below. Pieces fall off, are destroyed by the falls, and the bits are washed downstream. This is headward erosion, and the edge of the falls creeps slowly up the valley like a big snake gnawing toward its headwaters.

Little River Falls is the upstream end of Little River Canyon. Amazingly, this is the beginning of the kayak trail that goes over these falls (Class VI rapids) and into the canyon. About ten miles below, the river emerges from the canyon through a dramatic notch at Canyon Mouth Park and joins with the Coosa River. The falls must have begun there, where the river breached the side of the mountain, and they have been slowly creeping up the river's own channel to their present location for a very long time.

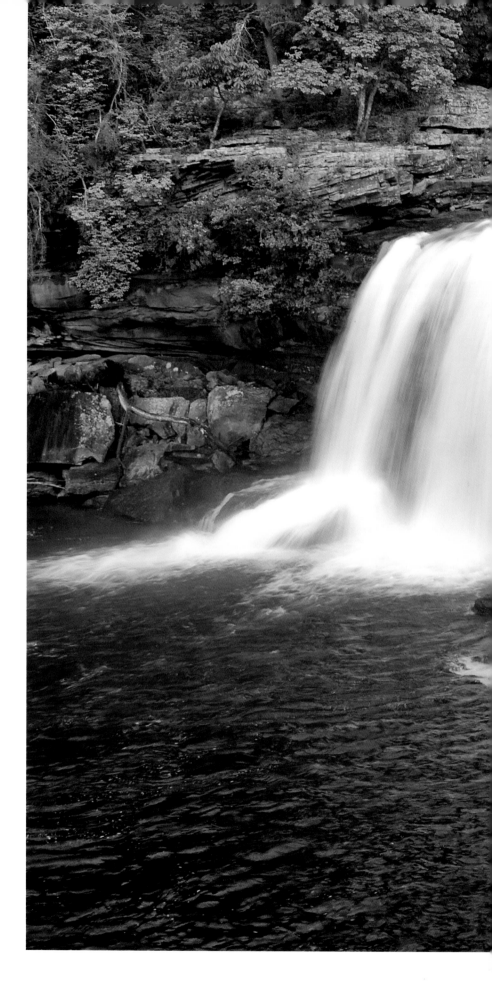

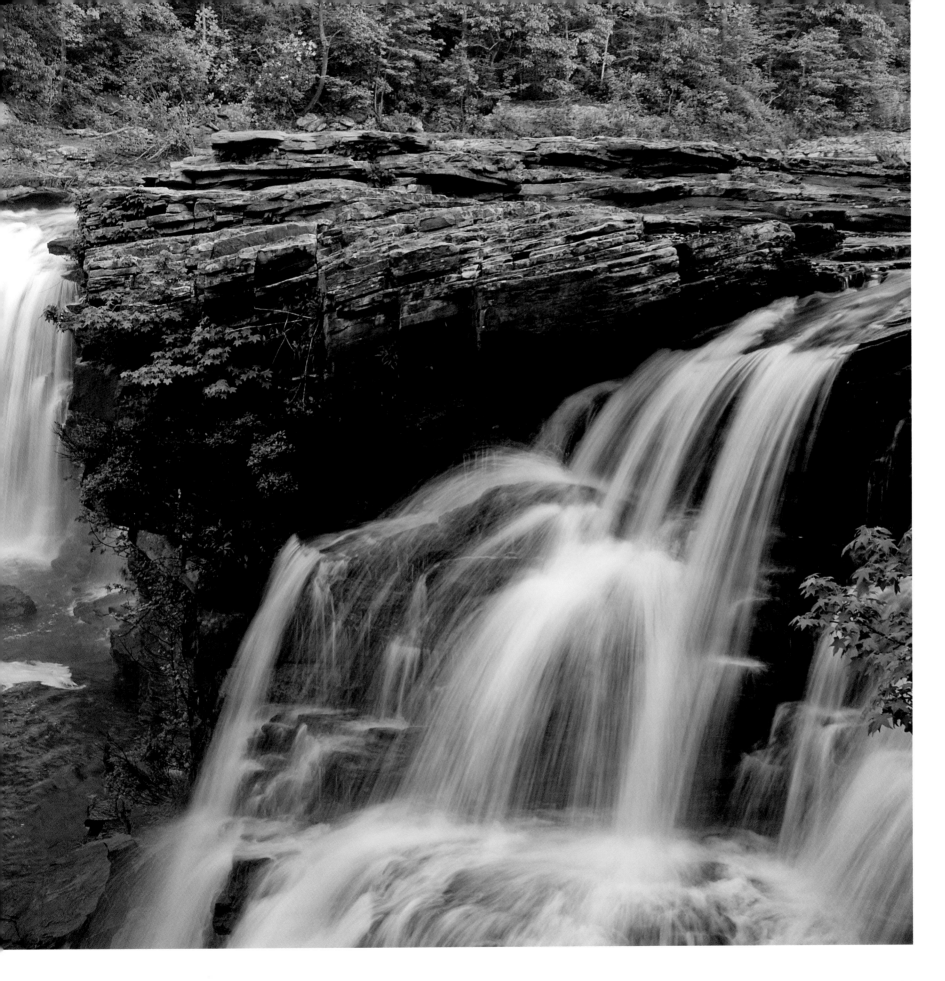

IN PRAISE OF BEECH TREES

Along the banks of the Cahaba River, Jefferson County, Alabama

Beeches are part of the old Pleistocene forest, left behind in the south, a relict species from a cooler and damper time. They are at their best on the cool, moist slopes. In the spring their sharp little buds finally push off the pale last-year's leaves, and out come those distinctive crisp beech leaves, straight-veined and scallop-edged.

Many things in the woods are rough, but beech trunks are like the smooth gray legs of dinosaurs. They make irresistible canvases for the sharp knives of lovers, a habit that would be even more irritating were the legends not so sincere. Other folks carve on them, too, and people are constantly besieging historians with reports of *arborglyphs* purporting to be the handiwork of famous historical figures. Maybe. Beech trees are not necessarily as old as they look, and there is no elegant way of verifying the age of graffiti.

After months of comforting shade, the tips of the branches finally begin to tarnish. Beeches are subtle and the bronze tips shade to gold and yellow as the inner leaves fade. Finally, sometime after New Year's, even the most stubborn leaves of other species fall, leaving a winter woods so gray and brown that the occasional evergreens—holly, magnolia, mountain laurel—seem like intruders. Deep in the winter woods, the persistent beech leaves gleam brown, but as the season progresses they become paler and paler. By February the leaves are faded and parchment-pale. The small beech trees in the forest are especially ghostlike.

All winter the rain comes down and drips off the branchlets and leaves. The more landscape that is *unimproved*—forested, uncleared, unditched, and unpaved—the more the water is held by a million little traps and obstructions. The rain sinks into the water table, where it feeds the springs and seepages that nourish the streams. Average stream flow is higher, and the rivers flow stronger in the dry season. But in an *improved* landscape—nicely cleared, ditched, and drained—all that water quickly runs off. The streams will miss that uncaptured groundwater in August.

Before I arrived,
who were the people living here?
Only violets remain.

—Issa (1763–1827)

PROJECTILE POINT

Early Archaic Palmer-style point from Cahaba River, Grants Mill, Jefferson County, Alabama

There were once a lot of Indians in Alabama, and they had been here for a long time. By about AD 1000 they had fully adopted an agricultural lifestyle and had begun to intensively farm the stream bottomlands. The Indians' principal towns had earthen mounds and elaborate political and religious organizations. The chronicles of Hernando de Soto reported that in the year 1540, cornfields adjoined cornfields for miles along the Coosa Valley, and much of the southern United States was like this. But de Soto also found abandoned towns, for the epidemics of European diseases had already begun. Most of the Indians of the southeast United States died soon after the European invasion, and within a few centuries the native cultures were destroyed.

Mounds, shell middens, pottery, and beautiful points are still to be found along the riverbanks. The points are the most evocative, looking so much like they did when they were new. Most points, particularly the larger and more elaborate ones, are much older than we commonly suspect. Many date from the Archaic cultures and are more than three thousand years old. We remember discovering the points in the fields when we were young and how casually we treated them before we realized that they are individual works of art, straight from the hands of people like ourselves, and should be treated with reverence, like the rivers along which they are found.

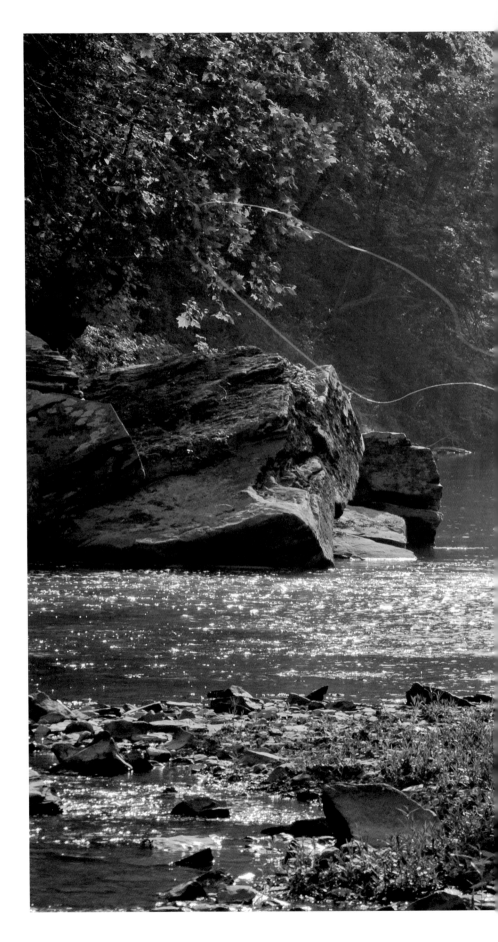

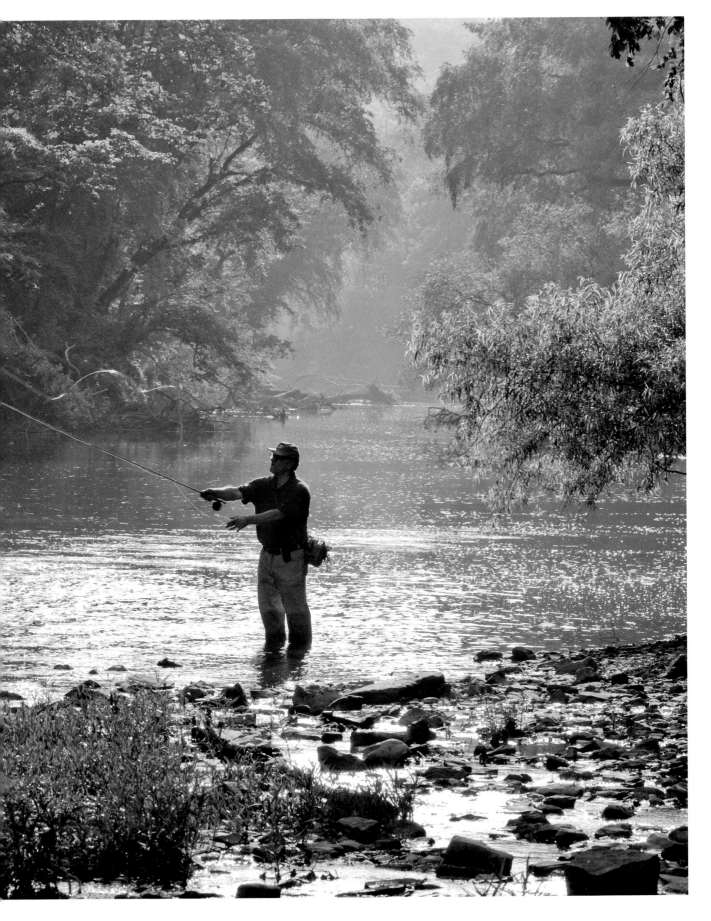

FISHING THE CAHABA

Cahaba River at Old Overton, twelve minutes from downtown Birmingham, Jefferson County, Alabama

The primary reason for the loss or endangerment of fish, mollusks, and other invertebrate species in Alabama is the decline in rocky habitats such as this one. Rocks and gravel, sand and mud, logs and vegetation provide for a huge diversity of microhabitat, occupied by a matching diversity of life. Many species are specifically adapted to small niches involving specific foods, rigorous requirements for reproduction, or safety from predators. Being instinctive rather than intelligent, changing their habits when conditions are altered is not an option, and they simply disappear.

Siltation from construction or dam building covers rocky stream structures, and lake organisms replace the stream species. Other, more subtle dangers lurk. Upstream dams, even those that provide adequate flow, may change water temperature, oxygen, and turbidity or alter the daily and seasonal flow, interrupting critical portions of a life cycle.

The aggravating part is, if this habitat is so important and there's so little of it left, why is it so difficult to get it preserved?

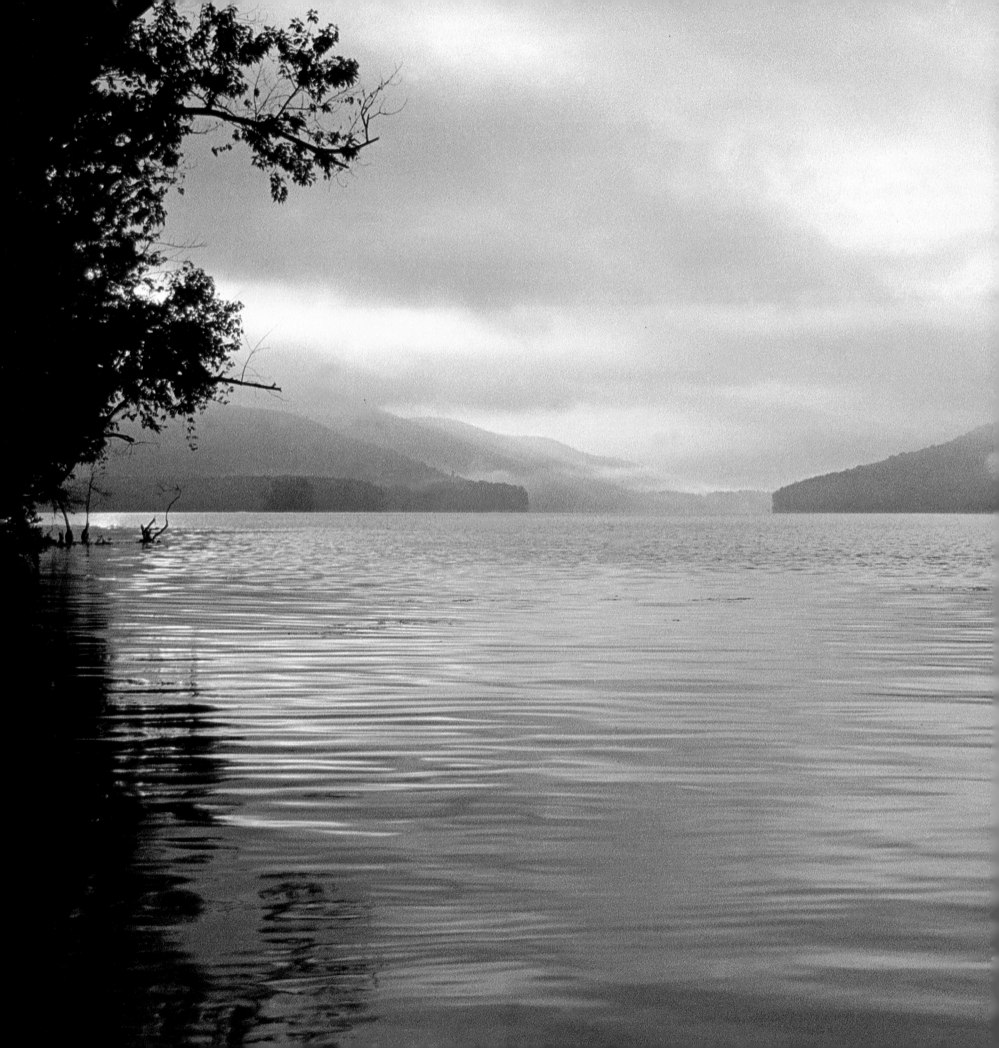

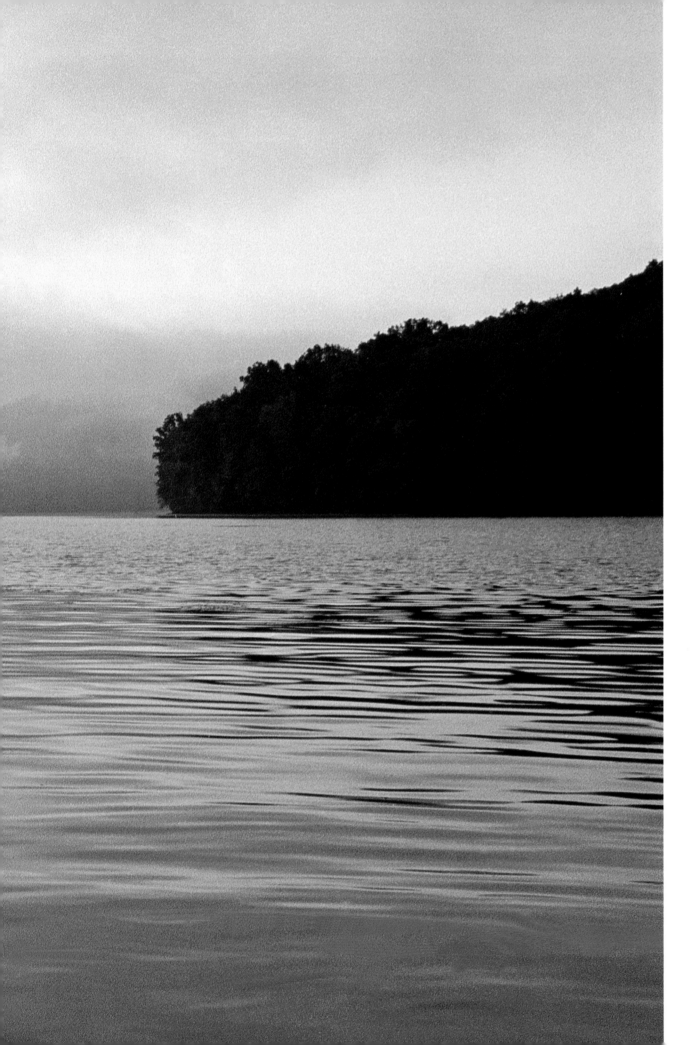

TENNESSEE RIVER SUNRISE

Mouth of Jones Creek at Tennessee River, Jackson County, Alabama

The Tennessee River drains the west side of the Smoky Mountains. One assumes its original inclination would have been to flow west toward the Mississippi Embayment, but it is guided by the edges of buried geologic structure. The river follows the rock weakness of the Sequatchie Valley (at the northwest edge of Sand Mountain) down into Alabama. From there it becomes involved with the uplifted highlands in central Tennessee—the Nashville Dome and the Highland Rim. Following the general strike of the structure, the Tennessee curves west and north. It eventually flows into the Ohio River just above its junction with the Mississippi.

In Alabama the Tennessee River's relatively narrow valley means that hills come down close to the stream, lending it a beautiful Rhine River flavor. Before the TVA lakes were constructed, long green pools alternated with rapids and shoals. The Indian population of the valley had been sizable since Ice Age times, so the banks are rich in shell mounds and there are deep middens in the bluff shelters up in the hills.

The Tennessee was the largest of Alabama's upland rivers, and its steep gradient made it a natural target for hydroelectric projects during the Great Depression. In an era when jobs were scarce, the Tennessee was accused of being a "loafing river" that should be put to work—a powerful argument in an era that still believed in taming the landscape.

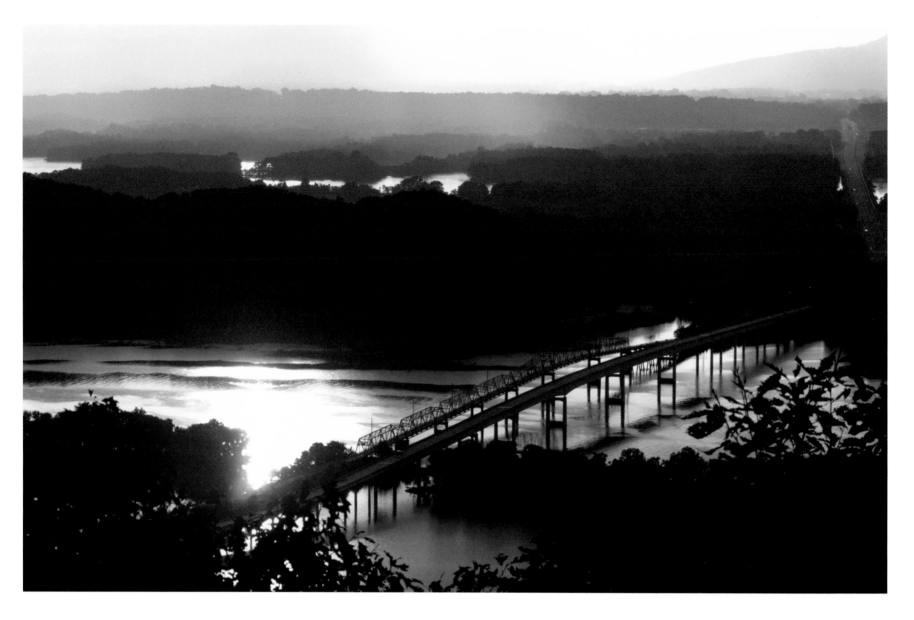

SUNSET ON THE CUMBERLAND PLATEAU

Tennessee River bridge at Scottsboro, Jackson County, Alabama

With fords and bridges, crossing the river is not always as problematic as getting to the river in the first place. Rivers tend to be surrounded by canyons, swamps, lowlands, canebrakes, bogs, beaver ponds, briar patches, and gum sloughs. By the beginning of the historic era, the Indians had been traveling the Southeast for millennia. They had it all figured out, and their well-established trade routes crisscrossed the region. These crooked foot trails followed the easy route along ridgelines and avoided lowlands. They crossed rivers mostly at fords where it was possible to approach the river without having to slog through the swamp.

The Europeans followed the Indian trails for the same reasons, and the foot trails shortly became horse trails. Horse trails became wagon roads and, later, motor roads.

Towns grew up at crossings on major rivers, particularly after the advent of the railroad. The oldest roads in any county are the crooked compromises of nearly two hundred years of road building superimposed on traditional foot and horse routes. (The often repeated joke about some winding road following a cow trail just may have some truth to it.) Bridges were built at narrows, where the valley wall was close to the river and a minimum of causeway across the swamp had to be built with picks, shovels, and mules.

After the end of the Great Depression, heavy machinery in road construction came into common use. It became possible to more or less draw a line across a map and build causeways, make cuts, and relieve steep grades. Since then, highway improvements have straightened out even traditional roads and allowed new roads and developments to cross hard-to-access natural areas. Some of our biggest and best natural areas have survived only by our inability (until recently) to build roads across them.

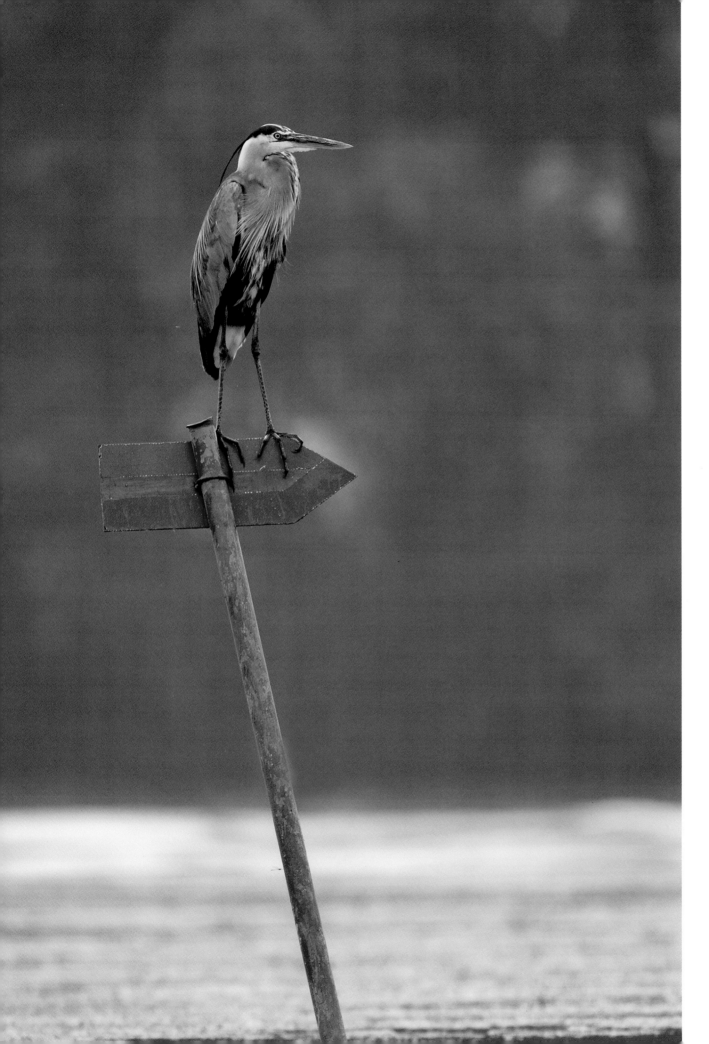

BLUE HERON

Contemplative *Ardea herodias*, Tennessee River, Jackson County, Alabama

The great blue heron is the solemn totem bird of Alabama waterways. If they weren't so common, people would drive miles to see these large birds. As it is, everyone still stops and looks at the giant wader, whose hoarse croak seems ill matched to a beautiful and graceful river spirit. One of the best things about being reincarnated as a heron would be that you would own the best time of the day—stalking the shallows early in the morning with rising mists and fishing with a spear. Herons are also fond of posing arrogantly, as if to take pity on the rest of us who have the bad karma to still be people.

On the other hand, generations of great blues on Soldier's Creek have eagerly answered to the hollered cry of "Oooh, Dodo! Here, Dodo!" They swoop down from the tops of the pines to stand on the dock and beg shamelessly for croakers and pinfish. Or you may be fishing on a sandbar when you become aware that *you are not alone.* Slowly you turn to find His Majesty staring fixedly at your minnow bucket. Go figure.

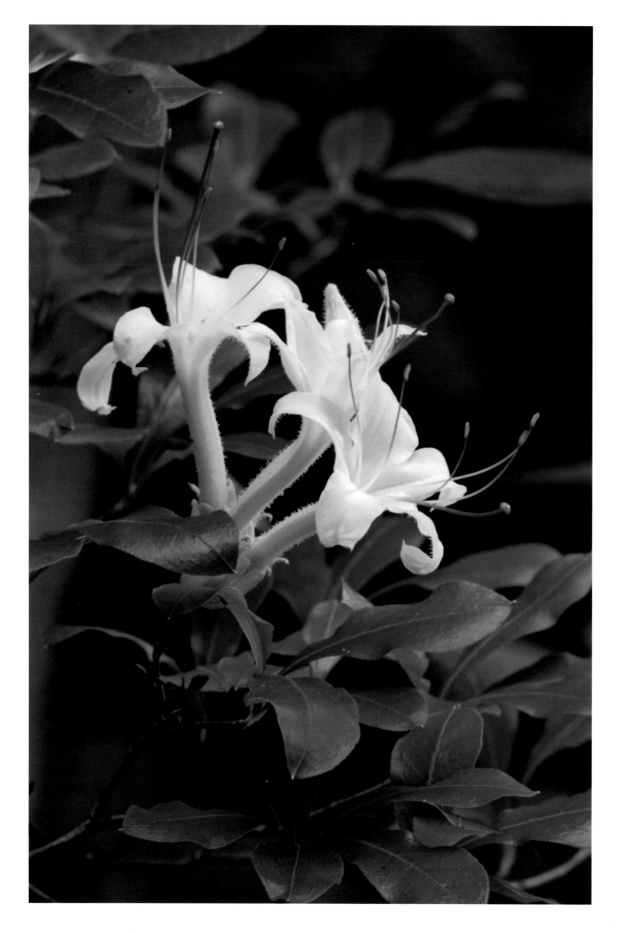

SMOOTH AZALEA

Rhododendron arborescens brightens the thicket near Blackwater Creek, north of Jasper, Walker County, Alabama

Not to be confused with the big evergreen rhododendrons of the mountains, nearly a dozen species of "bush honeysuckle" decorate the state with red, white, pink, and yellow flowers. They're at home in the forest understory, but they look their best where they get a little more sun, like along the edges of streams and country roads.

Alabama's wild azaleas don't get enough respect. The familiar cultivated azaleas are Asian imports. This irritates the Alabama wildflower folks who point out that our natives are underappreciated—being hardy, preadapted to the Alabama climate, and every bit as pretty as the exotics. Besides, some are fragrant. Such folks grumble that it would be nice if the horticulturists would put the effort spent in developing Asian cultivars and hybrids into improving the Alabama azaleas instead.

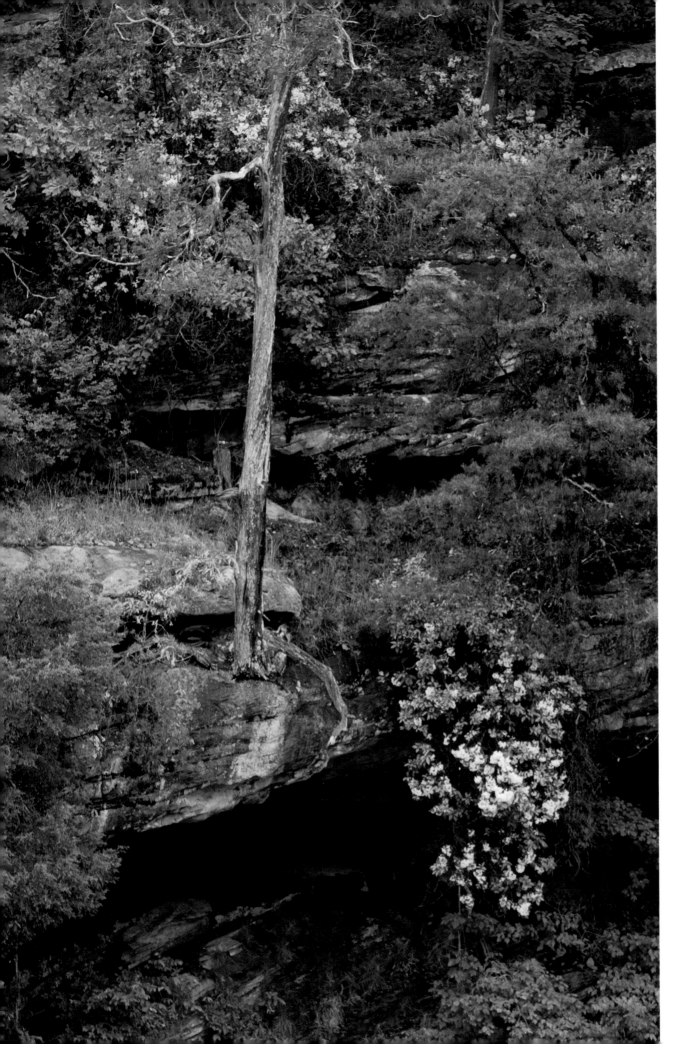

CLIFF GARDEN

Red cedar, cross vine, and mountain laurel at Cornelius Falls, Locust Fork, Blount County, Alabama

The Black Warrior is the big river of the Alabama plateau. Its three forks—Sipsey, Mulberry, and Locust—mostly flow through the rocks of the Pottsville Formation. The Pottsville is an ancient river-mouth deposit composed of countless layers of sandstone, shale, and coal. It is enormously thick, several thousand feet at its southern edge and thinning as it goes north toward the Tennessee Valley. Nearly an equal portion of this formation has been removed by erosion and is now part of the coastal plain.

The Pottsville Formation provides the sandstone layers that cap the mountains and hold up the cliffs and waterfalls. Most sand particles are made of quartz, which is very hard and resistant to erosion. So thanks to the Pottsville, a lot of the plateau streams (and those of the Valley and Ridge Province, for that matter) have steep valleys, cliffs, canyons, and waterfalls—Sipsey Fork, Hurricane Creek, Little River, Locust Fork, Bee Branch, Natural Bridge, the Dismals, Bear Creek, and others.

We can count on our fingers some of the factors responsible for this incredible hanging garden. Clinging to its Pottsville ledge, it is sunny and protected from disturbance. Late in the year, perched out there in the sun, it will be bone dry, but in the spring it is moist and early season plants grow in profusion. That particular layer may have a different soil, perhaps accounting for the lime-loving red cedar. How old do you suppose that poorly but ancient cedar is, anyway?

MISTY FALLS

Sunrise on the Locust Fork, Blount County, Alabama

Air is part of rivers, too. Air is in the spray from thundering falls, the haze on summer days, the preternatural clarity after a shower, or the ephemeral mists at dawn as the temperature changes. It is a cold wind seeping down your back when you raise the fly rod for another cast. It is the wind in your face as you try to paddle against it, and it is that electric feeling in the breeze as a thunderstorm approaches. Pursued by a sense of dread, you frantically paddle for the take-out spot. Then the wind overtakes you, and you are suddenly exhilarated by the wildness of it as huge drops of rain begin to smite you.

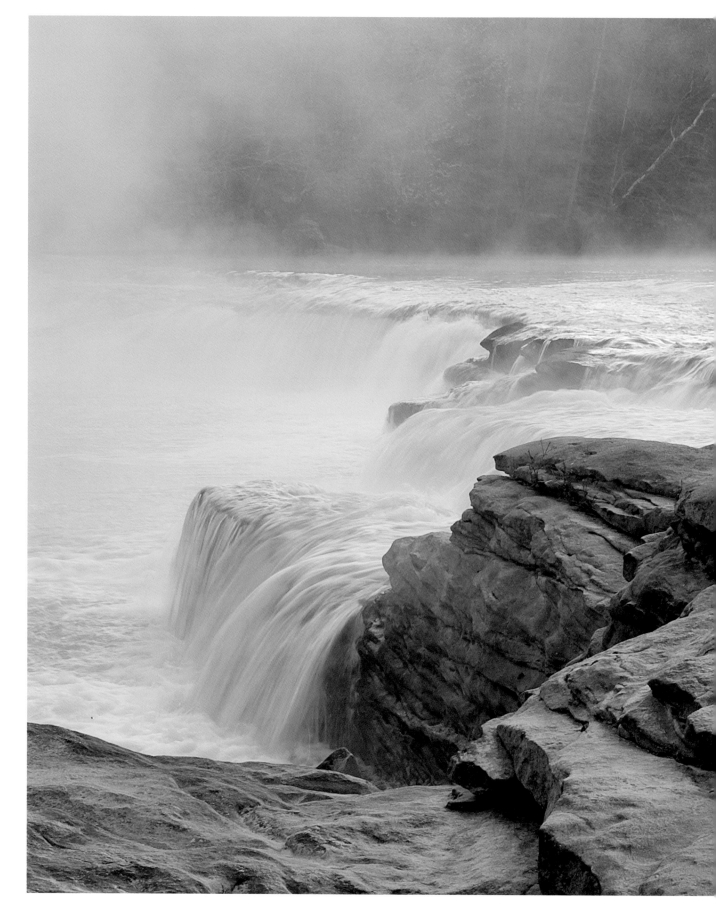

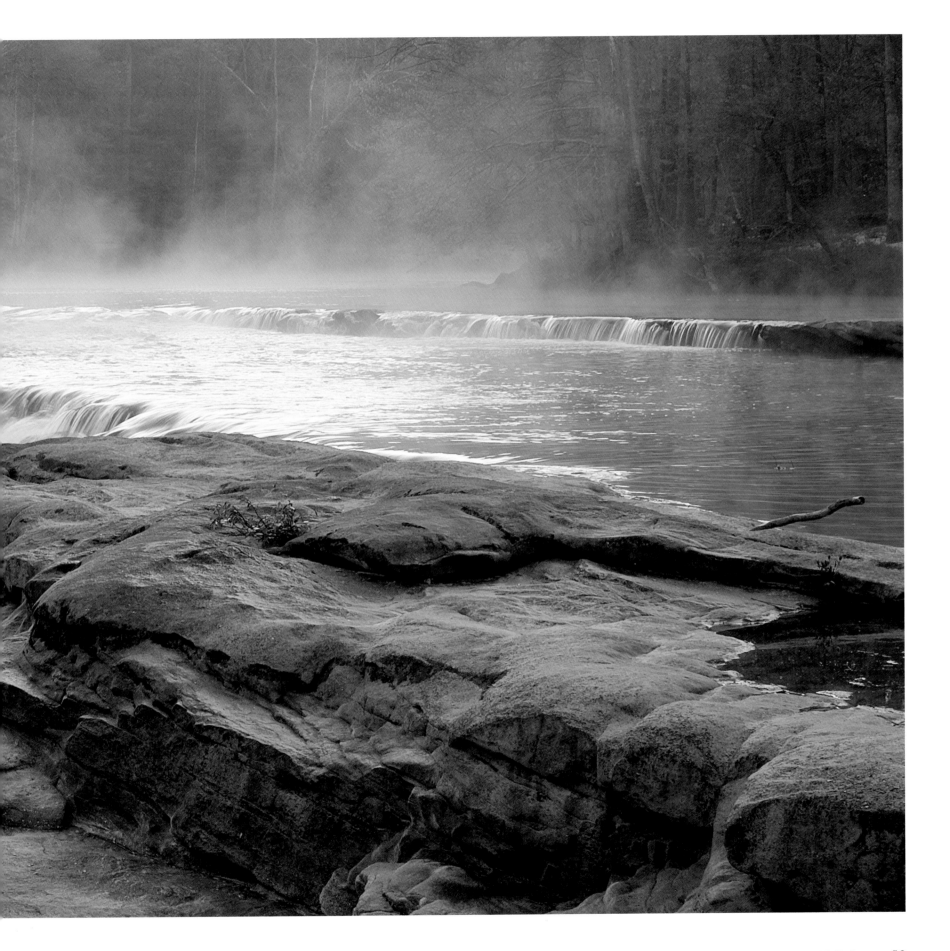

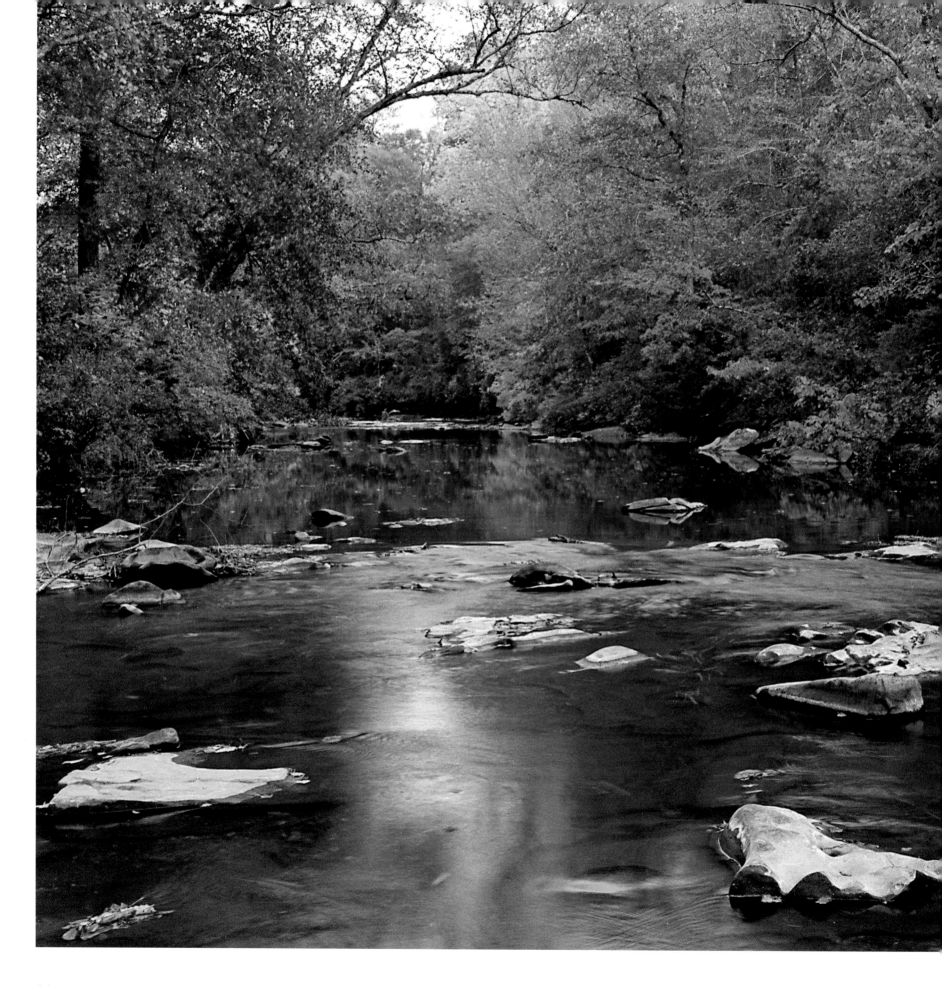

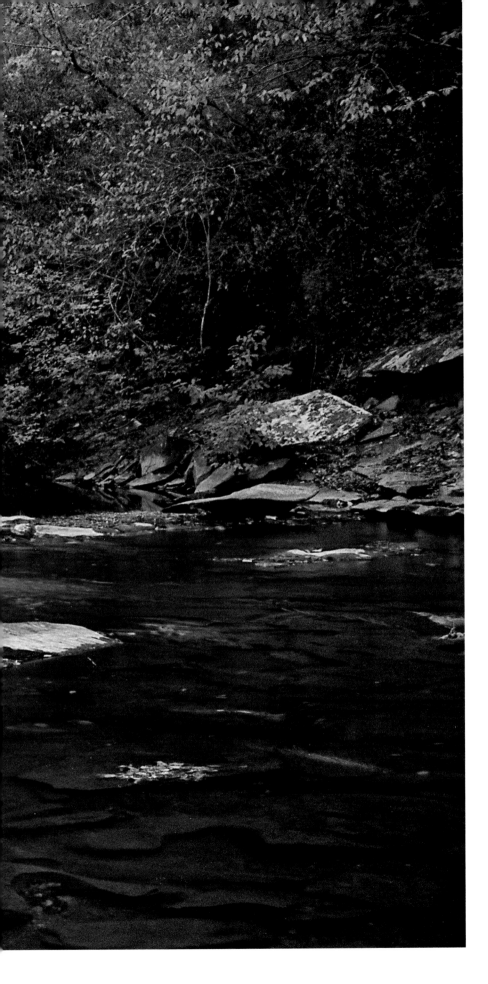

GUM TREE ON FIRE

Early fall on Hurricane Creek, Tuscaloosa County, Alabama

Hurricane Creek is something of an anomaly. It is the first canyon on the left bank of the Black Warrior River above the fall line. Almost all of this creek is within Tuscaloosa County, and its survival has been nigh unto a miracle. Being near the Warrior River, it was exploited early and often for timber and coal. There are literally hundreds of mines in the drainage, some of which are still active. Within recent memory, acid mine drainage has kept the water unnaturally clear and devoid of fish and insect life.

Then somewhere in the last twenty-five years, perhaps the unwitting beneficiary of mining and environmental reform, the creek began to recover. The locals first knew Hurricane Creek as a good place to swim and hang out. A canoeing organization formed, then morphed into an active preservationist group just in time to defend it against urban sprawl. The creekkeeper, John Wathen, has remarked that if he could just get the leaders of the companies that threaten it out on the river on an afternoon like this, his job would be a lot easier.

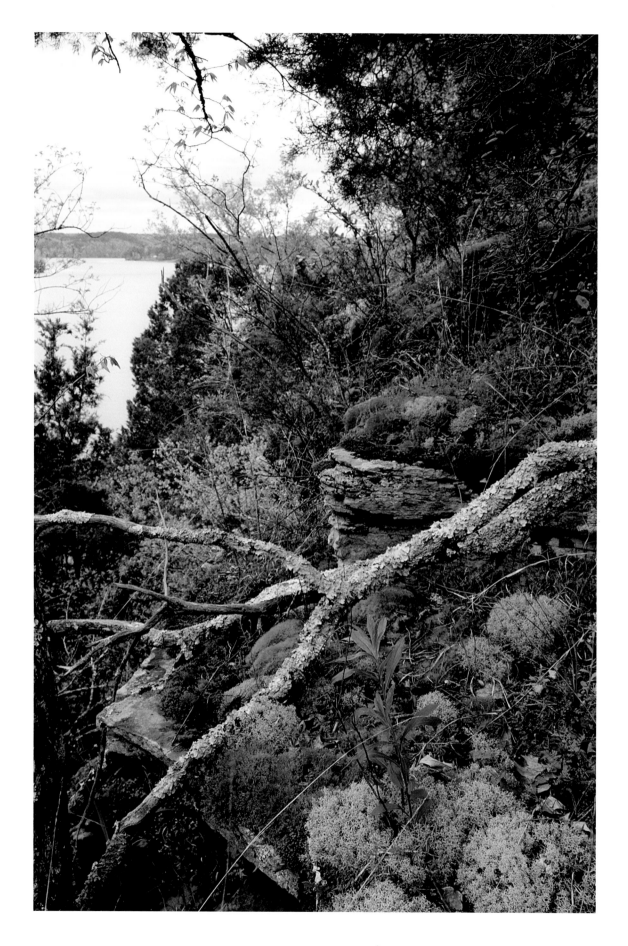

SPRING ON THE CROTON BLUFFS

Sweet sumac in bloom, and reindeer moss above Lock 14, Black Warrior River, Tuscaloosa County, Alabama

At the turn of the twentieth century, Alabama botanist Roland M. Harper recognized this area above Lock 14 as being particularly diverse. The rocky bluffs of the coal-bearing Pottsville Formation are the southernmost contact of the plateau with the coastal plain, and the combination of river, geology, and slightly alkaline soil chemistry has filled the area with unusual plants.

This is the type locality of the white-flowered Alabama snow wreath, *Neviusia alabamensis*, but it is not the only rare shrub on these bluffs. The Alabama croton, *Croton alabamensis*, is common here, even though by botanical happenstance it was first discovered at Pratt's Ferry on the Cahaba River. The Warrior's bluffs are classified as their own unique woodland type, Alabama Croton Woodland, and are characterized by the unique juxtaposition of Alabama croton, chinquapin oak, and red cedar. But it must be a hard life. The reindeer moss, a lichen, specializes in sandy soils that are drier than dry and markedly poor in nutrients.

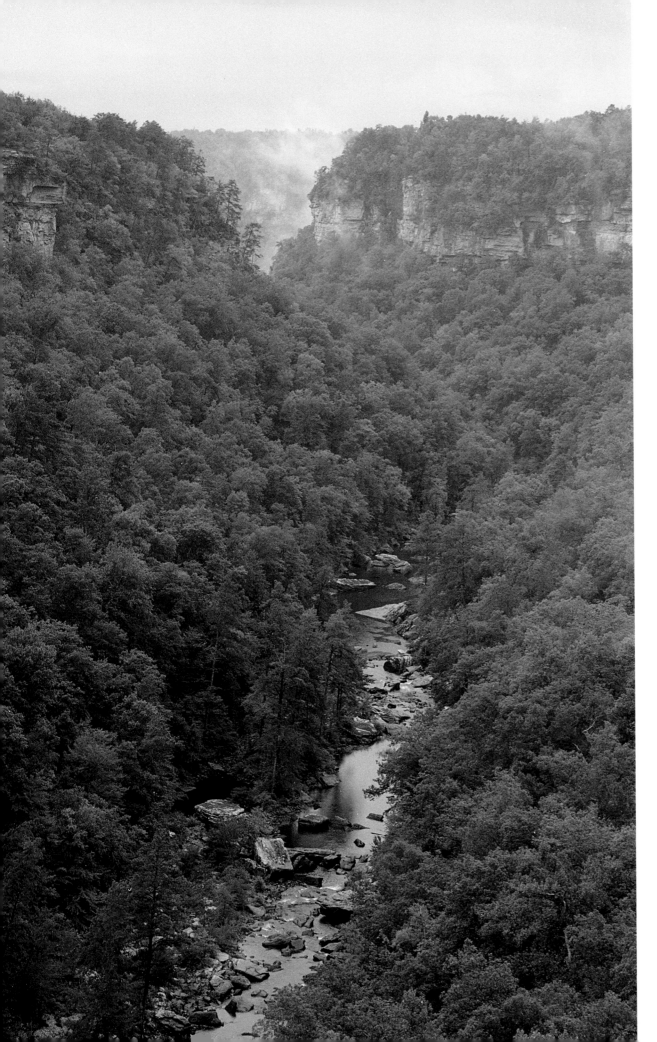

LITTLE RIVER CANYON

Little River Canyon National Preserve, Lookout Mountain, DeKalb and Cherokee Counties, Alabama

Imagine this: In northeast Alabama there is a river millions of years old that flows for thirty miles on top of a mountain. Little River is indeed such a stream. Practically its whole course is on top of Lookout Mountain, where it has eroded an amazing canyon with at least two spectacular waterfalls. It is not the only canyon in the state, but it's the best one.

The Valley and Ridge Province is the folded landscape on the west side of the continental collision that pushed up the southern Appalachians. Here the great Pangean collision wrinkled the rocks of the ancient coastal plain like pushing a rug on a slick floor. The portions of the landscape that bent upward formed long ridges, but their tops were fractured and they quickly began to erode. The portions that bent downward formed valleys, but these rocks became compressed, hardened, and resistant to erosion.

Let 300 million years pass (that's a long time, even in geology) and look at the valley and ridge landscape of today. The ancient fractured ridges have eroded so deeply that they form today's valleys. The ancient valleys, protected by their hardened surface, are now elevated ridges, such as Lookout Mountain. Little River is nothing less than the old stream that ran down the trough of the valley in ages past.

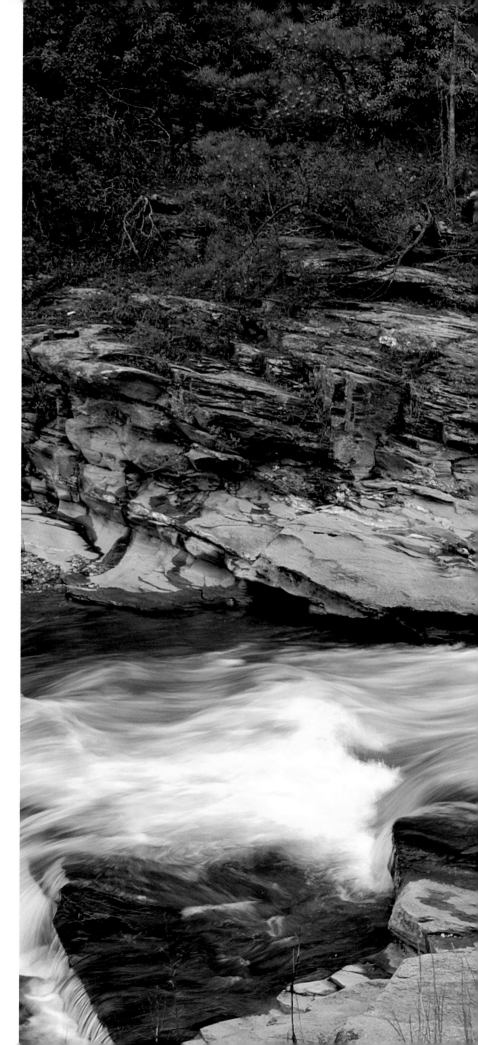

I have fallen in love with American names,
The sharp names that never get fat.

<div align="right">

—Stephen Vincent Benét

</div>

ROB ROY SHOALS

Talladega Creek, Talladega County, Alabama

"Excuse me, sir. Where is Rob Roy Shoals?"

"Where is Rob Roy Shoals? Well, Talladega Creek begins on the east side of Talladega Mountain at High Falls, down below Odom Point where the Chinnabee Silent Trail crosses the Cheaha Wilderness and turns into the Odom Trail (it was built by the Boy Scouts) and comes down past Cedar Mountain to Shinbone Valley, just north of Pyriton? Now, some would say it begins down at Bowdon Grove, though everybody agrees it is fed by Campbell Springs, flows past Erin between Clairmont Springs and London Mountain, past Weathers—I have kin at Weathers! It passes through the water gap near Chandler Springs—that's where Rob Roy Shoals is!—then past Waldo, where the railroad crosses? Then it goes through Talladega (you know, General Jackson and the Redstick War?), but the creek can't flow on west through the Sleeping Giants, so it turns south down the Talladega Valley past Reynolds Mill, Nottingham, and Kymulga, to just above Childersburg, where it flows into the Coosa River, though that's really Lay Lake there, you know, down below the old ammunition plant?"

"Oh, thank you!"

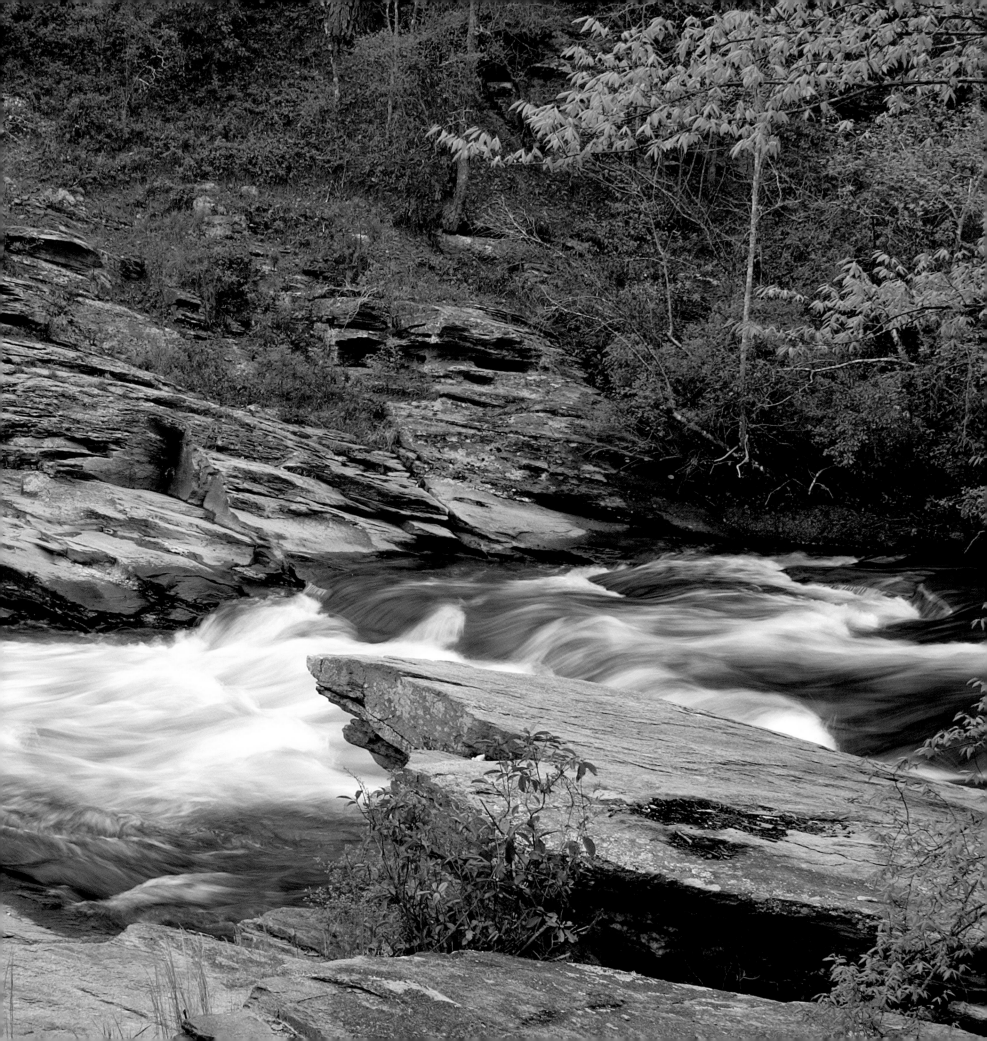

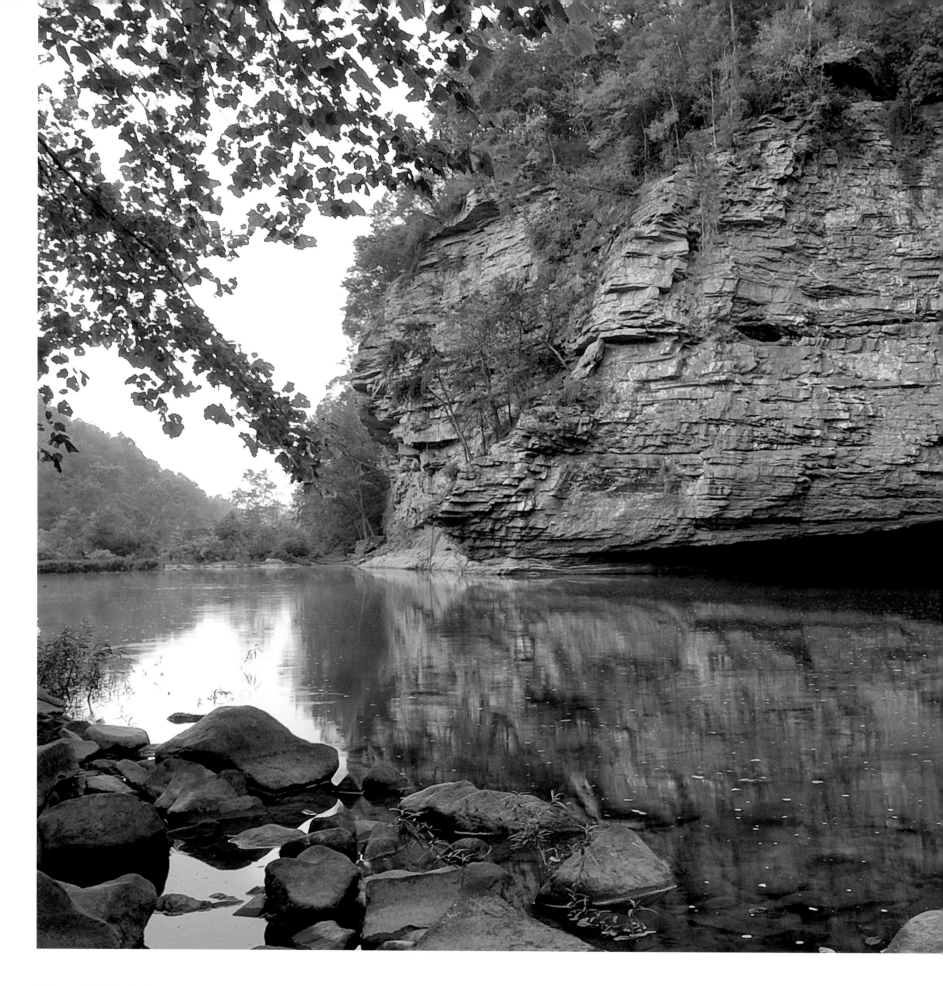

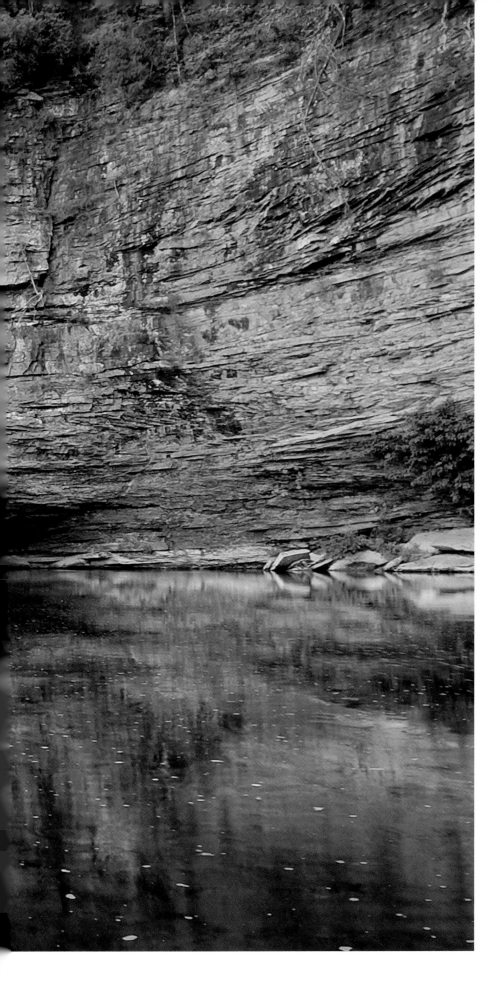

SCARIM BLUFF

Downstream from Swann Bridge, Locust Fork, Blount County, Alabama

A geological truism states that soft rocks form slopes and hard rocks form cliffs. At this place the river undercuts the hard limestone. At some point the rocks will simply fail and this hunk will fall off, maintaining the steep cliff face. The rubble becomes the rocks in the stream, where they will be ground to bits. At the right edge of the undercut, you can see a vertical fracture—a "joint"—where it will likely fail.

The plateau region is full of these joints, left over from the stress of mountain building to the east. There's not a lot of movement along these breaks; it's like a shattered car windshield—the stress of impact is relieved by the tiny fractures. Streams often follow the larger joints, because they erode faster along the weakened fractures. In some places streams take sudden doglegs at the intersection of two joints. This is sometimes more easily seen on a map, where a stream's sudden turns or unexpectedly straight stretches should make one suspicious of some kind of structural control.

It is hard to overemphasize the importance of fractures—large and small—in the weathering and erosion of the landscape. When you make little pieces out of large ones, the surface available for weathering is dramatically increased.

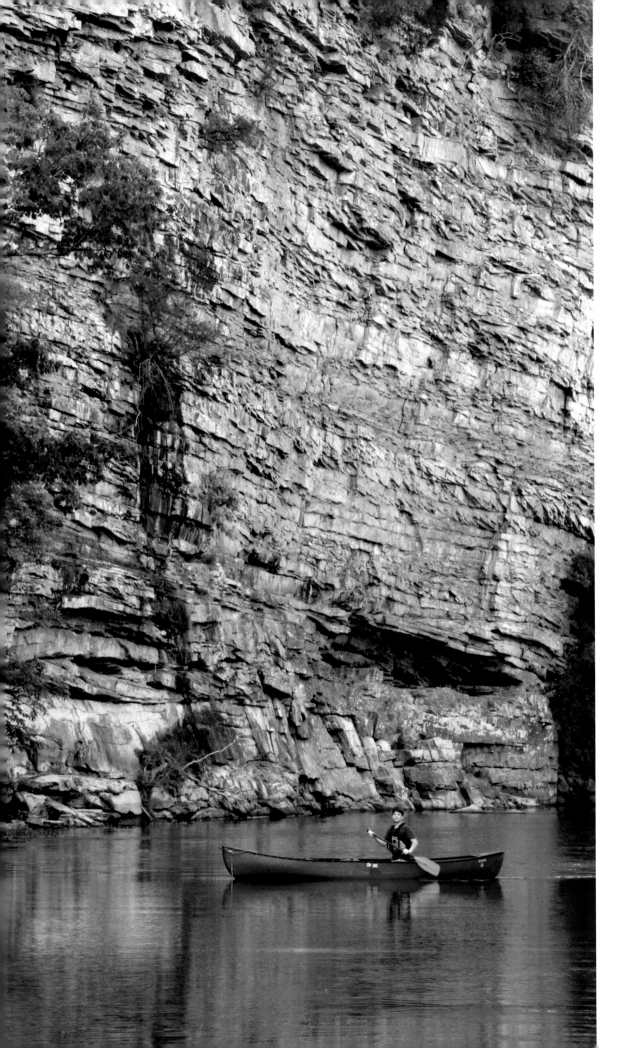

The mind seemed to grow giddy by looking so far into the abyss of time.

—John Playfair

TIME AND THE RIVER FLOWING

Locust Fork upstream from Swann Bridge, near Cleveland, Blount County, Alabama

Sometimes the rock strata need to speak. Nearly all of the Alabama plateau is covered by the thick sandstone and shale of the Pottsville Formation, so when you see limestone near the surface, there must be some kind of structural explanation. Locust Fork flows down the north edge of the complicated Birmingham geology that has brought up some deeper layers. Here it is the Mississippian-age limestone, which is older than (hence beneath) the Pottsville Formation. Limestone like this forms in warm tropical seas, so we know that long ago this spot was located near the equator.

Each layer represents a discrete instance, a time interval with a beginning and an end. Even today, deposition of sediment is episodic, with conditions changing from time to time. What causes these changes is not always immediately apparent, nor is it always clear how long it took to deposit each stratum, if there was a pause between depositional periods, or even if some were deposited and are now eroded away. The recipe also varies with water depth, how close this spot was to land, water temperature, currents, and the number of organisms living there. This kind of thing gets geologists all excited.

But the rest of us simply look up at the cliff as we drift under it. Play a game. Assign whatever average length to each interval you feel comfortable with (fifty years per layer?), and multiply it by the number of layers you can count. A big number for sure, and this is only a small portion of the very great thickness of the strata of the Coal Age, which is only one of a dozen major periods of geologic time. Early geologists tried this and attempted to calculate the age of the earth by adding together all of the layers and their presumed rate of deposition. It didn't work very well—too complicated, too many variables. But what it did accomplish was to convince them that the earth was very old indeed.

BLUE WILD INDIGO

Baptisia australis **in flower along Locust Fork, Blount County, Alabama**

Locust Fork predates the present landscape. Its course meanders back and forth like the path of a river wandering across a smooth coastal plain. But geologist Jim Lacefield points out that the river is deeply entrenched, its meanders cut down into narrow valleys. It has been rejuvenated! The low, ancient landscape of north Alabama has been raised so rapidly that the twisting river has cut deeper but has had no time to widen into a broad floodplain.

The steep valley and cliffs make this ancient and beautiful river one of the most scenic and diverse in Alabama. It is an outstanding boating stream with challenging rapids and difficult portages. The exposed limestone, deeply buried in most of the plateau drainages, gives it an exciting diversity of plants. Several botanists, notably the late wildflower expert George Woods, have suggested that Locust Fork's diverse soils and landscape, aggravated by its general inaccessibility, may hide undiscovered species.

Scenically beautiful, geologically interesting, biologically diverse, a national-level canoe and kayak resource—what would possess us to consider damming this stream in search of temporarily cheap water? Jacob and Esau and the mess of pottage would make a good text for that sermon.

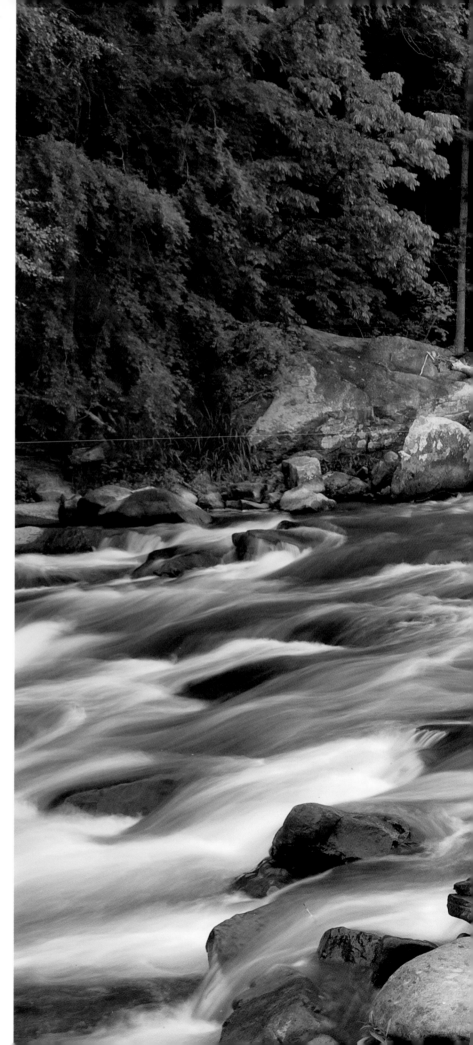

Don't take life so serious, son. It ain't permanent, nohow!

—Walt Kelly

BONY DOUBLE TROUBLE SHOALS

Downstream from King's Bend on Locust Fork, near Snead, Blount County, Alabama

Kayakers know different things about the river. They live for high water—rapids, falls, chutes, hydraulics. A well-known run develops a catalog of names for the difficult spots—the Boulder Garden, House Rock, Double Trouble, Billboard, Five-O, Training Wheel, the Pop-Up Hole, Agitator, and everybody's favorite, Lunchstop. Kayakers relish doing enders and pirouettes, brag of being run through a strainer or even being window-shaded. Their eyes light up, their hearts race, their voices rise!

Now *there* is a difference in perspective. Beginners, birders, fishermen, and photographers see these places as difficult or even dangerous—getting soaked is *bad.* Ah, but the kayakers see them as exciting, even desirable! Getting soaked is *good!* As we say down South, "Honey, they're a little *different!*"

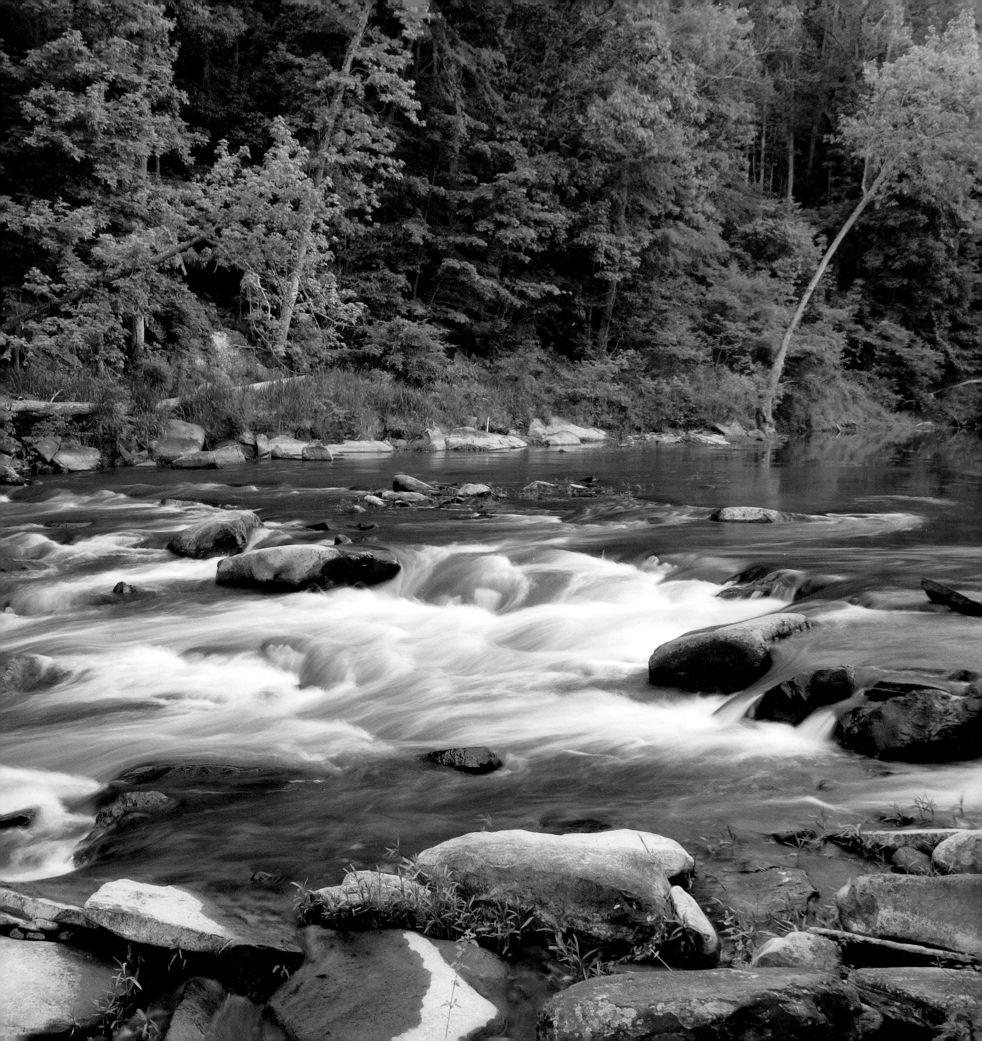

If I live to be old enough I may sit down under some bush, the last left in the utilitarian world, and feel thankful that intellect in its march has spared one vestige of the ancient forest for me to die by.

—Thomas Cole

LATE AFTERNOON ON THE OLD TRAIL

Rock shelter downstream from Sipsey Recreation Area, Bankhead National Forest, Sipsey River, Winston County, Alabama

Occasionally, it is instructive to get out of the boat, sit quietly, and commune with your ancestors.

During the Archaic era of Native American times, the climate was cooler and wetter. In this time before agriculture (before about 1000 BC), the Indians practiced a seasonal round of hunting and gathering, following the changing food sources as they became ripe. Winter often found small bands up on the warmer slopes in sheltered campsites, to which they returned each fall to hunt and gather nuts. In the spring these Indians descended into the valleys to gather ripening produce. When the river went down, they would camp by shoals to concentrate on the mussel resources. They knew the best places where the water was shallow and the clams were plentiful, and they made their annual camps on the same spot. Over thousands of seasons their waste piles turned into amazing shell mounds, some acres in area and twenty-five feet high. Shell middens are still visible along the eroding banks of many rivers.

Later, as agriculture slowly appeared, the Indian population increased, and it became concentrated in the river bottoms, where seasonal flooding kept the fields fertile. The bluff shelters still served as seasonal camps but for shorter periods. European travelers and hunters used them in frontier times, and still later some of these shelters were frequented by renegade Indians, escaping slaves, draft dodgers, and deserters from the Confederate Army. And from time to time, especially if there was water, a little whiskey might be made here and there.

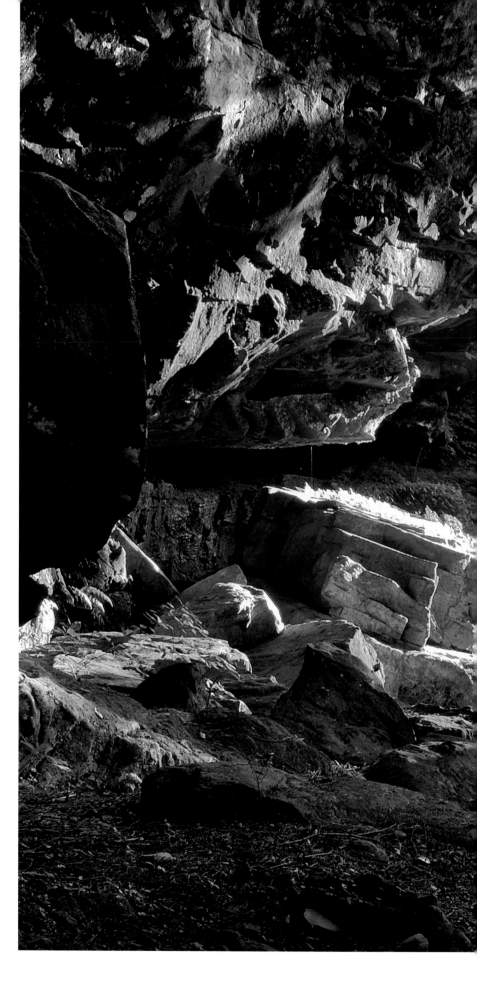

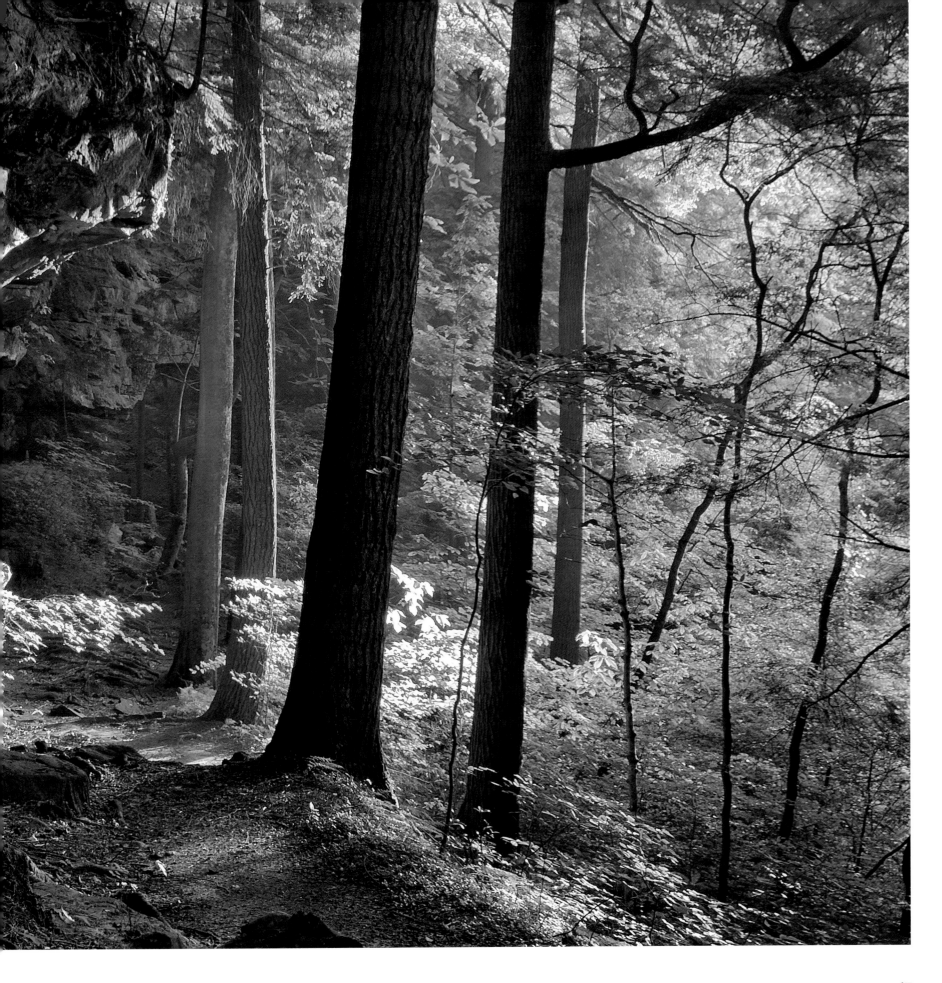

FALL COMES TO THE FERNS

Royal fern, *Osmunda regalis*, along Hurricane Creek, Tuscaloosa County, Alabama

Ferns are a favorite streamside treat. It is interesting that the varieties that grow along the bright margin of the stream are generally not the ones that grow in the shade. Even in prehistoric times the landscape was not the shadowy gloom of the old-growth forest, but was a mosaic that included patches of bright sunlight.

This large, distinctive species has been growing in Alabama since Pangean times. When the supercontinent broke up, the individual continents carried royal fern populations with them, and now it is one of the most widespread species on earth, occurring on every continent except Australia and Antarctica. It is no accident that the fossil ferns of the plateau's coal measures seem so familiar. Their relatives are still around!

THE FOREST'S EDGE

Intact riverine corridor along the Upper Cahaba River, upstream of old Overton landing, Jefferson County, Alabama

As we try to preserve rivers and the landscape, the goal is not to maintain the status quo, but to return the environment to some healthy reflection of the past, when things were "better." So when would that be? Conservationists of a historic bent warn of the "pristine myth," the notion that everything was once lush and green and perfect, with tall forests, beautiful flowers, little bunny rabbits, and so forth.

The reality is that while the landscape was indeed rich and full, with lots of unpolluted habitats, it was not a uniform carpet of giant trees. Instead, it was a mosaic, broken into large and small blocks of various ages and vegetations, with a large population of Native Americans and all of life forever subject to the tangled mess of storms and regular scouring by fire.

Upon reflection, we know this, but because there is so little of this landscape left, it's hard not to envision the past as old growth. Here and there you can still see a bit of the soaring cathedral-like woods that so charmed the early travelers. We still yearn for it, thick with vines, bright with flowers, and loud with birds.

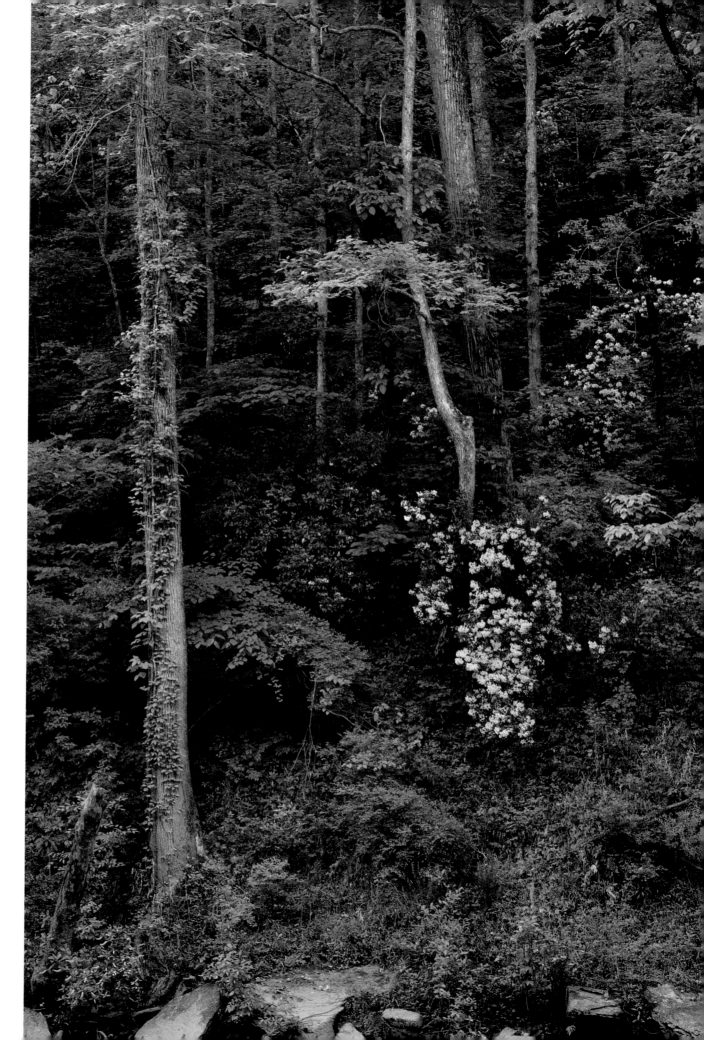

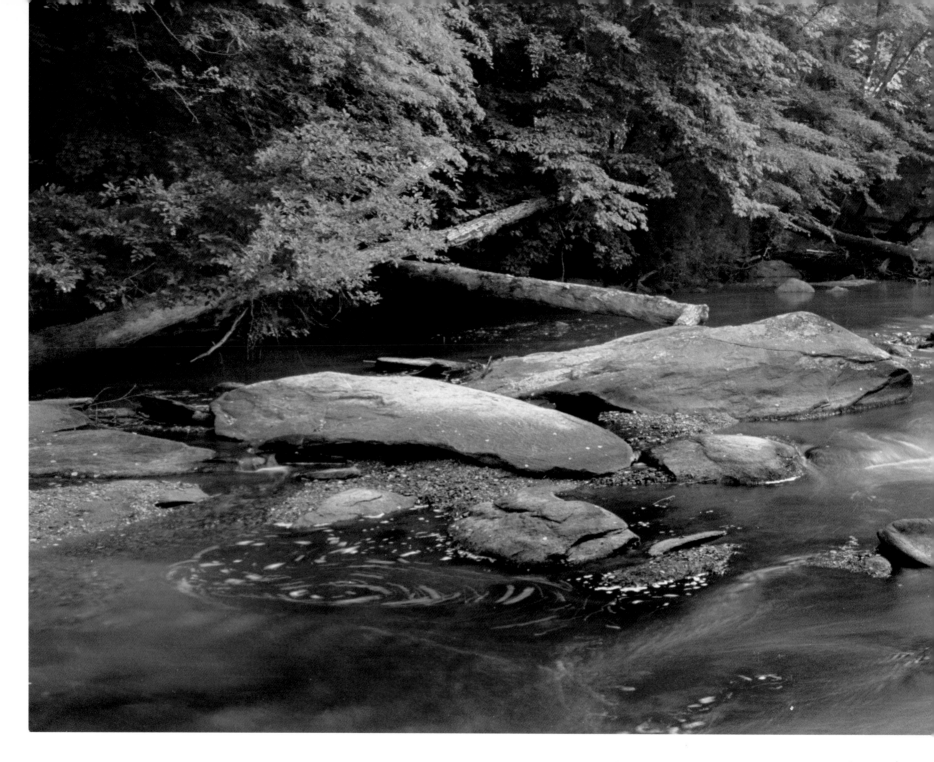

THE LICHEN-CAPPED ROCK

Tallapoosa River, Haralson County, Georgia

Sediment particles carried by turbulent water literally sandblast the surface of rocks and trees. Projecting rocks bear caps of moss and lichen, while below, the normal high water scours them clean. High-water marks are a common feature of rivers and can sometimes attain an awesome status when you discover them several feet above your head!

It turns out that the abrasion of particles against the bottom of the channel is an important agent of wear and downcutting. Large streams carry every sediment size from

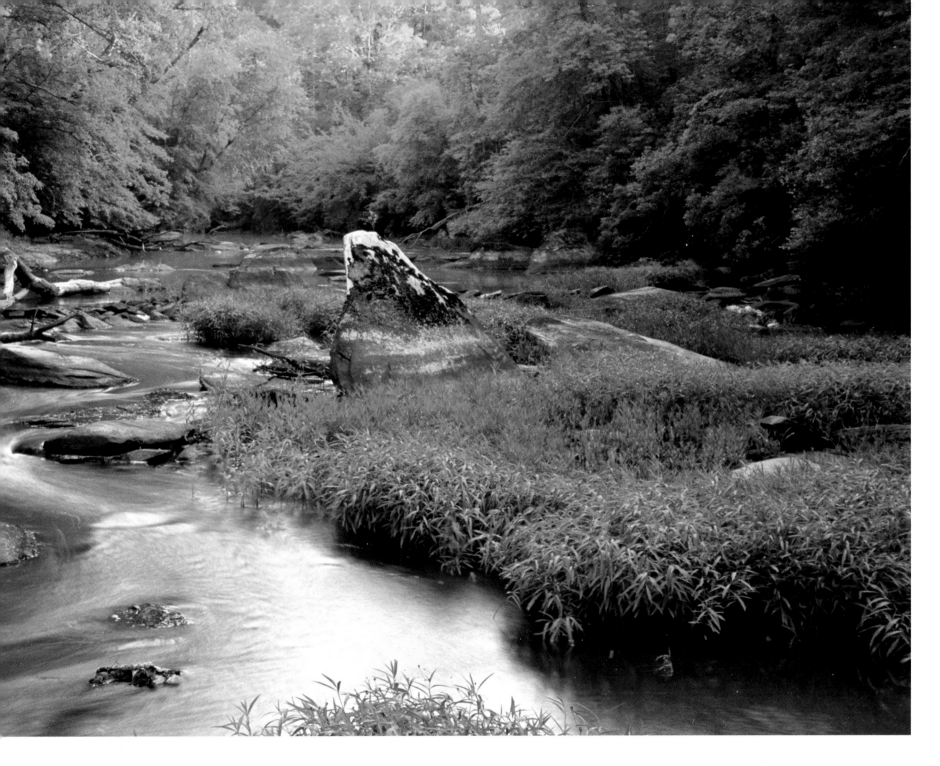

microscopic clay to sand, pebbles, cobbles, and boulders. The energy required to move the large chunks requires a large, swift stream, so big rocks tend to remain close to the headwaters of the river until they are sufficiently worn to be moved downstream. Farther downstream the streambed may consist of coarse sand and pebbles, becoming sandier then muddier as the stream slows in its lower reaches. In general, the finer the particles, the slower the current and the farther you are from the source of the sediments.

One of the sad points of the recent and unresolved water war with Georgia over the use of the water of the Tallapoosa River is that a beautiful stream is likely to be dam-aged. The water needs of a growing Atlanta are acute. One of the alternatives involves having this beautiful stretch impounded, though one doubts that its beauty as an underwater landscape would be as appreciated as leaving it in its natural splendor.

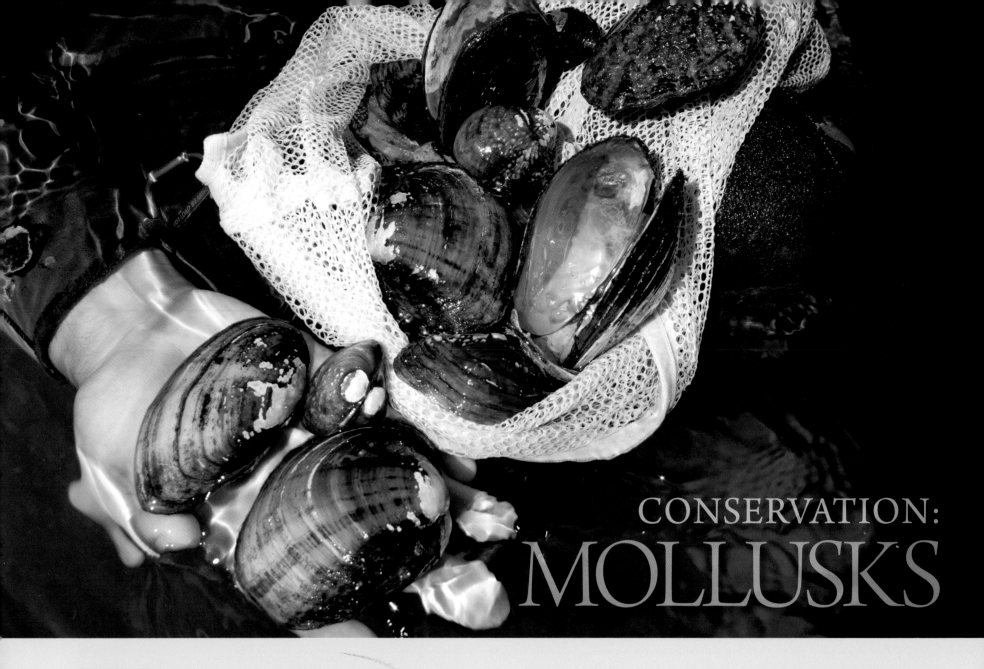

CONSERVATION:
MOLLUSKS

THERE MAY BE A CERTAIN PHYLOGENETIC PREJUDICE by us vertebrates against mollusks—an *ick* factor against the lower orders that have no bones. We shake our heads. For crying out loud, if Alabama has to be known for some wonderful diversity, why does it have to be snails and clams? But the closer you look at them, the more wonderful they become.

If for no other reason, we can enthuse because there are just so many of them—a variety comparable to birds or fishes. Mussel expert Jim Williams notes that Alabama has 178 species of mussels, fully 60 percent of all the varieties of mussels that exist in the United States. Dozens of species with fanciful names—heel splitters, and sandshells, spectacle cases, washboards, elk toes, bank climbers, pocketbooks, orbs, pigtoes, bleufers, and fatmuckets—covered the bottoms of some streams so thickly in historic times that it was reportedly hard to walk without stepping on them. Huge thick-walled mussels the

Above: **A cornucopia of Cahaba mussels showing thin- and thick-shelled varieties from different stream bottoms. Some varieties of mussels have bizarre reproductive habits. Most are vulnerable to water quality changes and streambed instability.**

size of salad plates gleamed inside with pink-and-white mother-of-pearl and provided for a rich pearl button industry in the Tennessee River. For thousands of years the Indians ate so many of them that they left huge moundlike middens of shell garbage.

Alabama's rocks and gravel bottoms were covered with snails, ranging from big knobby *Tulatomas* the size of golf balls to the tiny yellow, and recently rediscovered, Cahaba pebble snail, less than a quarter of an inch long. Paul Johnson of the Alabama Aquatic Biodiversity Center in Marion, Alabama, says that historically there were 181 varieties in the state. He believes that despite its twentieth-century loss of species, the

Mobile Basin may still have the greatest aquatic snail diversity on the planet. Why not? Its tributaries flow hundreds of miles above the fall line and through four giant physiographic provinces.

Below: **Paul Freeman of the Nature Conservancy and Randy Haddock of the Cahaba River Society turn over a rock in search of the Cahaba pebble snail. Even if in the future other vanished species are rediscovered, their ranges are likely to be tiny and vulnerable.** *Right:* **Tiny but full-grown Cahaba pebble snails,** *Clappia cahabensis.* **What is the purpose of such a rare and insignificant creature? No one knows. But its continued presence is an indicator that we are successfully taking care of the diverse stream environment that we have inherited. Would you want it to become extinct on your watch? It would be interesting to hear** *that* **excuse argued before His Honor in his heavenly courtroom.**

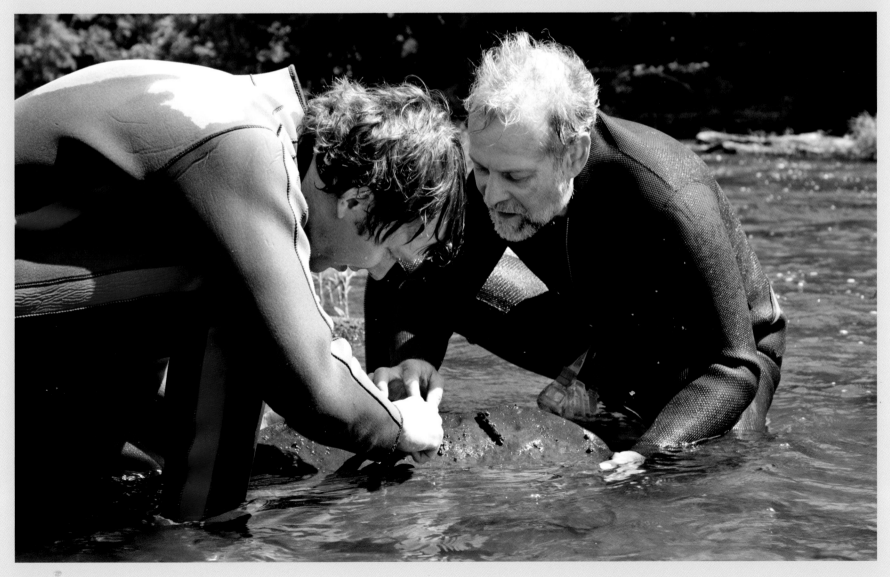

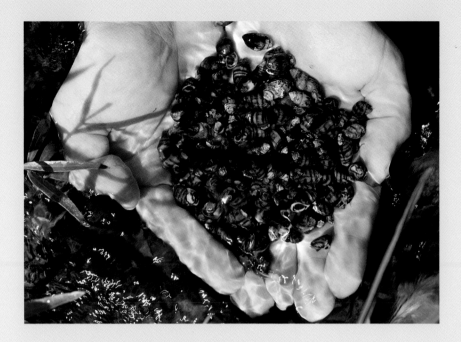

A good example is the plicate rock snail, *Leptoxis plicata.* Formerly common in the main channel of the Black Warrior River all the way to Demopolis, and in its major tributaries, the Mulberry and Locust Forks, the plicate rock snail was nearly destroyed by impoundment of the main channel and by water quality issues in the forks. A tiny surviving population in Locust Fork has been reduced by half in the last ten years. After a three-year effort sponsored by the U.S. Fish and Wildlife Service, Paul Johnson and his crew discovered how to breed a handful of wild-captured adults into tens of thousands of offspring. These have been reintroduced with good success along the Locust Fork, but the Mulberry Fork's water quality is still inadequate for the snails' survival. This all-your-eggs-in-one-basket feature of endangered species preservation should keep us all awake at night.

Why has the mollusk diversity taken it on the chin so? For one thing, mollusks are not very mobile. Unlike fishes, mollusks cannot move great distances during temporary

Above: **A handful of Cahaba snails of several different varieties, some restricted to just that river. The same preservation requirements for mollusks would be good for fish and Cahaba lilies—stable bottoms; low siltation; clean water; and a strong, seasonal current—the very characteristics of clean, free-flowing rivers.** *Right:* **A Cahaba mussel embedded in a gravel bar bares its camouflaged aperture. Mussels are filter feeders, living off detritus and microscopic plants and animals they strain out of the water. This leaves them particularly vulnerable to water quality and siltation problems. Some mussel species live near the surface; others spend long periods of time buried beneath the bottom. Sometimes they are very active and crawl through the bottom, leaving sinuous trails across the bars.**

Snails and mussels are greatly reduced now. Some are gone forever. The damming of the upland streams—Tennessee, Warrior, Coosa, Tallapoosa, Chattahoochee—dramatically changed clear, free-flowing rivers with exposed rock, sand, and gravel bottoms into green lakes with mud bottoms. Nearly forty species of snails perished with the impoundment of the Coosa and the Tennessee; among them was the smallest of our snails, the Coosa's tiny shoals sprite, *Amphigyra alabamensis,* less than a millimeter long full grown. Before its impoundment the Coosa River upstream from Wetumpka just may have been the richest mollusk habitat in the world.

Happily, in recent years eight of the long-lost Alabama species have been rediscovered in tiny populations clinging to small segments of tributary streams, some as short as a few hundred meters. It's nice to know that we still have the snails, but they are terrifyingly vulnerable.

disturbances. The sensitive ones simply die, and numbers of the others decline. Most of the snails are grazers, eating small animals, algae and detritus off rocks, and the mussels are filter feeders, both of these lifestyles being particularly sensitive to water quality. For example, the Coosa River, which has headwaters in the Valley and Ridge Province, flows through limestone, and its water contains a great deal of calcium. The Coosa's sister stream, the Tallapoosa, drains the piedmont, which has less limestone. It is weak in calcium and has nowhere near the mollusk diversity of the Coosa.

Mussels offer a good case for having the weirdest reproductive scheme in nature. The large majority of juvenile mussels are fish parasites. (What?) Typically, reproducing mussels create eggs that pass into their gill chambers. There they are fertilized by mussel sperm floating free in the water column. The fertilized eggs become larval mussels, or *glochidia*. When the mussel senses the presence of a nearby fish, it discharges the larvae in a gush of water into the gills or skin of the fish, where the glochidia latch on. Clinging

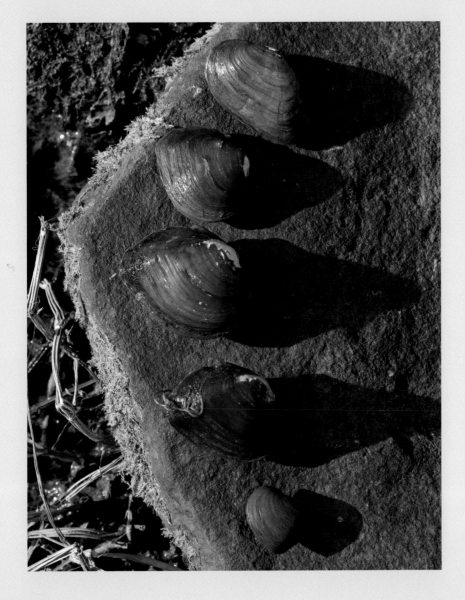

there for several weeks, the glochidia transform into baby mussels that eventually fall off into fresh habitat and grow into adults. Some of the mussel species are not choosy about which fish species is their host, but a surprising number of mussels are very specific and may select only one species or genus of fishes. Many species evert their mantles to simulate a variety of wiggling worms, minnows, or other food items. This naturally catches a fish's eye, and when it swims up to eat the worm, it gets a dose of parasitic glochidia for its trouble.

Some of these attraction strategies are very specific, which brings up the sad point that in some cases, if a particular fish is no longer present in a stream, certain mussels cannot breed, even if conditions otherwise exist for its survival. There is *a lot* more to discover about mussel life cycles, and it is likely to turn out to be more complicated, not less.

But Jim Williams and Paul Johnson stress that the primary problem with both mollusk and fish conservation is the instability of stream channels in modern times. Traditionally, stream channels are relatively stable, with firm bottoms and established banks and floodplains. The plants and animals have evolved to meet these challenges. In the space of just a few hundred years, and increasingly in these more urban times, the situation has changed. One of the major factors is the flash-floodlike stream conditions caused by storm runoff from cleared, ditched, and paved landscapes. Without vegetated valleys and floodplains, the landscape is simply too slick to absorb these sudden pulses of rain. Streams quickly rise to erosive levels. The bottoms are scoured, the banks collapse, and sediments are deposited and rearranged. Trees, which normally stabilize the banks, are toppled and clog the stream.

Williams and Johnson also stress that floodplain development is causing major damage. Thankfully, the days of large industrial pipes pouring pollution into the streams at a single point are mostly over. Now a more insidious danger is the propensity of people to build in the areas adjacent to streams. In addition to siltation and rapid runoff, the practice is responsible for non-point-source pollution. The cumulative release of oil, garden poisons, lawn fertilizer, malfunctioning septic tanks, and the careless daily effluent of modern living is an equally bad enemy of streams.

Stable banks and channels, fish and mollusk reproduction partners, unsilted substrates and free-flowing current, clean water and undeveloped floodplains—these are only a few of the complex conditions that suggest we should concentrate less on managing streams as if they were aquariums and more on simply preserving them intact, with their built-in complexity and diversity.

Left: **Alabama mussels, a mark of a healthy stream. Top, Triangular kidneyshell,** *Ptychobranchus greeni***; bottom four, Gulf pigtoe,** *Fusconaia cerina***.**

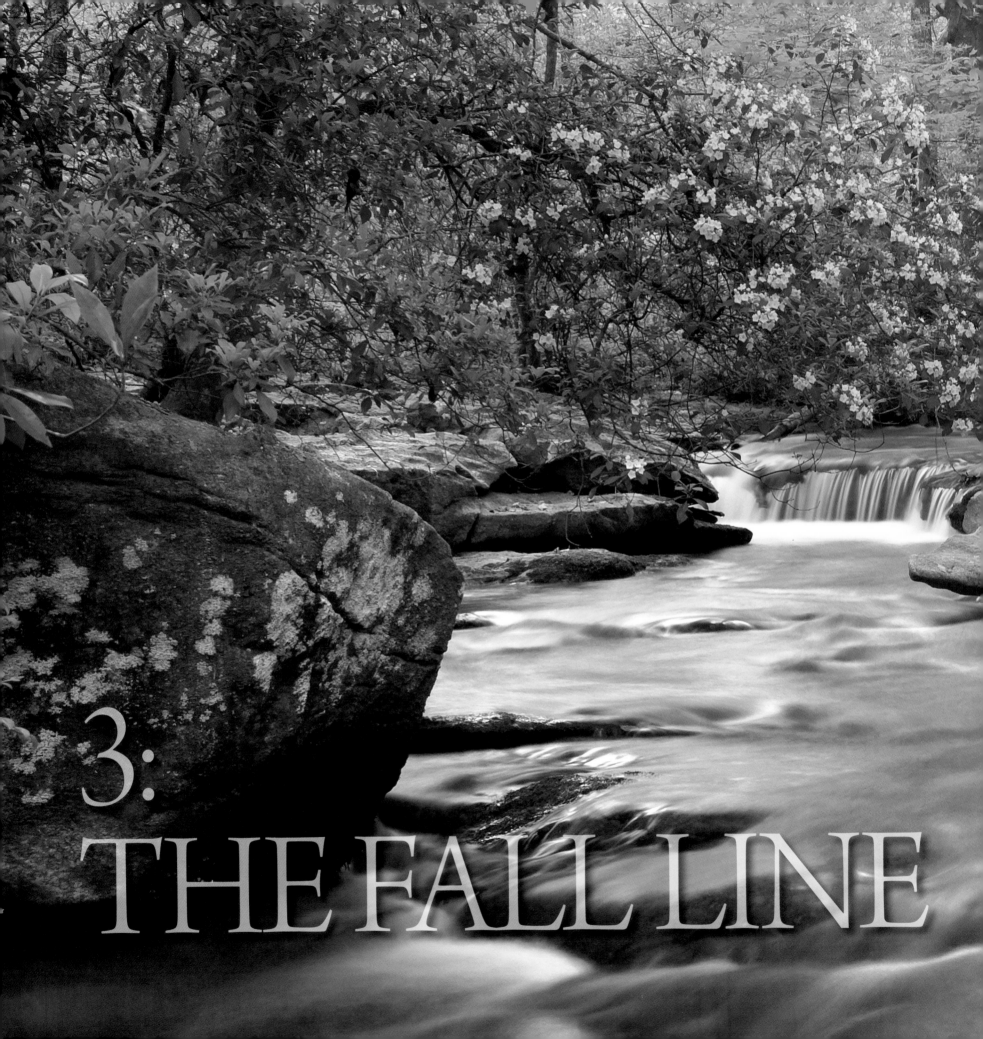

3:
THE FALL LINE

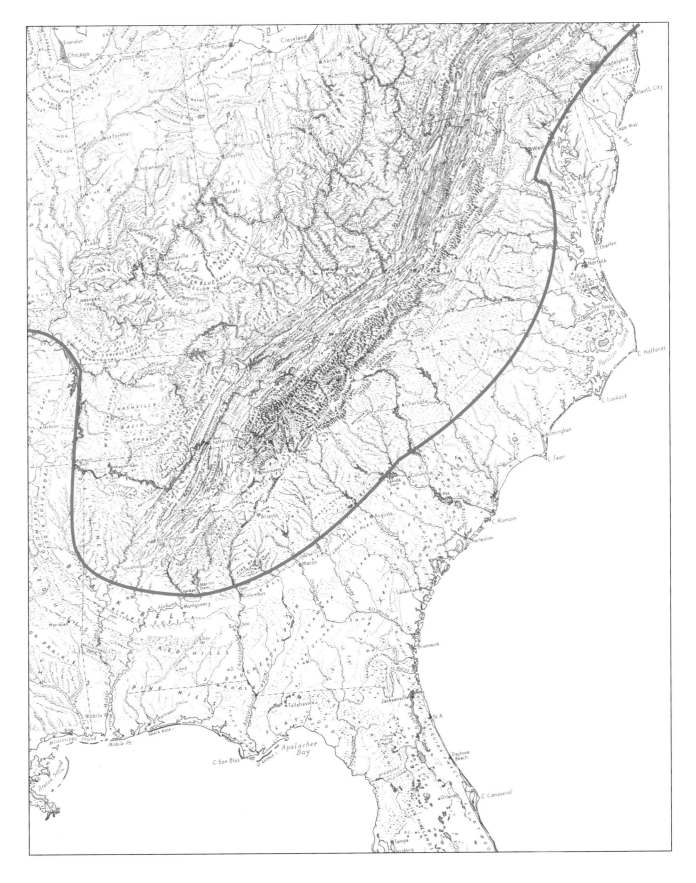

THE FALL LINE CHARTED ON ERWIN RAISZ'S INCREDIBLE MAP

Raisz's hand-drawn maps were anomalous even in the mid-twentieth century when they were drawn, but they are still unmatched for giving us the feel of the landscape. Here you can see the fall line from Tennessee to New Jersey and details of the Appalachians, including the Smokies with the Valley and Ridge Province behind them and the Piedmont Upland Province in front, with the coastal plain lapping up on it. In Alabama you can see the major river valleys—Chattahoochee, Tallapoosa, Coosa, Black Warrior, and the Tennessee. You can glimpse the Fall Line Hills and even the Escambia and Choctawhatchee Rivers rising on the Chunnenuggee Hills. Copyright Erwin Raisz. Permission granted by Raisz Landform Maps.

RIVER OF LILIES

Halfmile Shoals, downstream from Marvel, Cahaba River, Bibb County, Alabama

The Cahaba River drains the south side of the Birmingham geology. Its southward course crosses much of the rock structure at right angles and makes for a variable scene with rocky shoals, rapids, and cliffs. It is the longest of the remaining free-flowing rivers in the state and gives us an idea of what the now-impounded large rivers must have looked like above the fall line. The excitement and interest in preserving the river is driven by the nearly unbearable realization that this beautiful and important stream flows directly through the largest urban area in the state. It won't die by dam—by now the public probably wouldn't allow that. No, the danger now is that it will be nibbled to death by the little things—riverside development, drainage from parking lots, construction siltation, and inadequate sewer capacity—the death of a thousand careless insults.

To a person uninstructed in natural history, his country or seaside stroll is a walk through a gallery filled with wonderful works of art, nine-tenths of which have their faces turned to the wall.

—T. H. Huxley

SHOALS LILY

Hymenocallis coronaria **gets ready for the day at Hargrove Shoals, Cahaba River, Bibb County, Alabama**

The "crowned beautiful membrane," *Hymenocallis coronaria*, is plain to see in the shoals lily. There are several similar but terrestrial species of *Hymenocallis* in the south. The shoals, or Cahaba, lily is the only one that grows in big rocky streams, an extremely hostile environment for any flowering plant. But that's what makes it so special. If it were easy, any plant could do it.

There is still much to learn about the Cahaba lily. For example, it has a large blossom with nectar deep in its flower. What pollinates it? In an attempt to discover the unknown insect pollinator, Larry Davenport and Randy Haddock, leading researchers of the lilies, dragged aluminum lawn chairs out to the middle of the lily patch and, armed with nets, watched for visitors to the blossoms. No luck. Larry went home for the evening, but Randy stayed late and got stuck on the sandbar after dark. Vainly, he tried to dig out the truck's wheels. And there, in the light of the headlights, something large was visiting the flowers. Randy gave up on the truck, grabbed the net, and discovered that a strong-flying moth, the plebian sphinx moth, *Paratraea plebeja*, was a regular visitor to the flowers and was probably the primary pollinator. Elegant science.

So not only do you have to worry about the river and the flower, but you also have to be concerned about the pollinator's survival—what else it eats, where it breeds, what its caterpillar eats, where it spends the winter. It's the whole ecosystem that has to be preserved, not just the flower.

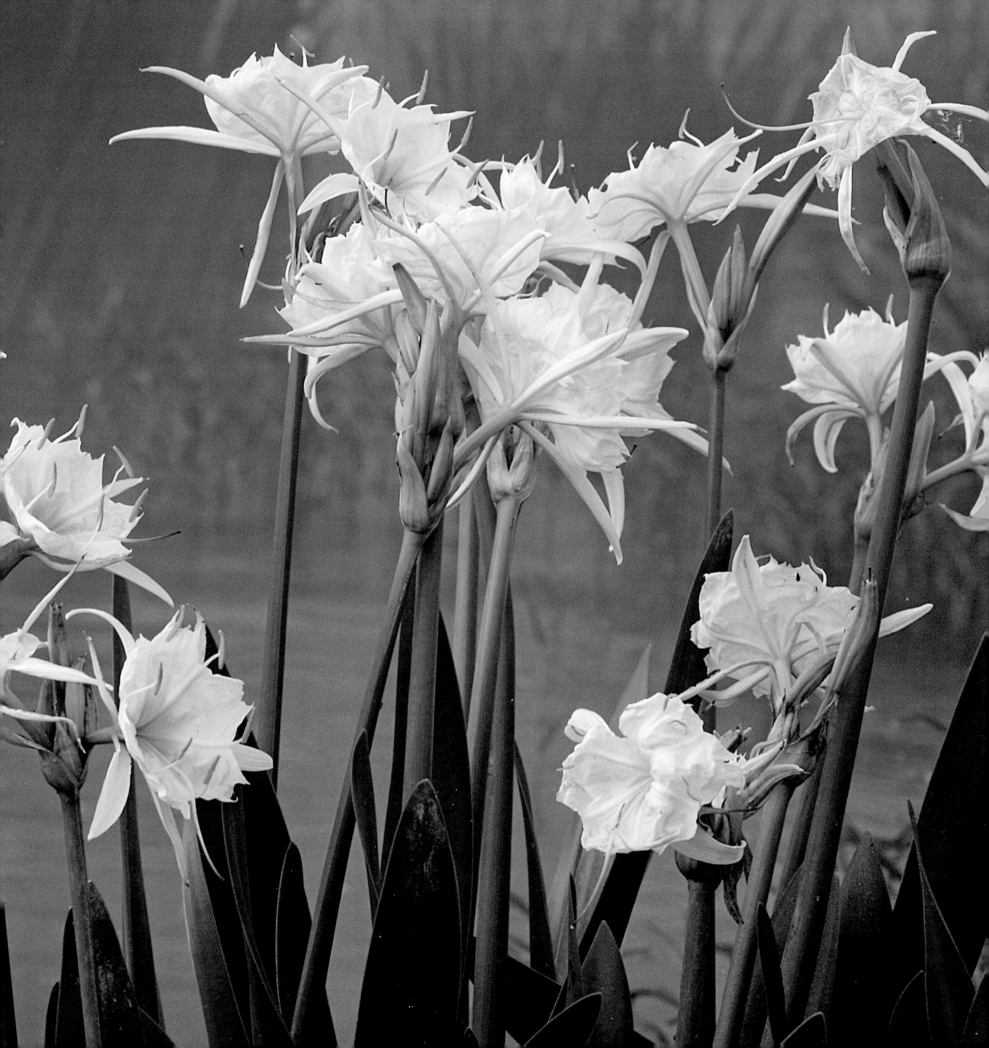

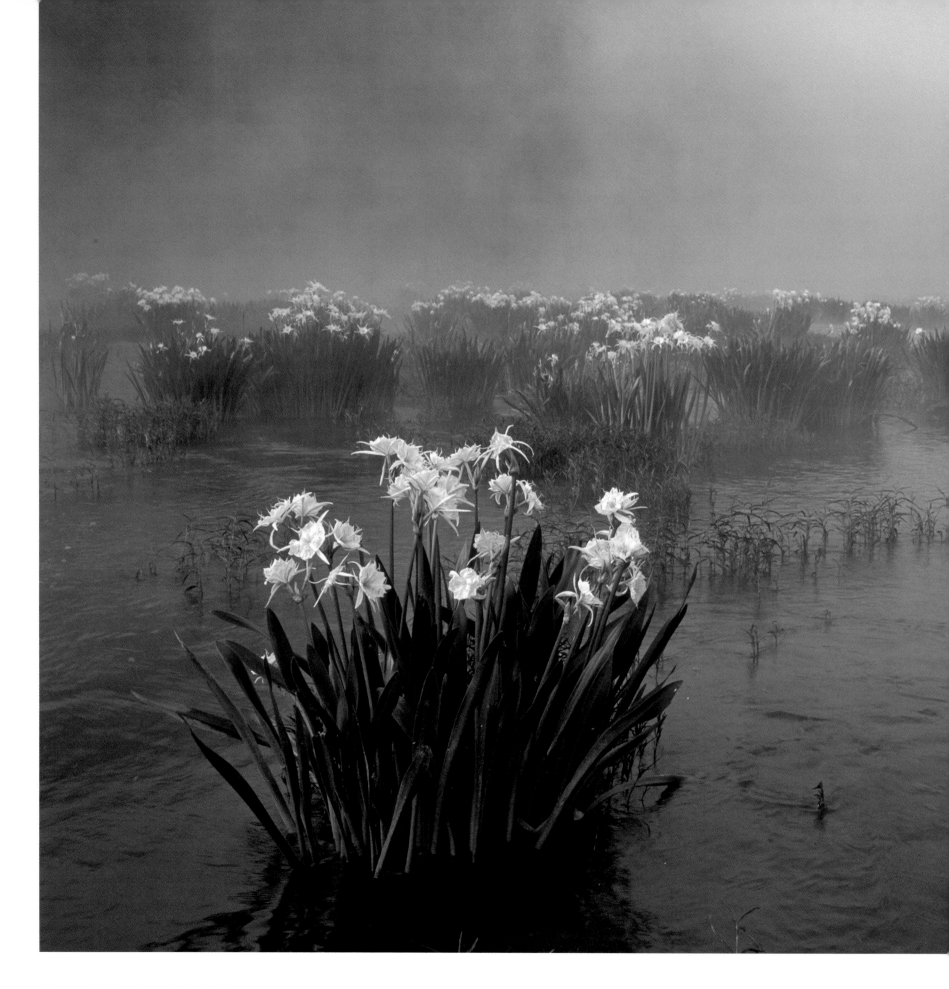

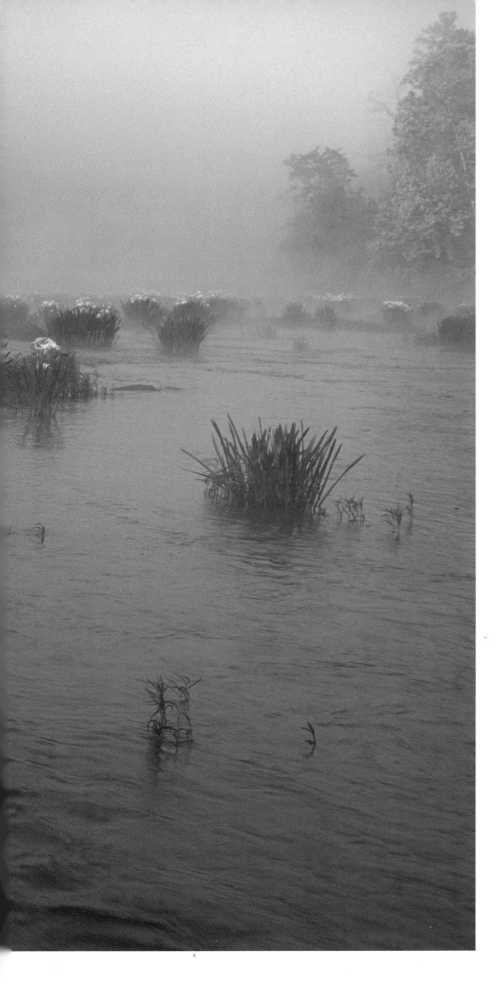

CAHABA LILY

One of the largest surviving stands of shoals lilies in the world at Cahaba River National Wildlife Refuge, Bibb County, Alabama

As a result of human activities during the past two hundred years, the total area available to the shoals lily has been greatly reduced, while the remaining habitat is being rapidly degraded—a classic case of endangerment due to habitat loss. The shoals lily grows only in sunlit rocky streams with significant current. Dams have flooded much of the critical big-river shoals habitat in the South. Sedimentation has filled some areas, allowing competition from less-specialized species. The Cahaba lily has also been threatened by water-release levels from hydroelectric plants and the poaching of lily bulbs from wild populations for resale.

Because of its obvious beauty and dwindling habitat, the Cahaba lily has become a symbol for the clean, unimpounded streams of central Alabama. The Cahaba River Society uses the lily extensively in its promotional materials, and it even appears on some Alabama car tags. Each May the city of West Blocton holds a Cahaba Lily Festival and names a Lily Queen. Few endangered wildflowers are as recognized and appreciated by the general public!

The U.S. Fish and Wildlife Service's recent acquisition of a large portion of the river downstream from Piper (including Hargrove Shoals) is the best thing that has happened to the Cahaba lily in a long time. There even seems to be talk of a sizable expansion of the refuge (but it might be bad luck to speak of it).

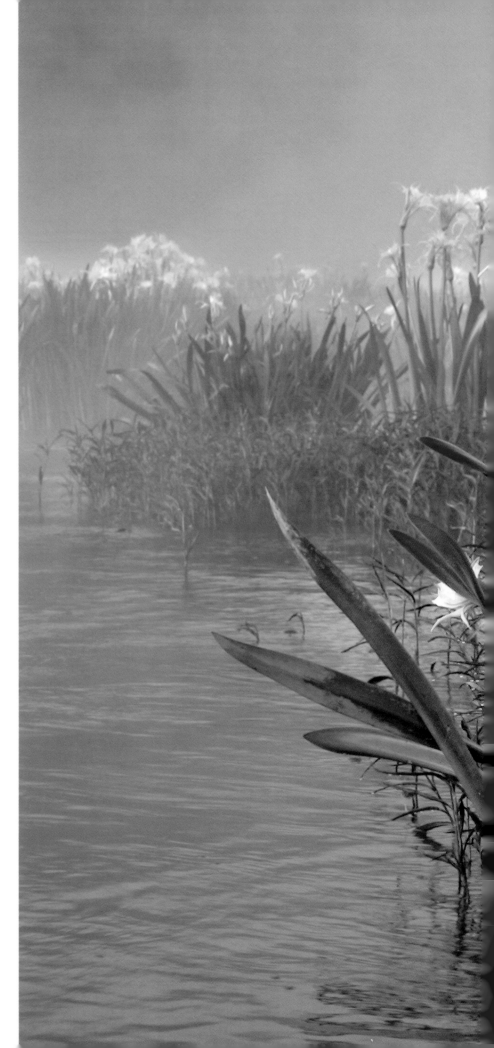

Mention the Cahaba lily and people grow silent and drift into space. People love this plant.

—Larry Davenport

LILY CLUMP

Hargrove Shoals, south of Piper, Cahaba River, Bibb County, Alabama

Since it is so beautiful and we are so proud of it, it is a bit of a disappointment to discover that the Cahaba lily isn't unique to Alabama (although most of the places where it still survives *are*). William Bartram discovered the shoals lily on the Savannah River above Augusta, Georgia, in 1773, though he failed to describe it properly and someone else got to name it. Historically the lily has been known to grow in most of the major river systems of the Southeast, but only at or above the fall line. No thanks to dams, it has now vanished from the main channels of the Warrior, Coosa, and Chattahoochee Rivers, and from much of the Tallapoosa as well. Alabama populations of the lily still occur in the Cahaba River, in several of the Upper Coosa and Upper Tallapoosa tributaries, and on Mulberry and Locust Forks.

While appearing quite delicate, the shoals lily is well adapted to survive in its difficult rocky habitat. It should not be confused with several woodland relatives, particularly its late-summer-blooming sister species, *Hymenocallis occidentalis*, the swamp spider lily. The shoals lily lives only in rocky rapids in full sun, which limits it to big rivers. The heavy seeds of the shoals lily sink into the spaces between the rocks, and its tuberlike roots lock it in place. So crucial is the lily's flood-swept rocky habitat that even moderate siltation is a deadly enemy. By late May it's usually ready to meet its public.

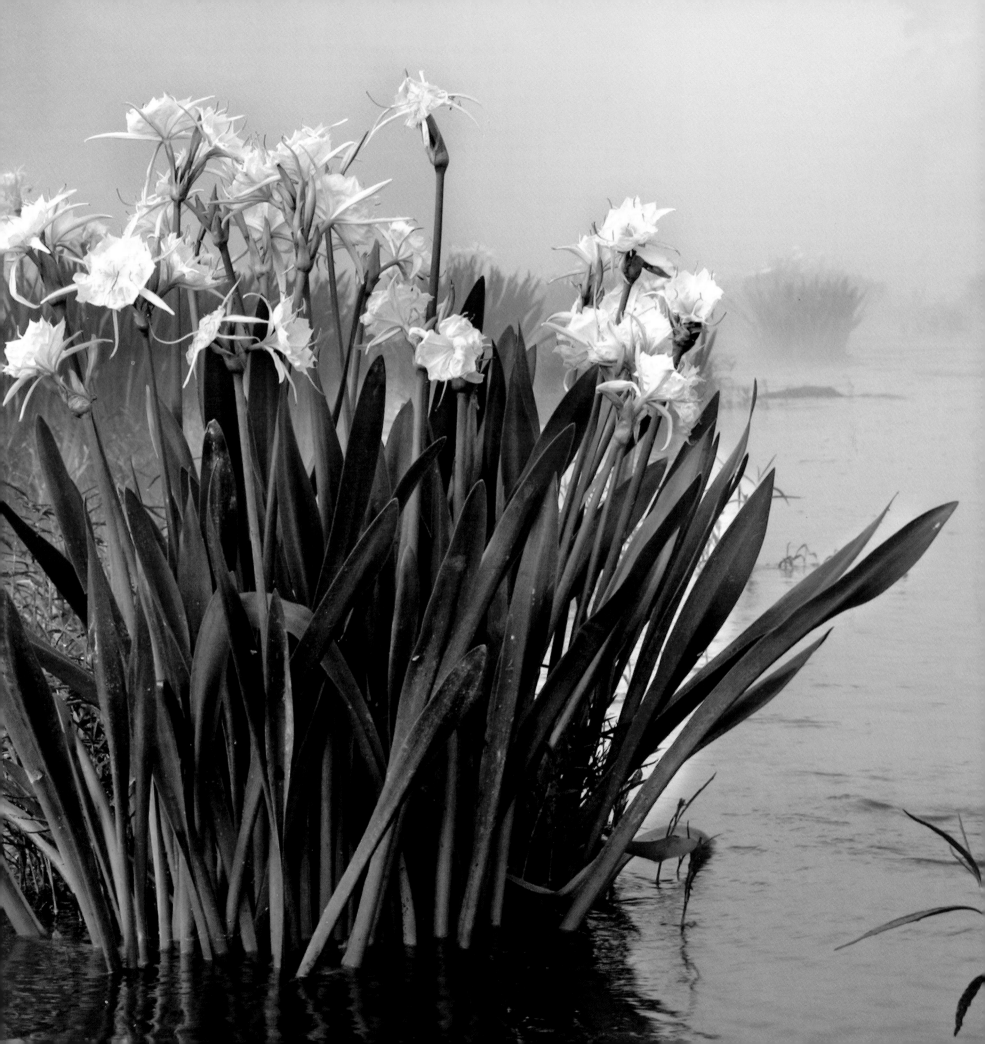

HIGH WATER AT THE LILY SHOALS

Halfmile Shoals, downstream from Marvel, Cahaba River, Bibb County, Alabama

Daily stream flow is determined by the gradual release of ground water, but high water comes from heavy rain. A given episode of high water may occur because of a particular storm upstream, but floods occur after several storms in a row, when the ground is soaked and all the swamps and beaver ponds are full. High water is notoriously hard to predict—too many variables. So after a protracted rain, everyone begins to watch his or her special talisman—the top of the opposite bank, the lowest limb on the snag, a spray-painted slash on a bridge abutment—or we summon up the river forecast on the Internet—"Oh gracious, it's up to 127 feet at the dam and the water's still rising!" And off we go to try to get the cattle out of the lower pasture.

Rivers are different in high water. They look different, smell different, and sound different. The rocks and snags are gone, and the water spreads all the way to the trees. There is an eerie silence about high water. Have you ever awakened early in camp and were suddenly aware that something has *changed*? And you go to the riverbank and indeed things *are changed*, and you're glad you pulled the boat up.

There is nothing constant in the universe,
All ebb and flow, and every shape that's born,
Bears in its womb the seeds of change.

—Ovid, *Metamorphoses* XV

RIFFLE

Ketona Dolomite Glades, Little Cahaba River, Bibb County, Alabama

Here the relationship between rocky shoals and the bedrock is clear. The little depressions in the rocks hold a modicum of soil and gravel bound together with the roots of the emergent plants. A few determined shrubs cling tightly to the bank. In low water, soil and gravel are trapped here and the plants grow high. But in high water this shallow spot will be swift, and we'd better hope those roots are well embedded. Anything not held fast will be swept away and the ledges scoured another fraction deeper. It is this endless negotiation between the forces of gathering and the restless hand of destruction that keeps the river both different and the same.

Who else do you suppose has hunkered here, got a drink of water, waited for friends, wrung out their shirt, grubbed mussels in the gravel, scratched fleas, or grabbled crawdads in the weeds? Looks like another shallows up above that bend. Do you suppose the fishing's better up there?

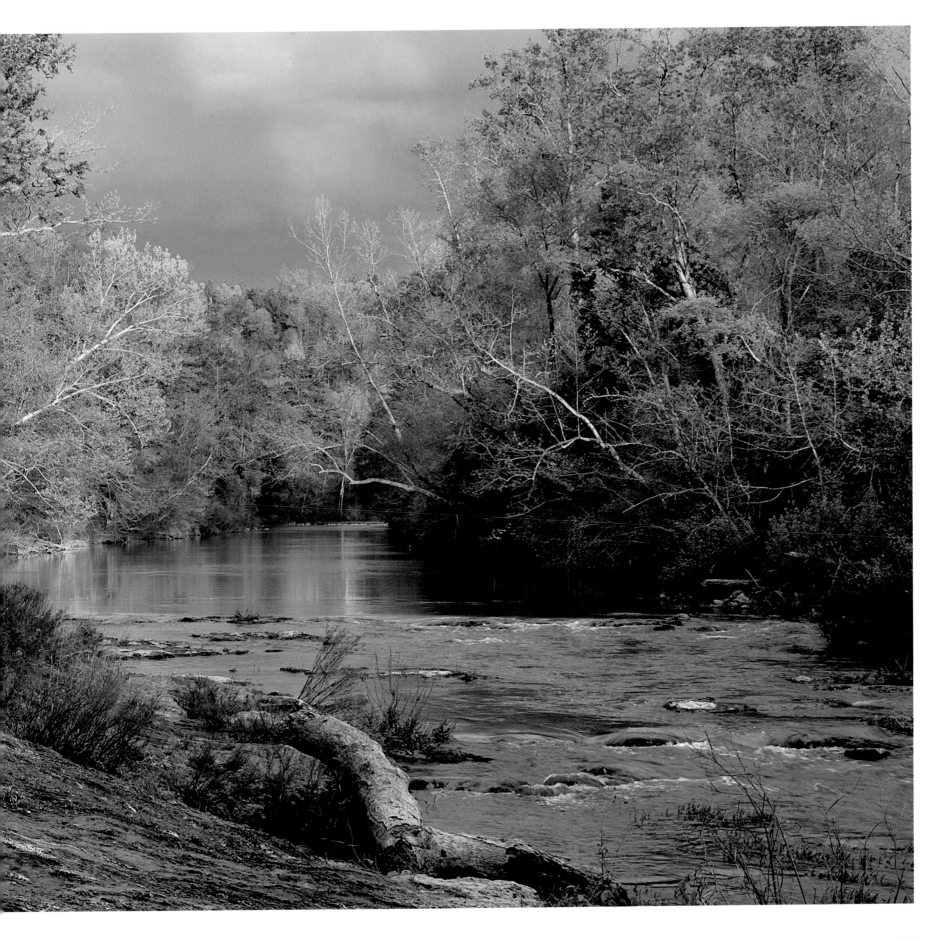

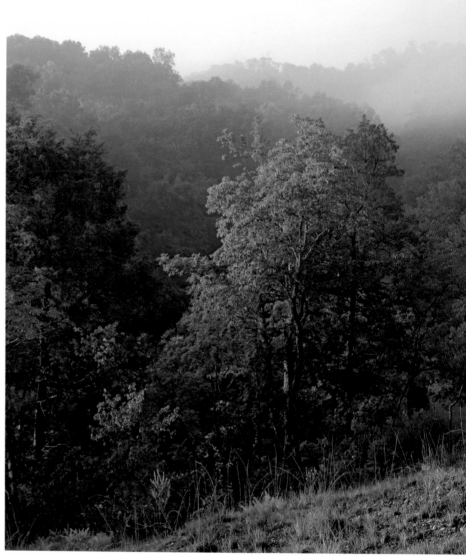

CAHABA INDIAN PAINTBRUSH

Castilleja kraliana, a unique Alabama glade plant, Ketona Glades, Bibb County, Alabama

The Bibb County glades are unique in that they are all outcrops of Ketona dolomite, a rock closely related to limestone. Dolomite is particularly rich in magnesium. When it weathers it forms an unusual magnesium-rich soil that is not tolerated by some common plants but is hospitable to magnesium-loving species. The Ketona Dolomite Glades are the only home in the known universe of the Cahaba paintbrush, a member of the foxglove family.

That unusual habitats are inhabited by unusual plants and animals is the key to understanding endangered species. It is not so much that some species are rare but that some habitats are rare. The organisms, carefully adapted to their niches by millions of years of trial and error, will do just fine, thank you, if their habitats are preserved.

The Ketona Glades are the focus of the new USFWS wildlife refuge in Bibb County. The glade is fragmented into about a dozen pieces, reflecting the tortured geology where the southernmost end of the Valley and Ridge Province dives beneath the Coastal Plain. Where dolomite layers outcrop, we get dolomite glades; where it is limestone, we get limestone plants; and where it is sandstone, we get more familiar species.

BIBB COUNTY GLADE

Early morning highlights the Ketona Dolomite Glades, Little Cahaba River, Bibb County, Alabama

Limestone areas are often honeycombed with caves and fissures. Such landscapes are often very dry and have few surface streams. Much of the drainage is down through the underground fractures, and the thin, limy soils hold little groundwater. These distinctive glade landscapes (actually of several subtle types) are scattered throughout the state and can often be distinguished by their predominance of red cedars. Historically, the state had much more open area than one would suppose. At the beginning of the nineteenth century, a third of the state was in longleaf pine, with its open, grassy undergrowth. Other considerable portions of the state, notably the Tennessee Valley and the Black Belt, had large tracts of glade and prairie. Several factors—frequent fires, dryness, and distinctive soil chemistry—combined to keep these landscapes open. Such areas attract specialized plants that are adapted to these conditions.

In 1819 a glade near Suggsville in Clarke County (along a limestone outcrop in the middle of the pine belt) contained some eight thousand acres of large cedar forest. Glades clearly have been around for a long time, because they have evolved unusual plants and animals that live nowhere else. The newly discovered Ketona Glades in Bibb County, here fascinating Chris Oberholster at the Alabama Conservancy, are home to at least eight never-before-described species. Other glade areas in south Alabama, the Black Belt, the Tennessee Valley, and adjacent Mississippi also include specialized endemic plants.

I always keep a supply of stimulant handy in case I see a snake—which I also keep handy.

—W. C. Fields

CANEBRAKE RATTLESNAKE

Crotalus horridus atricaudatus, having freshly swum the river near Hargrove Shoals, Cahaba River, Bibb County, Alabama

It's mostly the newcomers who worry about snakes. The old-timers generally dismiss them as inconsequential or come to some kind of an edgy compromise between grudging toleration and shrieking flight. If you can just get your heart rate down below "panic-stricken," snakes are fascinating. Grimmest and most dramatic of the lot are the rattlesnakes. Canebrake rattlers are the southern subspecies of the timber rattlesnake and by far the most common rattler in the state. They are beautiful creatures with chevron bars and a russet stripe down their back. They usually sport several inches of black satiny tail, which earns them the apt name "velvet-tail." All in all, they're a calm snake and don't seem to be very excitable.

Still, practically no encounters between people and rattlesnakes end with a living snake. Folks who will listen happily to your argument for the preservation of darters, mussels, and red-cockaded woodpeckers one minute will later happily describe how they recently killed a "big ol' rattlesnake." (It is well known that there are no small or ordinary-size rattlesnakes— they are all "big ol'" snakes.) The notion that one should simply step aside and allow the snake its space seems to be missing from the playbook.

But here's the catch. Now that wild bears, buffalos, wolves, and panthers are gone, what is left that can be wilder than a real, live rattlesnake? When you're nose to nose with the rattlesnake, you can still glimpse the ancient wilderness, red in tooth and claw. It is comforting to know that there is still something out there that is at least arguably dangerous. A life without rattlesnakes, lived safely under the umbrella of the rescue squad, would seem a little diminished.

Let them pass. Snakes have seniority. Besides, it would be a lesser world without them.

(Dr. Haldane, what can we discover of the mind of the Lord by examining his works?) Why, he has an inordinate fondness for beetles!

—J. B. S. Haldane

BANNER CLUBTAIL

Female *Gomphus apomyius* on the Tallapoosa River, upstream from Horseshoe Bend, Tallapoosa County, Alabama

Professor Haldane's famous line reminds us that we ought to be called the "insect planet." There are so many insects, and it is estimated that only a fraction--especially the larger and gaudier species—have been described. The River of Alabama is just full of them, ranging from the most minute no-see-ums (they of the dreadful bite) to dreadful hellgramites, predatory beetles, and electric light bugs. There are sixteen genera of mayflies, stoneflies, and caddisflies in the Cahaba alone. (These groups are indicative of clean water, which is why river conservationists get so excited about them.)

Most aquatic insects spend most of their lives as larvae, the adults emerging just long enough to court, breed, and make us marvel. But the dragonflies have a little more of an emergent life—though one of death and violence. They are "dragon" flies for sure—the adults dreadful, death-dealing predators of the air, and their sharp-jawed larvae stalk the depths.

Man's interest in animals seems to be working its way down the tree of life to the lower orders. First we hunted the mammals, then the larger birds. Then for a long time if you met someone in the woods with binoculars, you could assume that person was a birder. And soon there were butterfly listers and then dragonfly watchers. Now, with the publication of detailed field guides, it has become possible to identify insects in the field without killing them. A trip with an enthusiast is infective. Once you could say with comfort, "There's a pretty green dragonfly!" Now we are filled with confusion and angst: "Oh goodness, is that the elusive *Gomphus septima*? Or is it just a Banner Clubtail?" ("Drat!")

COWCUMBER FALL

Cowcumber magnolia, *Magnolia grandifolia*, trees and a fallen leaf, Weogufka Creek, Coosa Wildlife Management Area, Coosa County, Alabama

Cowcumber trees, with their giant leaves, form a dense shade. The forest floor is bare beneath them. So enormous are their leaves that in the summer they seem like the foliage of rainforests. But in the winter, standing by the bare gray trunks is like being in a hole in the woods, a one-tree clearing. At dusk the huge dead leaves are eerie, like pale shriveled carcasses on the forest floor.

Stillness is another river virtue. Stillness is not the mere absence of noise, but a separate spirit whose insect noises, birdcalls, and distant sounds accentuate the mood. Somewhere down below the water may come alive again and entertain our ears as well as our eyes, but for now, still is good. The water seems unmoving until something drifts by—the leaf a wrinkled metaphor for the evening, the river, ourselves.

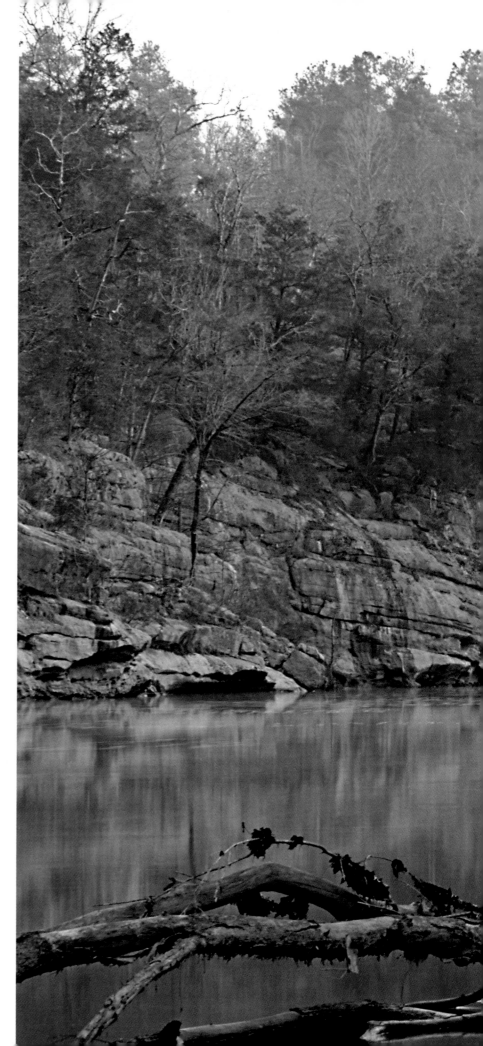

HISTORY OF THE EARTH

Below Pratt's Ferry, Cahaba River, Bibb County, Alabama

A little ways back, near the mouth of the Little Cahaba, we have come out of the Valley and Ridge Province, and the Cahaba River briefly transects the last corner of the piedmont. Suddenly there are high limestone bluffs that continue along its banks to below Pratt's Ferry. Here the relationship between the river and the geology is dramatically clear.

As the river twists back and forth across the landscape, it elicits new aspects from the rocks. Cliffs appear and disappear; long, deep pools alternate with hard ledges that suddenly shallow the river. Without warning, your paddle touches rock. "Where did that come from?" you wonder. Below Shultz Creek it's hard to say when you first become aware of the noise of the rapids. When you finally bring it to consciousness, you realize you have been hearing it for some time. From the seat of the canoe, you look down across a series of small drops that are difficult to see from upstream. The surface of the river that had seemed so level can actually be seen going downhill!

You start looking for channels to slip through the dozens of little rapids, and just above the bridge at Centreville your keel will graze one last ledge. And before the paddle strikes the water again, you will have leaped 100 million years into the future, across the fall line and onto the coastal plain.

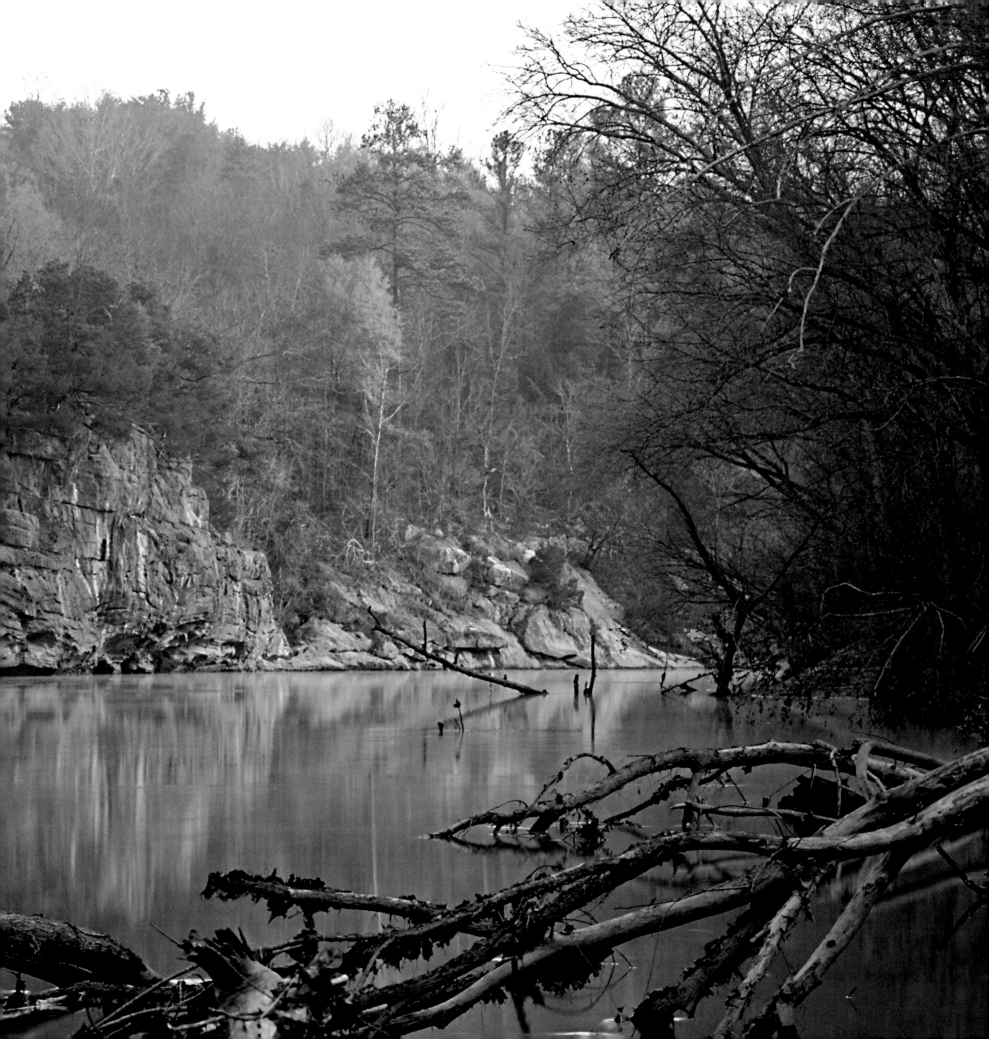

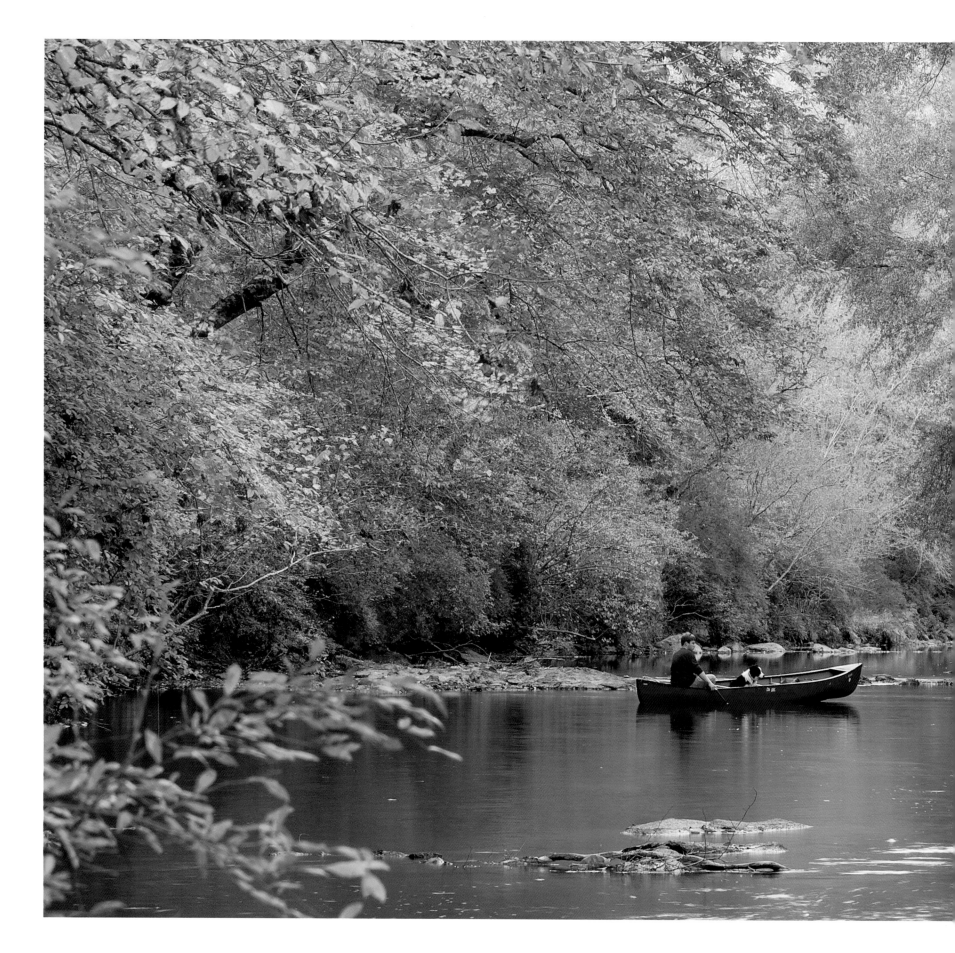

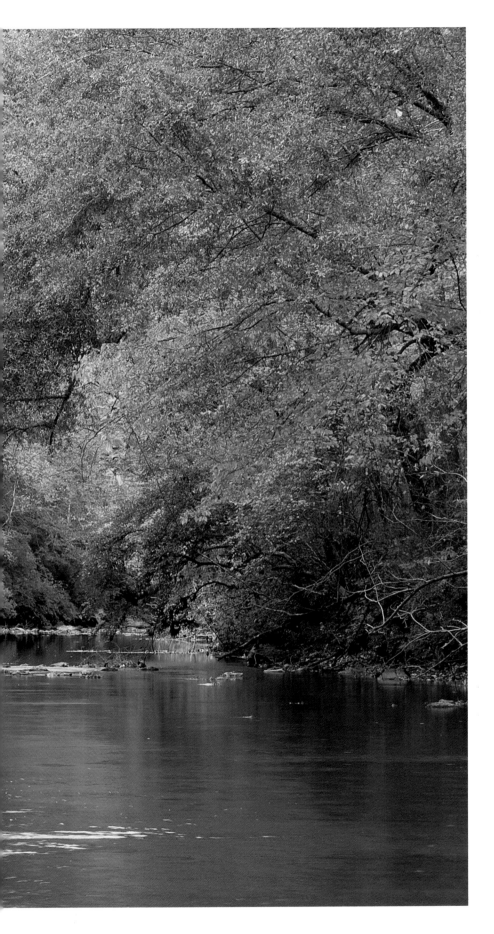

WEOGUFKA CREEK

Early fall on Weogufka Creek, Coosa County, Alabama

It has been proposed that there are actually two fall seasons in Alabama. It's not an exact science, but the first, the red fall, starts early, in September. This is when many of the red leaves (sumac, sourwood, sweetgum, and the reddest of them all—black gum) join the early yellow leaves (yellow poplar, maple, mulberries, and deciduous magnolias) to clash colors with the still-green laggard species. Later, depending on the weather, perhaps in late October, comes the second fall, the gold and yellow fall (oaks, hickories, beeches, and sycamores). The rich yellow fall contrasts nicely with the pines. This period often lasts until Thanksgiving, and some trees persist even later until the stubborn red oaks and beeches finally fade to brown, keeping their leaves until spring. It always comes as a surprise when it is all over.

A certain number of the leaves find their way onto the water and spin by to entertain the canoeists as they search for openings in the riffles deep enough to slip through. The water is down, and on a good day the boat coasts like magic and slithers over the gravel with barely a touch. Sometimes you have to get out and wade—though, other than prune-shaped feet at the end of the day, that won't be an unpleasant chore until November.

AT THE FOOT OF THE DEVIL'S STAIRCASE

Morning, upstream from Wetumpka, Coosa River, Elmore County, Alabama

At first glance this appears to be a pristine river scene, but this is below Jordan Dam, where flow from the generators has so altered the ecology and flow patterns that the river is greatly injured. Particularly damaged are the river mollusks. Before impoundment the Coosa River's miles of big-water rapids may have had the world's finest diversity of snails and mussels. The construction of Jordan and Mitchell Dams wiped out many of these mollusks, including new species that were described from collections after they had become extinct in the wild. The construction of these dams in the twentieth century's hasty enthusiasm for hydroelectric power just may have been history's single most destructive blow to Alabama aquatic life.

And then there are those funny rocks. There in the foreground and across the river are those peculiarly slanting rocks. They point to the Wetumpka Astrobleme, the crater of a huge meteor that fell in dinosaur times, when the area was still a shallow ocean. The hills behind Wetumpka are the eroded rim and rebound ridges of the four-mile-wide crater. If the land of Alabama has a memory, then the fall of the Wetumpka meteorite must have been the most dreadful incident of its half-billion-year lifetime. The metamorphic bedrock, which should be deeply buried, was peeled back and upthrust by the explosion, and its tilted fragments still point to ground zero.

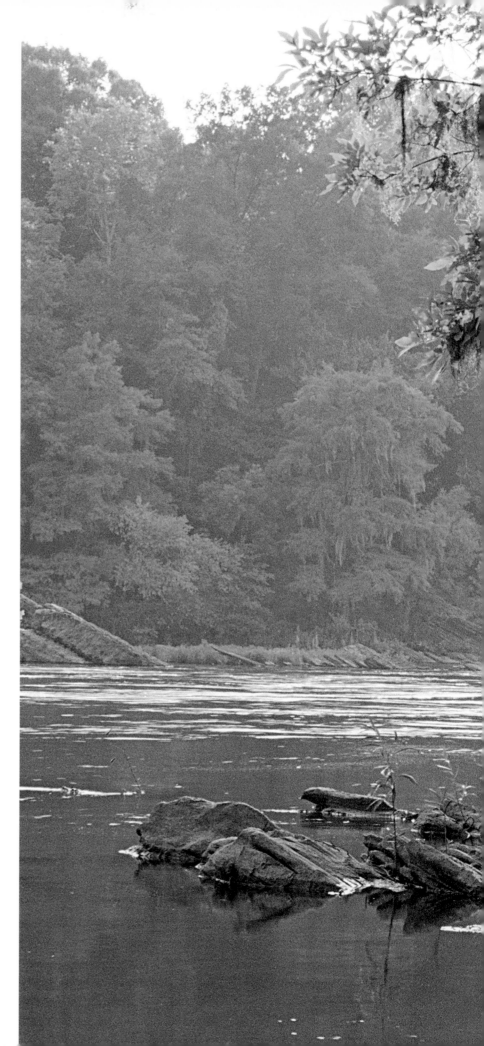

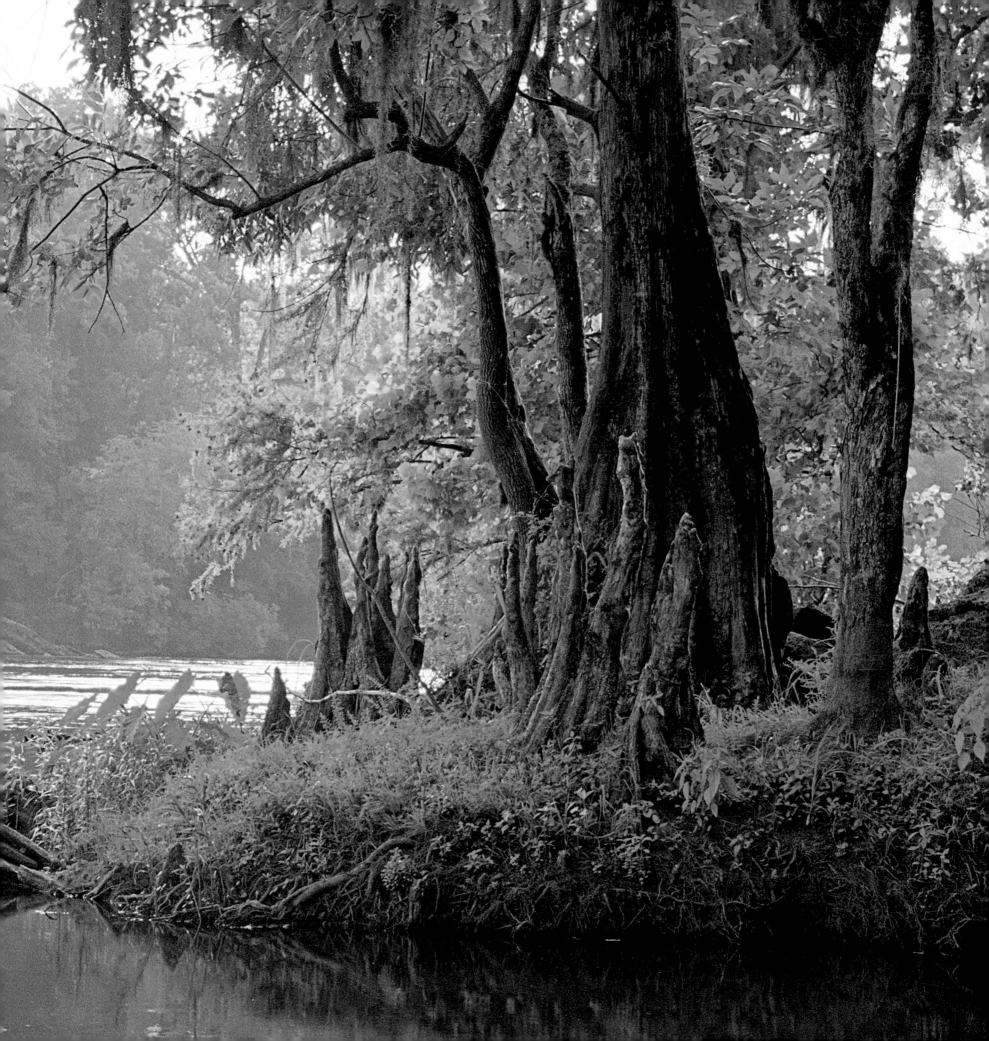

CONSERVATION:
WATER QUALITY

IT IS NOT VERY CLEAR WHEN THE BIG SET OF CONCRETE CULVERTS was built across the Cahaba River at Marvel above West Blocton. The Marvel Slab was never a public road but was constructed by a mining company as a coal-hauling shortcut across the river. Nevertheless, long past its utility as a bridge, it has acted as a low dam and as a barrier for boats, fishes, and other species. For some years the Nature Conservancy, backed by citizens, boaters, and other conservation organizations, steadily campaigned to remove it. In 2005 they succeeded.

Within a year the improvement in the river was obvious. A free-flowing channel became established, sediments were reduced, and the diversity of species had dramati-

Above: **Green Heron,** *Butorides virescens,* **stalks lunch on American lotus,** *Nelumbo lutea.*

cally improved. By June 2006 the area was populated with rare mussels and snails, a sign of high water quality.

So what is the point of this little feel-good story? The point is not really that high-quality habitat and water quality can be repaired, though it can (and this was indeed a victory for the river). But a better point might be that if the river had been maintained in its natural state in the first place, we wouldn't have had to go through this struggle to repair it.

A healthy river attracts people for a number of reasons. We can make a list of the usual suspects: clean drinking water, great boating and fishing, biological diversity, recreation, beauty, nourishment of the soul, and so forth. Many of these are deep and satisfying personal motivations for our commitment to river conservation.

But it is also appropriate to strike an altruistic moral stance and summon forth the parable of the good steward who invested his money for the betterment of his master's business. We do indeed have the responsibility for taking care of His nice planet. The same book that says we are to have dominion over the earth says nothing about the right

Right: The unlamented death of the Marvel Slab in 2005. It is an unfamiliar feeling to welcome the arrival of a large yellow machine to a river. *Below:* The site of the departed and unlamented Marvel Slab; a natural environment reestablished.

Top: Sculpin heaven. A most excellently ugly sculpin (probably *Cottus carolinae*) guards his feeding station. He is surrounded by clean, oxygenated water; a gravel bottom; snails and mussels; and mossy rocks full of insects and microorganisms. Life is good! *Above:* **Appalachia jewelwing damselflies, *Calopteryx angustipennis*, in a mating wheel position. These beautiful metallic damselflies are familiar spirits on Alabama float trips.**

to spoil it. Nowhere in the Bible are we given free rein; in fact, most of it concerns our responsibilities.

These values, emphasizing planning, restraint, postponed gratification, and the appreciation of beauty and God's world, would seem to most rational people enough motivation to repair the past and plan for the future. But as Alabamians, we know that calm, considered planning will not always prevail. Because in the end, like many things, the choice has less to do with reason than with money.

The Marvel Slab was built to reduce the cost of hauling coal. Against clear, rational argument, money is what drives the urbanization of the floodplain. Plans to dam Locust Fork (for which there are alternatives) in exchange for a piddlingly cheaper water bill is a shameful choice. Short-term planning that builds inadequate storm drains and catchment basins because they are less expensive abuses water without concern for downstream consequences.

As the Nature Conservancy's Chris Oberholster points out about water quality issues, "You can pay now or pay later, but later is much more expensive." He notes that even if protecting watersheds by easement or purchase seems expensive at the present, that expense is nothing compared with having to build, staff, and operate elaborate water purification facilities or become involved in heroic measures to save an endangered species.

This is too important to stand by mutely. We have to become involved, both individually and as groups. We can have clean water at a moderate cost by being careful with what we have, repairing egregiously damaged systems where we must, providing realistic budgets for conservation agencies, and insisting on planning a rational development strategy for the future. Take this to the bank: development *is going to occur* as the landscape becomes increasingly populated and urbanized. Our job is to urge appropriate choices. To paraphrase a recent observation, "It's the planning, stupid!"

Paul Johnson of the Alabama Aquatic Biodiversity Center makes a solid argument for how severely undervalued river ecosystem services are. The argument goes something like this: Domestic tap water in most Western European countries is up to four times more expensive than it is in the United States—and you may hestitate to drink the water from the tap. The rivers in Europe have been so degraded that the water treatment process there is more involved, and it naturally costs considerably more to get that water to the customer. The average cost of water in the United States is $2.49 for about one thousand gallons of tap water. In Germany, France, and Denmark the costs now exceed $8.50 for the same amount. Figuring an average use of about sixty-five hundred gallons per household per month, U.S. customers save roughly $38 dollars a month, which, multiplied by 12 months, equals a savings of $456 per customer per year. Birmingham Water Works is the largest water system in the state of

Above: Locust Fork steams in the chill of morning, the very essence of wild river. If the Birmingham water works follows through on its plan to dam the river, this wild scene will vanish beneath forty feet of still water. *Far right:* Kids on a river beach, storing memories for a lifetime. There are few sandbars on an impounded river. For the most part, this scene is gone from the Alabama, Coosa, Tallapoosa or Tennessee.

Alabama and serves more than 750,000 customers in the surrounding five counties. This equals a yearly advantage of $342,000,000 for just the Birmingham area, and you can drink the water. So much for the notion that more comprehensive stream conservation programs wouldn't pay for themselves. Remember, only about 1 percent of the world's freshwater is available for use.

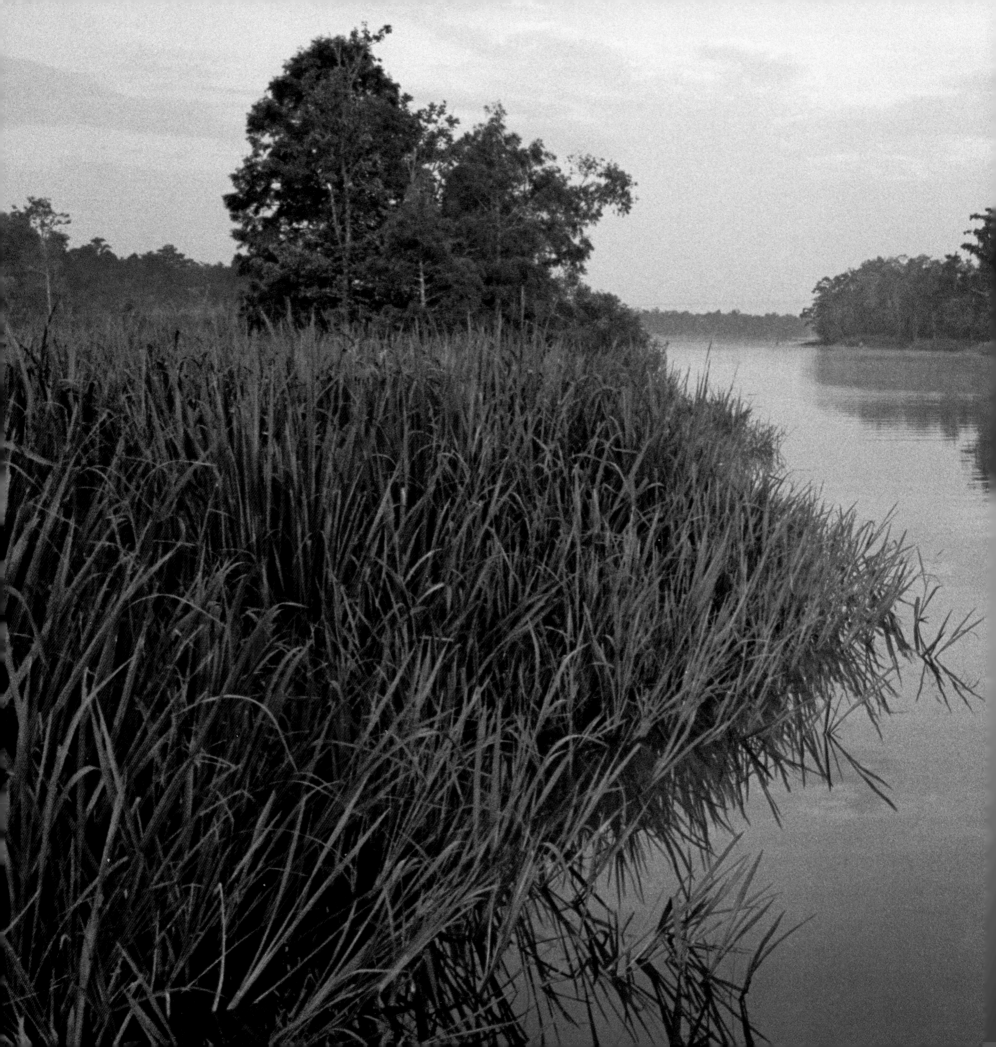

4:
THE COASTAL
PLAIN

LIBERATED FROM THE STRICTURES OF THE HARD ROCKS of old north Alabama, the River of Alabama now flows across the new part of Alabama—the great *Gulf Coastal Plain*. Beginning about 200 million years ago, the vast Pangean continent began to break up. A great crack formed along the middle of the Appalachians and then turned and cut across south Alabama, southeast to northwest, in the direction of Arkansas. The eastern part of the mountains went off as part of Africa. But portions of Africa remained behind. Fragments were ripped off the retreating continent and fell behind, scattered to the southeast, and formed the basement of south Alabama, Georgia, and Florida. These fragments were submerged by the opening gulf and the Atlantic Ocean.

Meanwhile, the remaining Appalachian Mountains deposited sediments into this deep and widening new ocean. Eventually a new south Alabama was built as the eroded bits of the Appalachians were deposited layer by layer on top of the stranded African fragments to build the modern coastal plain. The coastal plain overlaps the edge of the old continent, and the eroded roots of the Appalachians dip down beneath the newer layers for some distance into south Alabama.

TENSAW MORNING

Previous pages: Gravine Island on the Tensaw River, Baldwin County, Alabama

The Tensas Indians originally lived in Louisiana. Wasted by disease, they became involved in difficulties with their neighbors, and about 1740 they moved north of Mobile to be near their friends, the French. At the end of the French and Indian War, they moved back to Louisiana with the French, but their name lives on in Alabama. Anglicized through the years, "Tensas" became "Tensaw" and referred to the area encompassing the great swamp of Lower Clarke, Mobile, and Baldwin Counties. Until the Creek War, this and the Tennessee Valley were the only white settlements in Alabama. In the Tensaw, many of these early settlers were *métis*—Indian-white families, largely the offspring of Scots and Irish traders and their Creek and Choctaw brides. In 1813 hundreds of these people were killed at Fort Mims at the hands of their Redstick relatives.

It is encouraging that we have been able to preserve a portion of the Tensaw Swamp. The area has 236 species of fishes, 12 of which are on the endangered list. Three of its reptiles, 19 of its mussels, and 7 of its snails are also in trouble. Parts of the swamp have been dreadfully savaged by timbering, but given time will perhaps recover. The Tensaw was once the home of panthers and ivory-billed woodpeckers. Who knows? Perhaps it will be again.

Alabamians are used to thinking of the ocean being to the south, but for much of the time since the breakup of Pangea, the center of what is now the North American continent was covered in water—the great Mississippi Embayment—and the ocean was as much to the west as to the south. Only comparatively recently has the Mississippi Embayment filled with sediments.

In the coastal plain the appearance of the Great River of Alabama changes dramatically. No longer held in erosion-resistant rocky valleys, it immediately begins to twist and meander all over the landscape, cutting into one side of the channel and building new floodplain on the other. When it floods, the river deposits sand and mud. During a flood the river occasionally takes a shortcut and cuts off one of its own meanders, forming an oxbow lake. These gradually fill to form dead lakes and sloughs. The meander belt becomes littered with abandoned river channels in various stages of being filled up. Cypress, which is absent above the fall line, and gum trees tend to fill the shallower sloughs. Bottomland hardwoods cover the floodplain.

In general, the sand, being heavier, is deposited along the edges of rivers, eventually forming high natural levees. As the floodwaters flow over the levees, they drop their sand by the river but carry their loads of fine silt and clay away from the river. But now the muddy water is trapped on the floodplain and is prevented from flowing back to the river by the levees. This trapped water is the backswamp. This is what gives the river its fertile muddy bottomlands and so desirably holds the floodwater for gradual release. After a rainy winter, sometimes it is April or May before a big swamp like the Sipsey Swamp or the Tensaw Swamp gives up its water.

The inland portion of the coastal plain is oldest and was deposited during the Cretaceous period—the age of dinosaurs. It is called the *Upper Coastal Plain*. Our river flows first through the red clay Fall Line Hills, the endless hilly landscape between Tuscaloosa and Montgomery. But soon the landscape flattens out and you are in the dark-soiled Black Belt, curiously derived from a white bedrock—the famed Selma Chalk. The chalk area is an old sea bottom and is full of fossils—mosasaurs, ammonites, and giant sea turtles. Here and there bits of dinosaurs are scattered, the fragments of carcasses that floated out to sea on forgotten Cretaceous rivers. Along the river, high white cliffs alternate with swamps, woods, and prairies to create a surreal landscape hardly seen elsewhere.

The more recent portion of the coastal plain stretches from the southernmost edge of the Black Belt to the Gulf of Mexico. It is called the *Lower Coastal Plain* and dates from the Tertiary period—the age of birds and mammals. This is where the bones of the *Basilosaurus* whale, our enormous state fossil, and the rare and elusive Red Hills salamander, the state amphibian, are found. As we cross the geologically banded coastal plain, long stretches of plains and rolling hills alternate with high

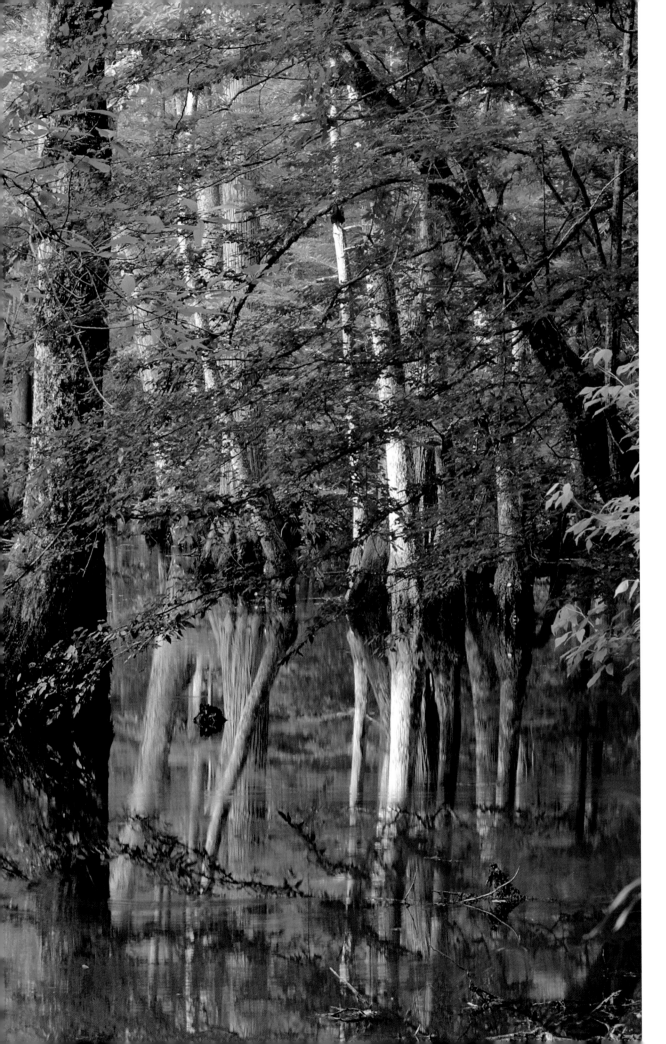

Wake up and howl, there's light in the swamp!

—Garrison Keillor

CYPRESS STAND

Sipsey River Swamp, south of Buhl, Tuscaloosa County, Alabama

The bald cypress's unique form and habitat make it the uncontested king of the swamps. Despite its enormous numbers, it is a specialty species whose trick is growing in deep water where few trees will grow, yet it cannot reproduce there.

Cypress has special requirements for reproduction. Its seeds drop from its cones and are spread by the high water of winter. If they wind up in a sunny place, they will sprout, but until they grow tall enough to keep their leaves above the surface, they will drown in the next year's high water. A fortuitous seed cast up high on a bank explains the scattered individuals we see here and there, but not the deep-water groves. For those, cypress needs a drought—a long one—long enough to expose the bottoms of sloughs and swamps and skip the next year's spring flood. Then the seedlings can grow tall enough in the dry years to survive the return of normal high water. After that the cypress grows happily while all of its competitors drown. Stands of single-age trees are common, all dating from the same drought.

The cypress doesn't hit this trifecta very often. The trees try to reproduce every year, but safe behind their watery moat they can afford to wait for just the right drought. Such conditions are rare, so the trees that live the longest get more times at bat. When successful, they scatter their genes for long life, and the species has evolved the ability to live to great age.

cuesta ridges, where harder, more erosion-resistant layers of rock form curved lines of hills across Alabama.

The Black Belt, being made largely of limestone, is easily dissolved. It has weathered mostly flat and is some two hundred feet lower than the Fall Line Hills to the north and the Red Hills to the south. Because it is low, it has gathered most of the rivers that flow from the Alabama uplands into two large streams. The Tombigbee River unites the western streams (Sipsey, Buttahatchee, Luxapalila, and Black Warrior), and the Alabama River gathers the eastern ones (Cahaba, Coosa, and Tallapoosa). These large rivers head for Mobile Bay but have to punch through the cuestas and high hills to the south.

At the southern edge of the Black Belt, the next several layers are much harder than the chalk. These layers have resisted erosion enough to be exposed as the very large arc of the Chunnenuggee Hills. This prominent feature stretches across the state from Sumter County to Georgia. It forms a broken, yet distinct, two-hundred-foot-high barrier across the state, and none but the largest rivers penetrate it (the Alabama, Tombigbee, and Chattahoochee). So high and broad is the southern slope of the Chunnenuggee Hills that it gives rise to several big coastal drainages—the Pea, the Conecuh/Escambia complex, and the Choctawhatchee. Farther south, an additional swarm of streams arise on the slopes of other cuestas (Escatawpa, Perdido, Yellow, Blackwater, and Chipola Rivers), blackwater streams that drain the pine barrens and flow straight to the gulf.

As we float down the river, these harder layers form the bluffs: China Bluff, Jones Bluff, Choctaw Bluff, St. Stephens Bluff, Claiborne Bluff, and scores of others. These were once river landmarks, high spots where you could get at the river without having to cross the swamp. Since they never flood, many were home to landings or towns. Some sported cotton slides, long timber chutes for delivering cotton bales down to the steamboats.

In an age before dams our coastal plain river would become a trickle in late summer and fall, with long green pools interspersed with stretches of gravel and lined with sandbars. To see what Alabama coastal plain rivers looked like before most were impounded, check out the Cahaba's incredible Barton Beach in Perry County.

At low water the river was too shallow for bateaux, shallops, and steamboats, but was passable for dugouts. Sometimes huge semipermanent logjams, miles in length, blocked navigation for years, only to vanish overnight during a particularly high flood. The bars had so many mussels embedded in the sand that you could not walk for stepping on them. Enormous fish—sturgeons, gars, spoonbills, and giant catfish—competed for amazement with endless seasonal runs of fish coming in from the sea to spawn, including Alabama shad, Atlantic sturgeons, and American eels. Sometimes even needlefish, mullet, and sharks visited far inland.

In the wet season, travel would shake off its malaise and the steamboats could run. Because of their slow upstream speed and the twists of the river, their low-pressure engines would sometimes be audible for half a day before they arrived at the landing. Up on the plateau, farmers would build big flatboats out of green timber, fill them with coal dug from open pits, and set off downstream at spring flood. Propelling the scows with nothing but poles, they would shoot the fall line rapids, float to Mobile, sell the coal and lumber from the boat, and walk home in time to put in a crop and begin work on a new boat. Lumber rafts of great size were skillfully assembled and floated to the mill and market.

One great story is told about the commandant at Fort Tombecbé in Sumter County, Monsieur de la Gauterais, who in the 1750s hired some helpers and built a giant raft of squared red cedar timber that was sixty feet long, twenty-five feet wide, and drew twelve feet of water. At the spring freshet, he took leave and rode the five-hundred-ton juggernaut three hundred miles to Mobile and sold the timber.

Alabama indeed lived up to its nickname, the Cotton State. The flood of settlers into Alabama after the Creek War, a movement dubbed "Alabama Fever," was based almost completely on the lure of cotton land. Also, as early as 1818 practical steamboats floated on the state's rivers. With the double whammy of the right crop and a new mode of transportation, Mobile was transformed from a sad backwater to an important cotton port. The rivers became lined with cotton landings. Some serviced single plantations, and some developed into important towns—Bluffport, Gainesville, Cahawba, Moscow, Prairie Bluff, Bell's Landing, MacIntosh Bluff, Claiborne, Selma, Montgomery, and Eufaula.

So difficult were Alabama roads, it was worthwhile to maintain the navigability of even small rivers. Many of the smaller coastal rivers, such as Escambia, Conecuh, Choctawhatchee, and Chipola, had steamboats. Amazingly small streams supported steamboat navigation in season; there are reports of two hundred cotton bale steamboats navigating high on the Conecuh River. So plentiful were Alabama streams that in antebellum times the state put all of its money into steamboat transportation, and when the War Between the States broke out, the lack of railroads became a critical factor. For example, Old Cahawba was a larger town than its rival, Selma. So scarce were rails and rollingstock that during the war the railroad was moved from Cahawba to service the Confederate ordnance works at Selma. After the war there was no money to move it back, so Selma eventually prospered and Cahawba became a ghost town.

Although steamboats remained important after the war, railroads gradually replaced them for all except bulk cargo. Most of the cotton landings disappeared or became irrelevant. Still, the lure of inexpensive transportation was (and remains) a driving force in the construction of dams and the destruction of the natural course of rivers.

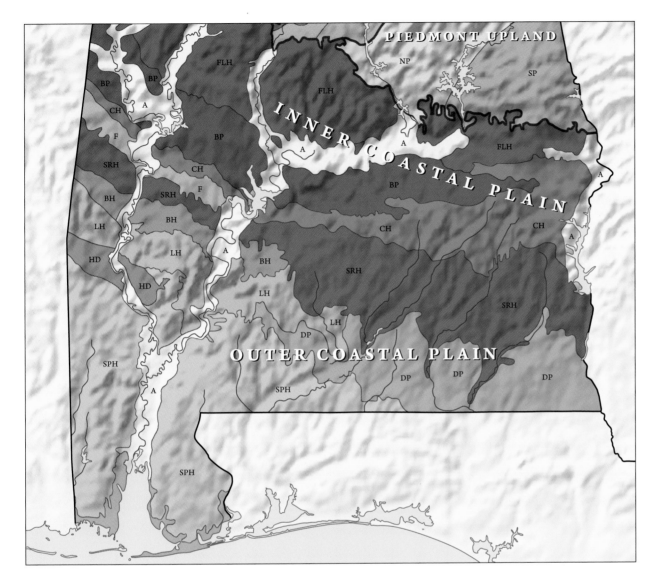

The map shows regions labeled: PIEDMONT UPLAND, INNER COASTAL PLAIN, OUTER COASTAL PLAIN, with abbreviations FLH, NP, SP, BP, CH, A, F, SRH, BH, LH, HD, DP, SPH scattered across the map.

ALABAMA COASTAL PLAIN

The large coastal plain is divided into two parts. The inland part is the Upper Coastal Plain. It is older, dating from the Cretaceous period (late in the age of dinosaurs), and is between 65 and 100 million years old. The Upper Coastal Plain includes the Fall Line Hills (FLH) and the Black Belt (BP). The Chunnenuggee Hills (CH) run along the southern edge of the Black Belt.

The outer part of the province is the Lower Coastal Plain. It is slightly younger and dates from the Tertiary period (the age of birds and mammals). This land is 65 million years old where it joins the Upper Coastal Plain and becomes younger, layer by layer, as it approaches the coast. Several cuestas, some very noticeable, arc through the Lower Coastal Plain. The seacoast—Gulf Shores, the Fort Morgan peninsula, and Dauphin Island—represents essentially modern times. This map and the map on page 39 adapted from a map by The University of Alabama Cartographic Research Laboratory.

Finally, the Great River must come to the Gulf of Mexico. During the last Ice Age, when the sea level was low, the rivers each cut a deep valley at their mouth. Then, when the ice melted and the sea level rose, it flooded and little bays were created at Panama City and Perdido as well as bigger bays at Appalachicola, Choctawhatchee, Pensacola, and Mobile. Mobile Bay was enormous and extended all the way up to Clarke County. In the last ten thousand years (as the sea level has risen) the Alabama and Tombigbee Rivers have filled in the north end of Mobile Bay to form the great Tensaw Swamp (also called the Mobile Delta). The smaller coastal drainages have similar histories and similar swamps.

At the mouths of the rivers, the bays become estuaries as freshwater gives way to salt marsh. The rivers' gradients become nearly flat, and the rivers become more influenced by tides than by the river's flow. But there is one more surprise. Coastal currents in the gulf run east to west, and they take all the sand supplied by the rivers and push it to the west, where it forms spits and barrier islands—the St. Joseph Peninsula, Panama

City, Santa Rosa, Perdido, Gulf Shores, Fort Morgan, and Dauphin Island. These are the most actively changing parts of the Alabama landscape, each beach built from sand supplied by the rivers to the east.

So now our journey is complete. We have journeyed to the headwaters and accompanied the water of a million springs and seepages of the Great River of Alabama down to the sea. Now we can follow the muddy shallows of Mobile Bay down the Eastern Shore. We can pull out on the bay shore of Fort Morgan and walk across the spit to the beach. It has been a long and hopeful journey. While parts of the river looked a little worn, it is not all spoiled, and there are plenty of reasons to hope that we can make it even better. We realize that we can improve our stewardship—with a little more care, a little more planning, and a stronger ethic to preserve what cannot be replaced—because we hope our children will find it even nicer.

Let's load up the canoe and do it again!

BUTTRESSED CYPRESS

Conecuh River, Solon-Dixon Forestry Center, Covington and Escambia Counties, Alabama

Here are the cypresses in all their ancient glory. The trees in each grove are typically about the same size, lucky beneficiaries of a single forgotten drought. They squat in the remnant of an ancient slough, covered in green moss and blue lichens and surrounded by their unique root extensions, known as knees. It's a dry spring, and the water level is not as high as usual.

It is a sight unchanged since the Ice Ages. We cannot separate the natural history of the state from the Native American story. By the time the big mound complex was built at Moundville, a large population of Indians had cleared much of the state's bottomlands for farms. But there was a fatal flaw in this Indian Eden. The ultimate source of contagious diseases in humans is livestock, and since the Native Americans had few domestic animals, they had few contagious diseases. Thus, when contact with the newly arrived Europeans introduced smallpox, measles, whooping cough, and other familiar diseases to the unprotected Indian population, the effects on the Indians were devastating, and most of them died.

No explorer ever saw the fully populated Indian landscape of the mid-South. By the arrival of the French in the early 1700s, the depopulation of the Southeast was dramatic, and much of the landscape cleared by the large pre-Columbian Indian population had returned to forest.

The swamp has looked this way for thousands of years and expects to remain so for a thousand more. Hope we can oblige.

On the Tombigbee River so bright I was born
In a hut made of husks of the tall yellow corn.
And there I first met with my Julia so true
And I rowed her about in my gum tree canoe

<div align="right">—S. S. Steele</div>

HURRICANE BAYOU

In the heart of the Mobile Delta on the Tensaw River, Baldwin County, Alabama

The Mobile Delta is the child of the last Ice Age. The accumulation of ice at the earth's poles caused the sea level to drop by almost four hundred feet, and the saltwater withdrew perhaps fifty miles farther south. The Tombigbee and Alabama Rivers joined and carved a big valley clear to the Gulf of Mexico. At the end of the last glacial advance, the polar ice began to melt and the sea level began to rise again. All the alluvium that forms the present delta and provides the muddy shallows of modern Mobile Bay has been deposited since that time. The rising sea flooded the lower end of the valley and formed Mobile Bay about seven thousand years ago. The delta and the sandy spits and islands at the coast are the youngest sizable parts of Alabama. But many of the fine details are more recent. The Mobile Delta is still growing—you can clearly see it filling in behind the causeway. Someday it will fill the whole bay.

What was the name of the river that flowed through the Mobile Valley during the Ice Age? Do you suppose it looked like this? Can you imagine mammoths, camels, and Hereford-size ground sloths grazing along its banks? And who do you suppose lived on the broad plain south of Mobile Point and Dauphin Island until the ocean returned?

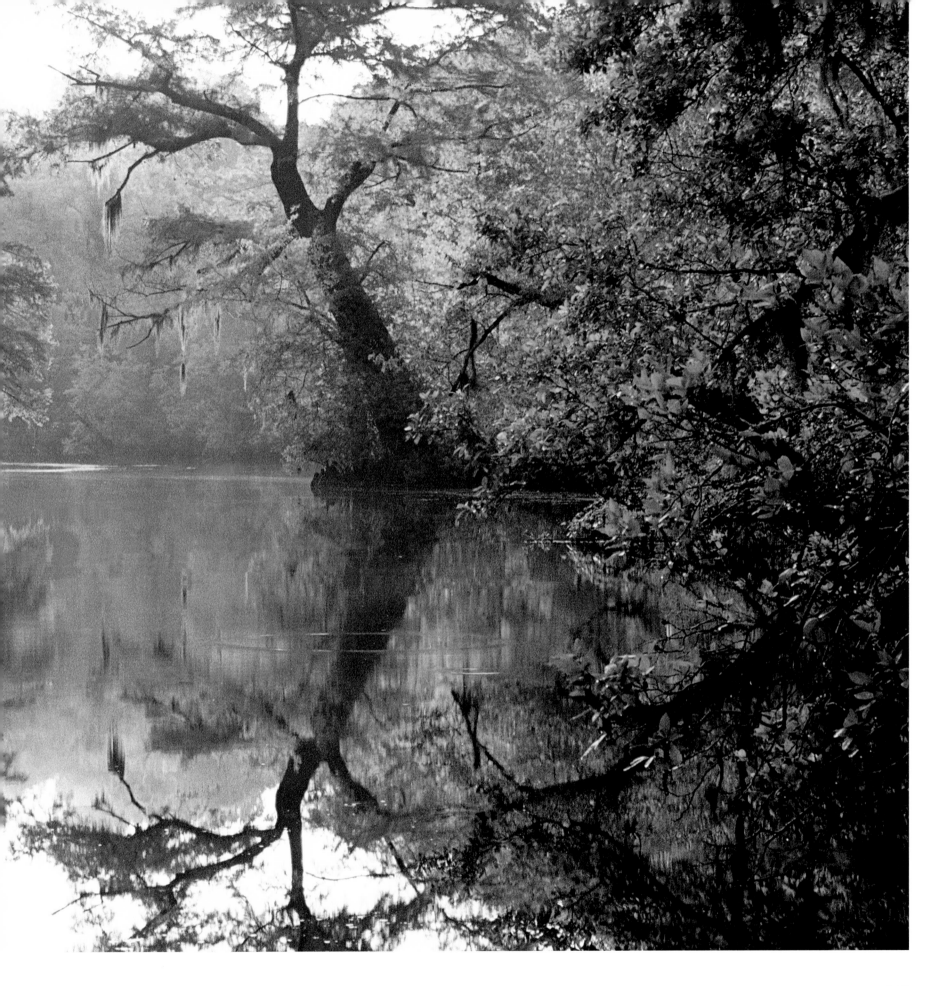

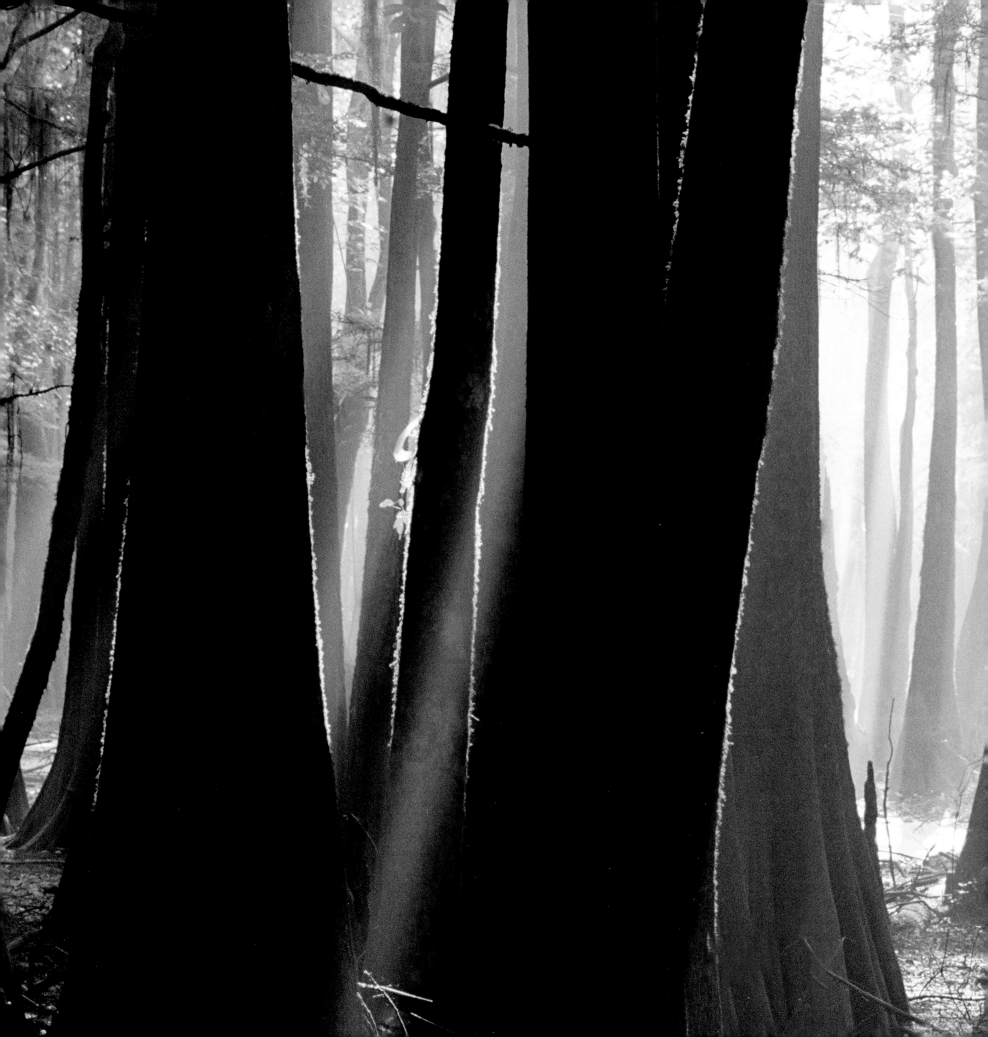

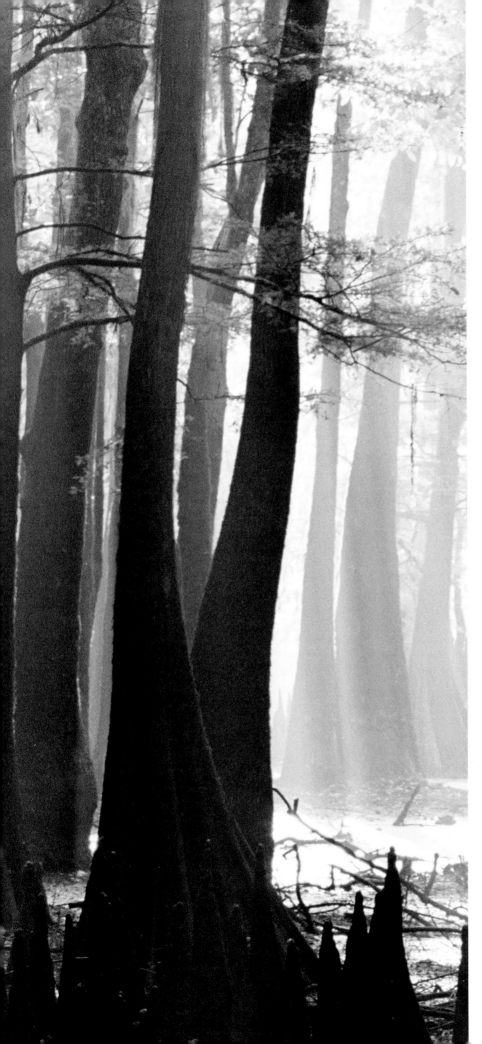

From ghoulies and ghosties and long-legged beasties, and things that go bump in the night, good Lord deliver us.

<div align="right">

—Scots Traditional

</div>

CYPRESS WOODS

Near McIntosh, Lower Tombigbee River, Washington County, Alabama

One cannot ignore the notion that swamps are spooky places. When you get to know them, of course, they are fascinating, but you do have to admit to their unworldly appearance. This might as well be a photograph from the yet-undiscovered Martian woods. No telling what might live in there. Anything from the Cherokee *uktena*, the giant underwater horned rattlesnake with a fabulous magic crystal between his eyes, to the equally fabulous ivory-billed woodpecker, perhaps returned from extinction.

In an age before electric lights this was a dark world. Were we caught on the river at night, we might forgive our grandparents' quaint lore. How brave would we be without science as an antidote to the green gleam of foxfire, the elusive glow of will-o'-the-wisp, and the screams of night birds or worse?

Some night in camp, make a pact: no lights.

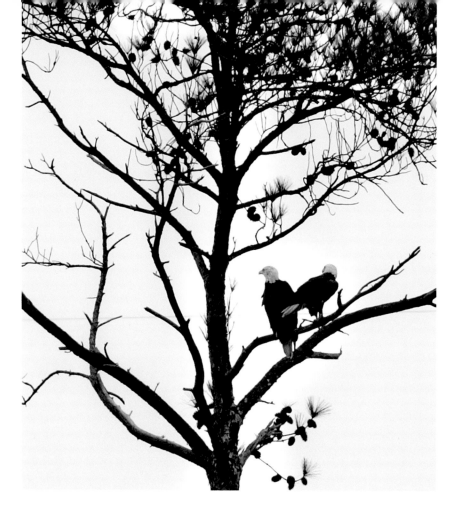

TWO EAGLES!

Bald eagles, *Haliaeetus leucocephalus*, claim the Cahaba River near Heiberger Church, Perry County, Alabama

We hope that our children will never experience the surprise we felt of seeing two eagles in the same tree, because we hope eagles will someday be so common they will have to shoo them off their trash cans. We hope the kids will have to deal with angry bass fishermen protesting that the eagles are eating up all the fish.

Most of us were adults before we ever saw an Alabama eagle. In the mid-1980s the Alabama Museum of Natural History organized a public eagle-watching trip. On a bitterly cold day in January, when the roads were iced over and the ground was frozen, two vanloads of eagle watchers traveled to the Bankhead Lock on the Black Warrior River and stepped out into a bitter ten-degree wind. After several icy, eagle-less minutes, the group started to become restive. Suddenly, as if on cue, an enormous white-head flew directly over the group, dropped onto the water, and caught a large fish. The eagle carried it to a tree less than one hundred yards away, ate it with great gusto, and then flew off.

The trip leader: "Any questions?"

The group spokesman: "How *did* you arrange that?"

And they loaded up and went home, agreeing it was the best eagle trip ever.

OSPREY

Basin Negro, Tensaw River, Tensaw Delta, Baldwin County, Alabama

Ospreys were one of the victims of the DDT incident. This well-known story is worth considering. DDT, an effective insecticide, does not chemically degrade in the environment. Even in low concentrations it is taken up by microorganisms, which are

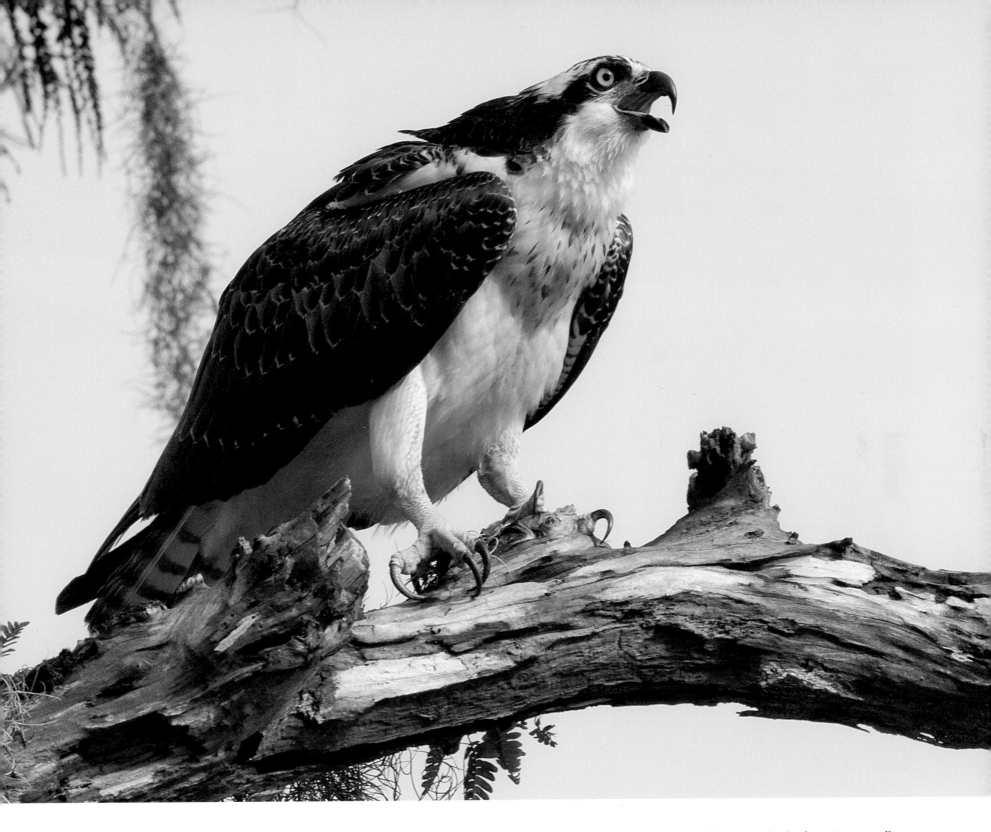

eaten by progressively larger creatures, each of which collect in their bodies all the DDT accumulated by the organisms they have consumed—a process described by the ever-so-apt term "biomagnification."

The big fish-eating birds—eagles, pelicans, ospreys—eventually accumulated dosages of DDT that may not have killed them outright, but thinned their eggshells to the point that they were unable to successfully hatch a clutch of eggs. Dramatically reduced numbers set off a generation-long restoration effort that has only recently begun to bear fruit, or eaglets!

This story is so familiar. Why are we dithering over mercury? Is it that perhaps we lack a dramatically declining favorite creature?

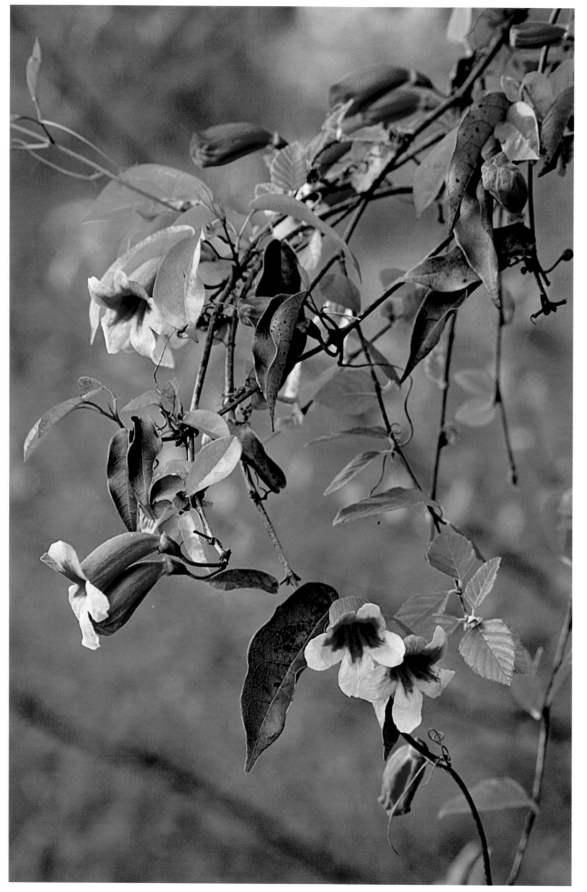

CROSS VINE

***Anisostichus capreolata* overhanging the Escataw-pa River, Mobile County Alabama**

In the South, the bignonia family is composed of three of the most obvious and attractive flowers in the region—catalpa, cross vine, and trumpet vine. The name "cross vine" comes from the cross-shaped pith chamber that is revealed when you cut the vine. The white-flowered catalpa is the source of bait caterpillars and "Indian cigars." In the country, the bright orange trumpet vine is known as cow itch and is universally presumed to be poisonous, though no one can quite describe its symptoms.

The riverside in prehistoric times must have seemed more like a tropical rain forest. Dozens of species of flowering trees and vines shouldered one another in competition for sunlight. Lianas—vines that grow from limb to limb—covered the sunlit flanks of the trees so that you couldn't see into the forest. Grapes, cross vine, trumpet vine, greenbrier, Dutchman's pipes, moonseed, coral berries, poison ivy, Virginia creeper, catalpa, redbud, sycamores, and magnolias—the list of streamside species goes on and on. Add the flocks of screaming green-and-yellow Carolina parakeets and sun-darkening flights of passenger pigeons, and the image is complete.

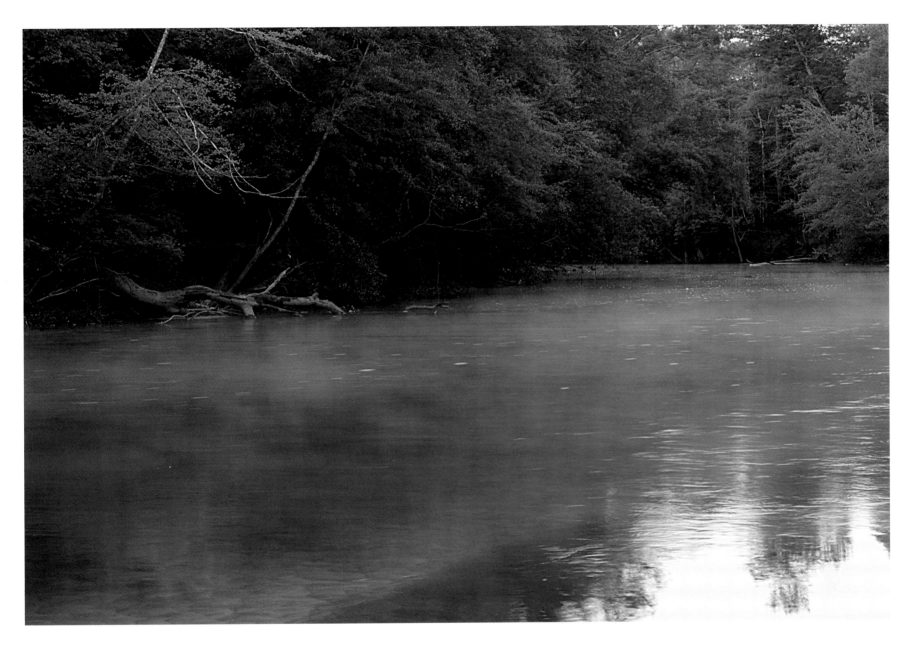

BLACK WATER

Escatawpa River in a mysterious mood, near the Mississippi line, Mobile County, Alabama

Many of the small coastal rivers are tea-colored streams, heavily stained with vegetable tannins leached out of the sandy soil. They flow in the midst of dark swamps, shaded by tall trees dripping with vines and Spanish moss. All of this made a bad impression on the European colonists, who dubbed them with names like Yellow River, Blackwater River, Perdido River (Spanish for "lost," perhaps in a bad way), Bayou Negro (Spanish for "black bayou"), Blackwater Bay, and, most ominously, the Styx River.

Isolated communities in an immense, empty landscape with bad roads and poor communications must have given the early generations of Alabamians a sense of being very far from home. The image of the children of Israel wandering in the desert must have resonated with them. Their churches are commonly named for remote biblical campsites or distant congregations—Shiloh, Nebo, Pisgah, Moriah, Bethel, Gilgal, Rehoboth, Antioch, and Macedonia. But like John the Baptist, they all came down to the rivers in hope, to baptize their children and neighbors.

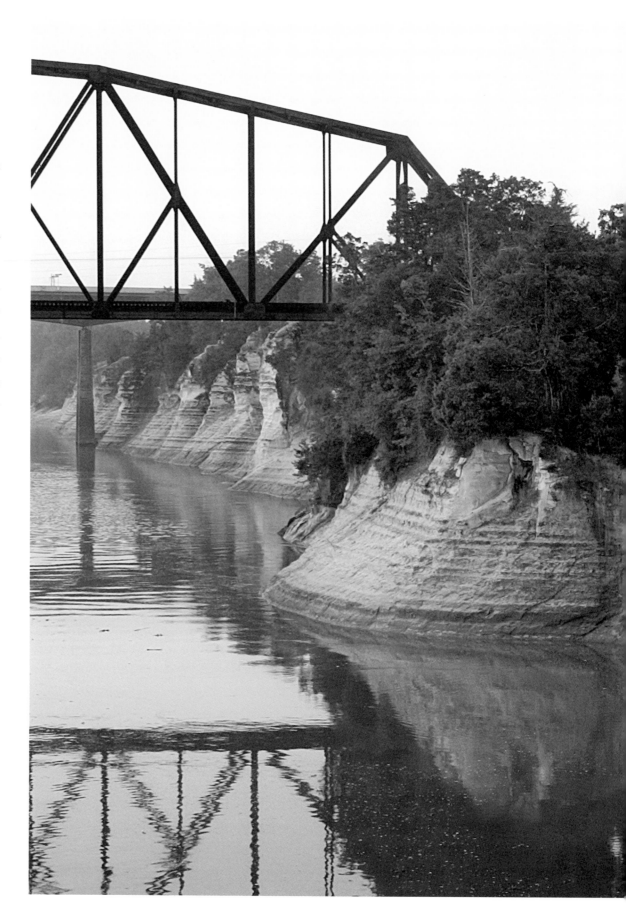

[T]he time of the rising waters, which at length took the raft away and him with four people upon it; this raft drew about 12 feet of water, and came down the river without let or hindrance carrying before it every obstacle (even bending large trees under it) all the way down to Mobile.

—Bernard Romans

CHALK BLUFFS BELOW FORT TOMBECBÉ

Downstream from Jones Bluff, Tombigbee River north of Epes, Sumter County, Alabama

Less the bridge, this view was enjoyed by the original inhabitants of western Alabama. Bernard Romans, who paddled by here in January 1772, examined the ruins of the old French Fort Tombecbé. In 1736 Jean-Baptiste Le Moyne de Bienville paraded six hundred French soldiers on the black prairie in front of the fort before marching on the Chickasaw Indians. The French lost.

It is from this place that Monsieur de la Gauterais, the commandant of the fort, rode his giant cedar log raft to Mobile—Alabama's first great river story. And just upstream was George Strother Gaines's Choctaw trading post, the Indians' reward for being on the winning side of the Creek War.

The Selma Chalk bluffs of the Black Belt decorate both the Tombigbee and the Alabama Rivers. These high bluffs were brilliant white landmarks throughout the frontier and steamboat eras. Some of the bluffs were capped with sizable river towns that faded away as the railroad age prevailed. Just downstream from Fort Tombecbé, the large and prospering antebellum town of Bluffport stood on its bluff. But the railroad crossed the river here at Epes, and though now reduced to a hamlet, it has survived. But not a trace of Bluffport remains except its cisterns gouged into the soft white marl.

It is lucky that in 1783, when the Spanish rebuilt the wooden Fort Tombecbé, which they renamed Fort Confederation, they built an earth fort out of white chalky soil, or there would be no trace if it either.

TIGER SWALLOWTAILS ON A
BLAZING STAR

**Black prairie remnant near Fort Tombecbé, north
of Epes, Tombigbee River, Sumter County, Alabama**

It sometimes seems that nature is a bit over the top.
The standard answer to the question of why flora and fauna
have bright colors is "to attract mates or pollinators." Still,
little gray mice make baby mice, little brown beetles make
new beetles, and green grass makes (ho-hum) green grass.
But just look at these excessively beautiful organisms—*Liatris*, the blazing star of the black prairie, and the state mascot,
Papilio glaucus, the tiger swallowtail. Both of them are much
prettier than they have to be.

There's been some discussion lately of whether we
should have fierce sports mascots such as lions and tigers and
bears. Surely nobody can object to this set of school colors—
black, yellow, and violet. You can just see the pride in the gym
as they announce: "Ladies and gentlemen, the Fighting Tiger
Swallowtails!"

Hmmm. May need to think some more on that.

Join the shuffling throng,
Hear the music and song.
It's simply great, mate, waiting on the levee,
Waiting for the Robert E. Lee.

—L. Wolfe Gilbert

SANDBAR

Free-flowing portion of the lower Alabama River below Claiborne Lock, Monroe County, Alabama

Sandbars were more common before the rivers were dammed. Since sand particles are heavier than mud, sand is deposited in high-current areas at the edges of the stream, especially during floods. Along the bank it builds ridges (levees) and sandbars, while the finer, more transportable clay and silt is carried downstream or away from the river, deeper into the swamp. The finer the sediment, the farther you are from the river's current; true even in ancient rocks.

Sandbars are the river's front porch. Fishermen come to fish. Fish come up to cavort in the shallows. Animals come to drink. Lovers come to watch the sunset. Turtles, gators, and canoeists sun themselves. Scouts camp. Churches have picnics. Old philosophers contemplate the moon.

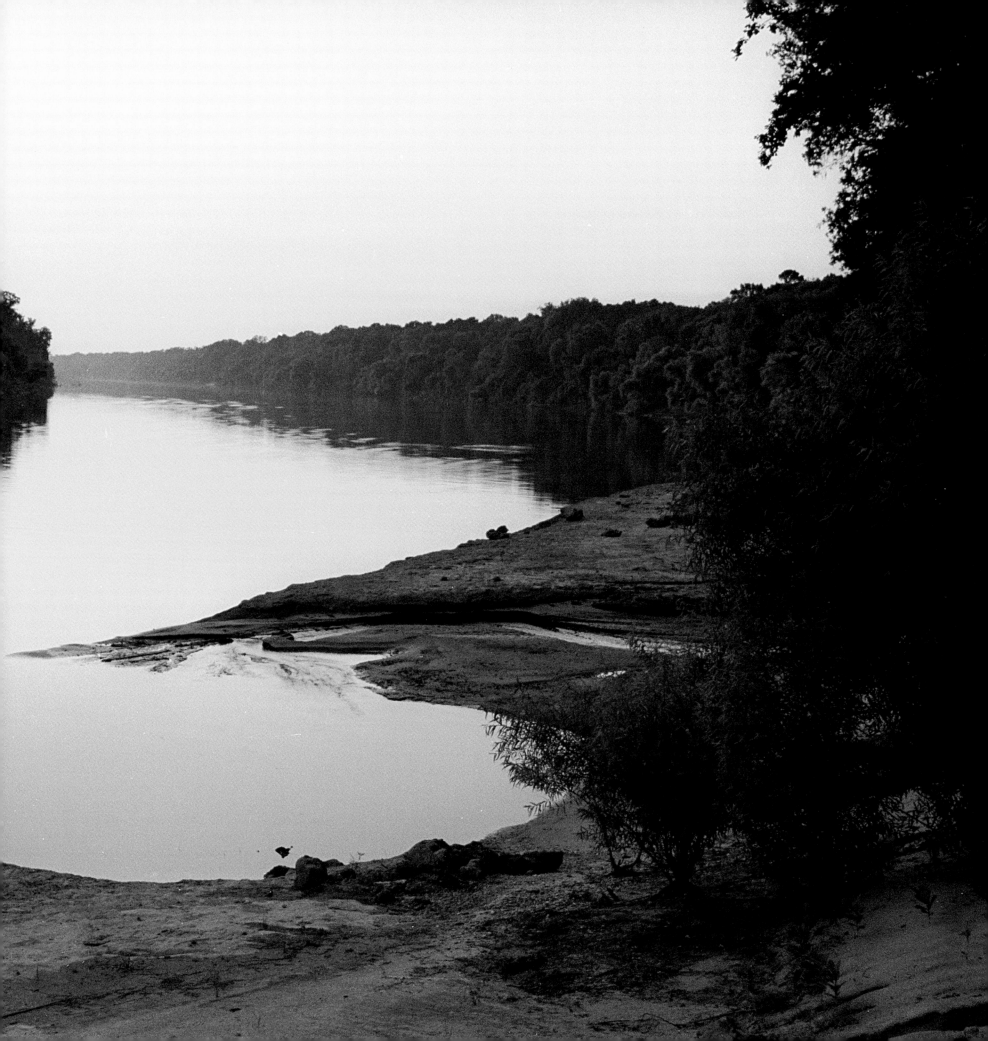

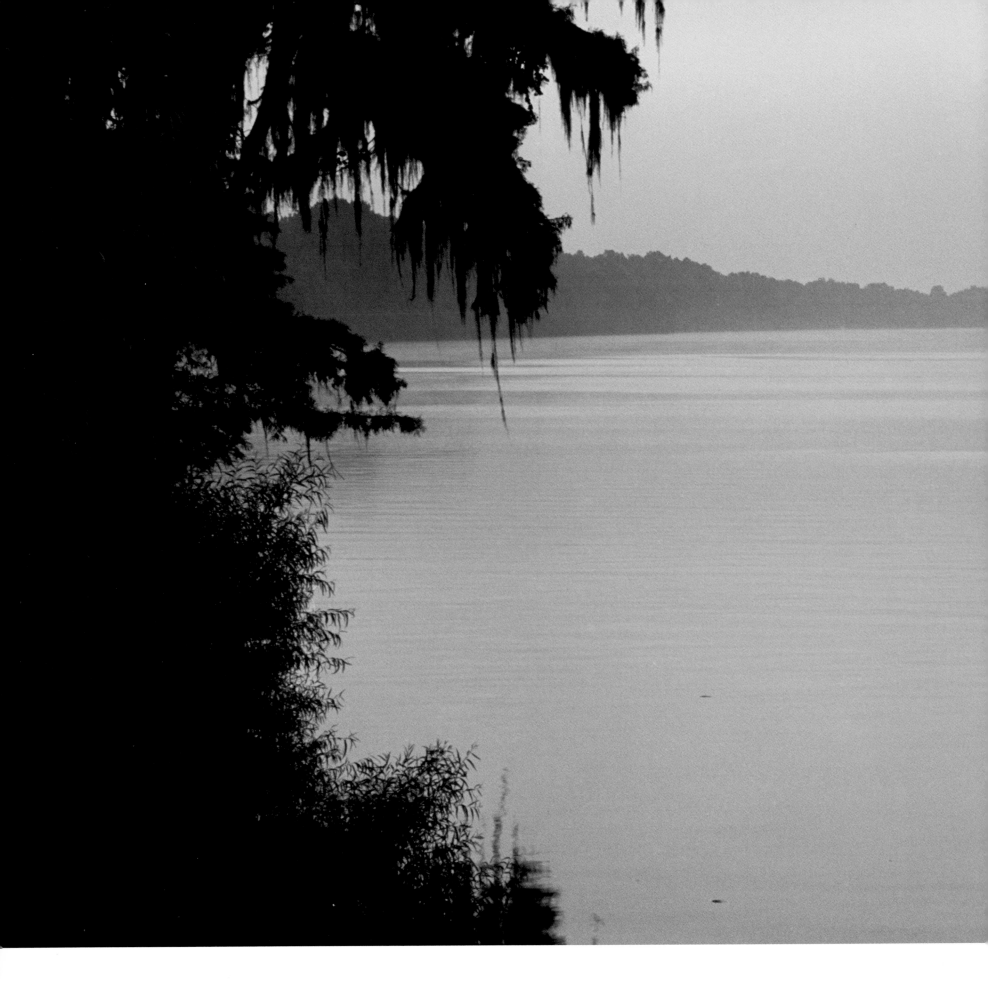

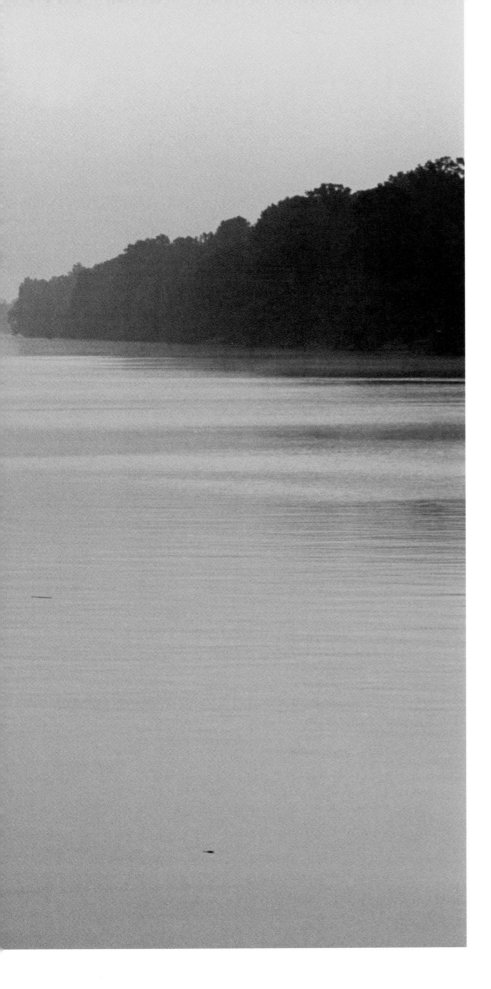

A cartload is brought home from the field, nearly every evening, to supply the demand of the family for the next day; for during this torrid weather, very little business but the eating of water-melons is transacted.

—Philip Henry Gosse, 1838

ALABAMA RIVER SUNSET

Looking upstream from Old Cahawba, junction of Cahaba and Alabama Rivers, Dallas County, Alabama

In an age before dams the Great River of Alabama would become a trickle in late summer and fall, with long green pools interspersed with stretches of gravel and sand. In the winter and spring it rushed and flooded, and shoals of fish surged upstream to spawn. The steamboats ran, too, bringing goods from the gulf ports and taking back fortunes in warehoused cotton.

Oyster shells are still to be found in the old river towns. Brought up from Mobile on the decks of steamboats in barrels of seawater, oysters were favorite delicacies when the river permitted. Now, dammed and controlled, the river has lost its seasonal nature and a good deal of its charm.

Old Cahawba had two high points. From 1819 to 1825 it was Alabama's first capital. Initially chosen for its central location at the junction of two rivers, politics moved the capital up to Tuscaloosa to be nearer the populous Tennessee Valley. Stripped of its political role, Cahawba declined, but the coming prosperity of the Black Belt cotton era and the installation of a railroad rejuvenated the town as a river port. Although it thrived until the 1860s, the town never recovered from the war and the loss of the railroad to Selma. Only one sad house remains.

[I] listened in amazement to the noise within, which I could compare to nothing else than the sound of a large wheel revolving under a powerful stream. It was yet dusky, so that I could hardly see the hour on my watch, but I estimated the time which they took in getting out at more than thirty minutes.

—John J. Audubon

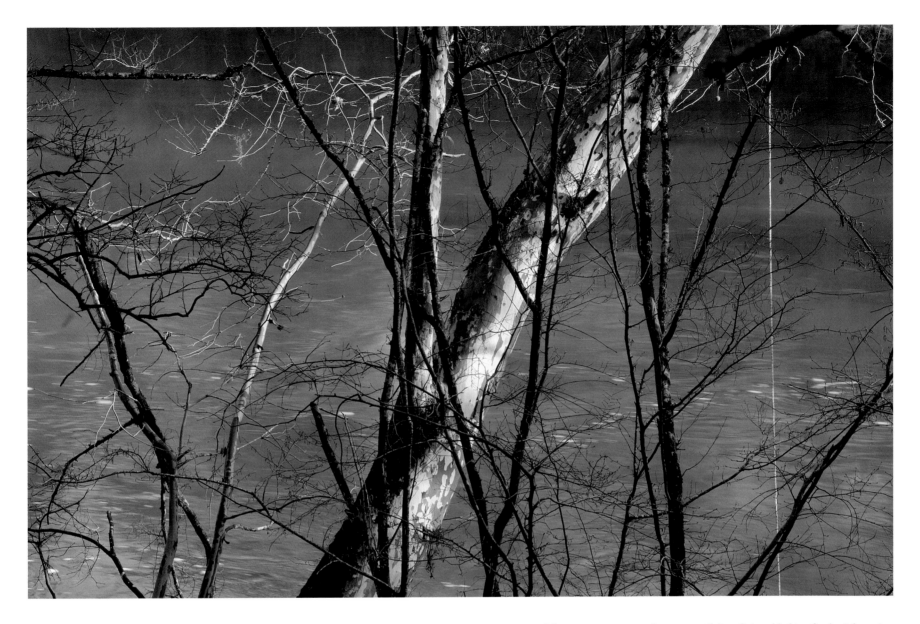

SYCAMORES

White limbs gleam along the Conecuh River, Conecuh County, Alabama

A short hymn of praise for the sycamore, *Platanus occidentalis.* The sycamore tree is another river creature that, were it not so common, people would travel to see. They are perhaps the largest of the eastern trees, at least in girth. There are reports of newcomers selecting a large hollow sycamore, cutting a door into its side, and setting up housekeeping. Since sycamore wood is not highly prized, one can still find large trees along many stream bottoms.

The distinctive smooth white bark of sycamores' limbs and upper trunks is unforgettable. Their large maplelike leaves fall late and blow about all winter with a clatter. They are fast-growing bare-ground colonizers and quickly spring up on sandbars, old fields, and along the scoured banks of rivers after spring floods.

Mr. Audubon was witness to chimney swifts' traditional habit of colonial nesting and roosting in hollow trees, often in sycamores. He once calculated that nine thousand birds flew out of one roost tree in a thirty-minute dawn rush. Now they happily nest in chimneys. One wonders if modern times are good or bad for chimney swifts.

Young sycamores insinuate themselves along the margins of the stream. Gradually they and the river come to an understanding concerning just how far the tree may lean over the flow. And come spring, some brave soul will be the first to grab that rope and swing like Tarzan out into the cold green river. Chill bumps and high status: "Hey, Bubba, watch this!" Short pause and big splash: "Whoo-ee! That's cold!"

NAME OF THE RIVER

Sepulga River, north of Brooklyn, Conecuh County, Alabama

Coastal Alabama and northwest Florida still have free-flowing rivers. Several large coastal streams gather their headwaters on the Chunnenuggee Hills, the great broken ridge that sweeps across mid-Alabama below the Black Belt. Others flow from other cuestas farther south, charming streams with magic names—Conecuh and Pea Rivers, Choctawhatchee River, Sepulga and Escambia Rivers, Burnt Corn and Murder Creeks, Yellow River, Tight Eye and Double Bridge Creeks. Who knows their original Indian names? Some are simply forgotten, and some were filtered through French and Spanish ears onto English and American maps. Conecuh County was so full of native cane that the various Native American translations for Conecuh all involve something like "cane-brake" or "cane down there."

Because the population of the region is small, many of the rivers are still clean or undamaged enough to have runs of giant sturgeon coming upriver to spawn in the gravel shoals. One photographer, camped out on a sandbar, was awakened by an enormous splash! Flashlight in hand, she searched unsuccessfully for tracks, certain a horse had leaped into the water. The locals said, "Nah, it's just the sturgeons. We go out on the bridge at night to watch them jump!" As recently as 1941, an eight-foot, 360-pound sturgeon was caught and photographed on the Cahaba at Centreville. But there are downstream dams on the Alabama now, and those days are over. Still, it's nice to know the sturgeons still lurk in the coastal rivers.

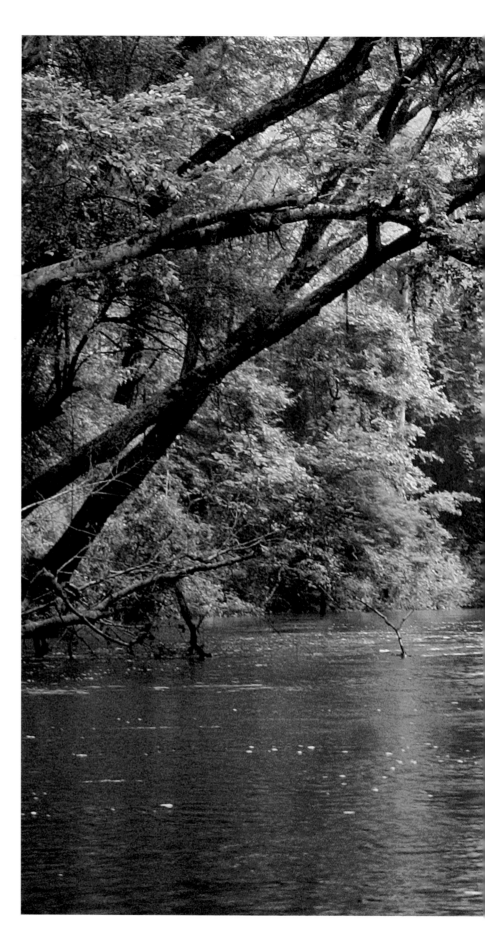

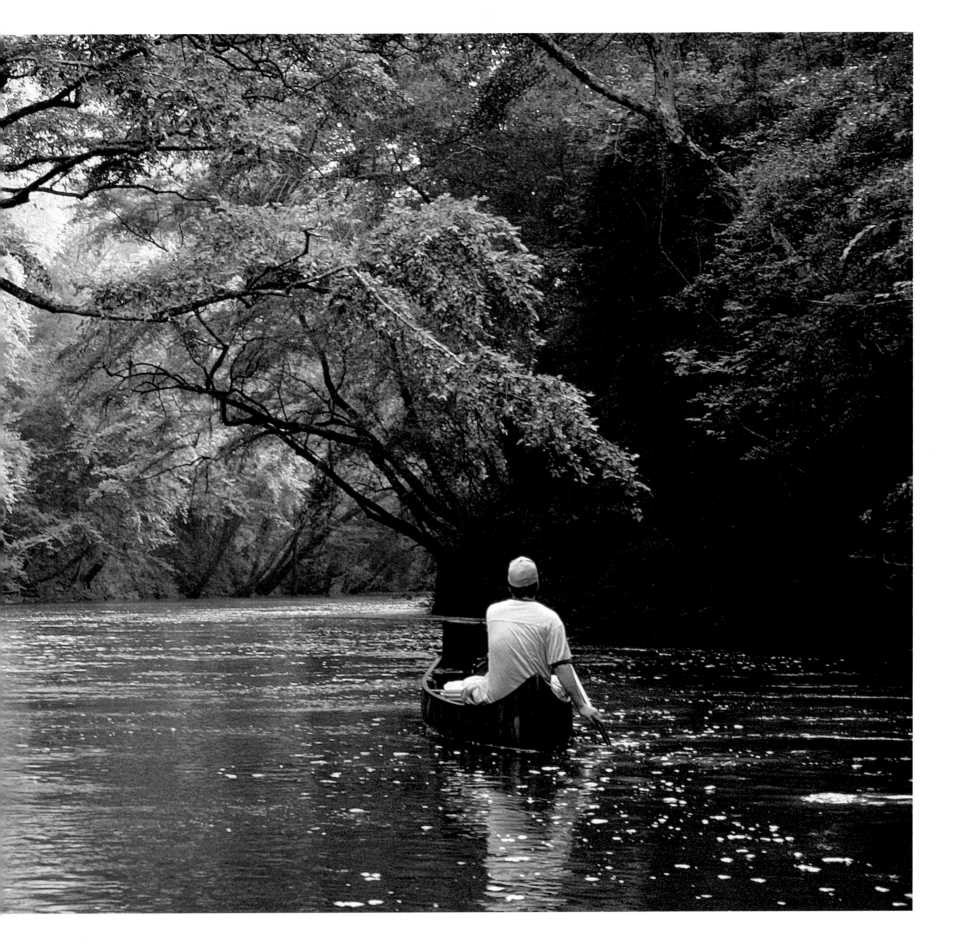

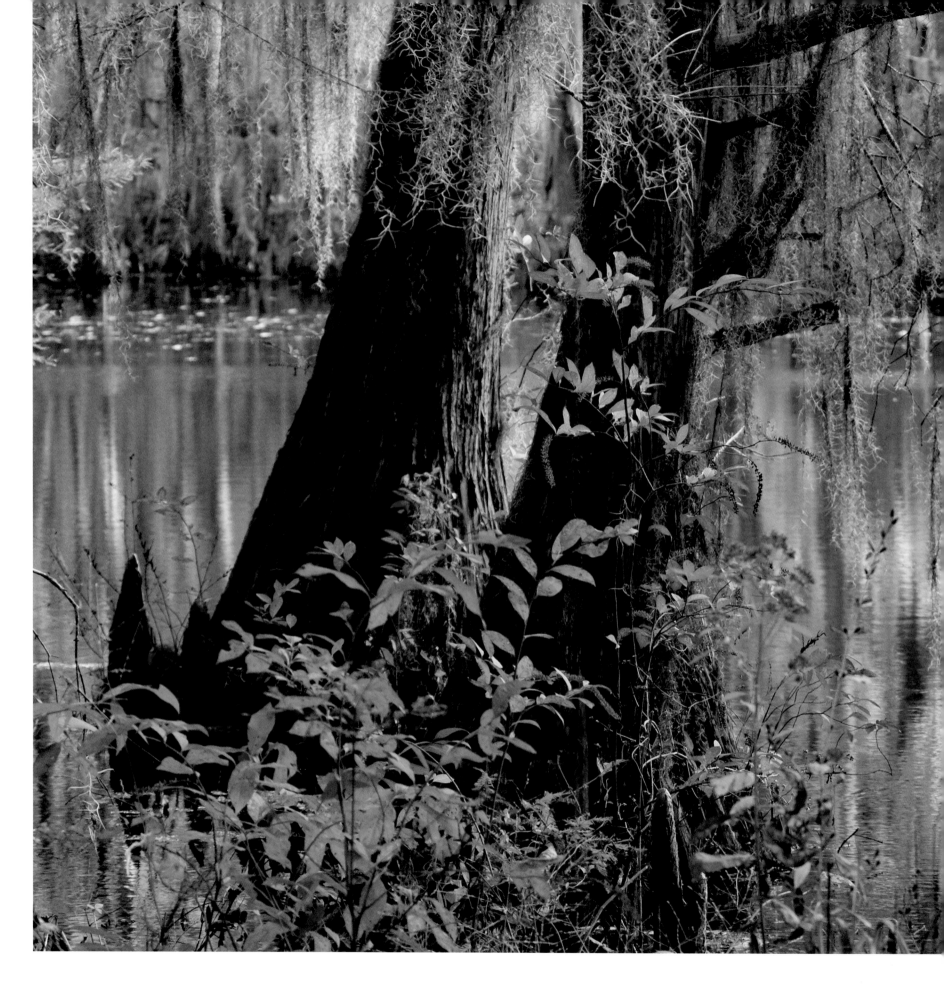

The propriety of correct nomenclature was impressed upon me . . .
I inadvertently spoke of it as a "singular creature," but . . . the overseer promptly
corrected my mistake. "A 'Possum, Sir, is not a critter, but a varmint."

—Phillip Henry Gosse

SPANISH MOSS

South of the moss line at Perry Lakes Park, near Sprott, Cahaba River, Perry County, Alabama

If the alligator is the Ur-animal of Southern myth, then surely Spanish moss is its plant equivalent. In the true sense of the word, it is a wonderful plant. There is an invisible boundary across Alabama (roughly along Highway 14), a magical meridian of temperature and humidity, north of which Spanish moss simply will not grow. A million hopeful vacationers have tried. Even within its range, no doubt to doubly confound us, it contrives to grow plentifully in one tree but not the one next to it.

Spanish moss is a bromeliad, the same family as pineapples. It has tiny green flowers and windblown seeds. It is not a parasite, but an air plant, gathering moisture from the air and nutrients from the dust. There is no evidence that it directly damages its host tree. That a tree heavily burdened with moss might be more subject to wind damage is reasonable. But more pernicious is the myth that for some evil reason, legions of red bugs gather in the fronds to ambush unwary Spanish moss-strokers.

"Leave that alone, Johnny, it's full of chiggers!"

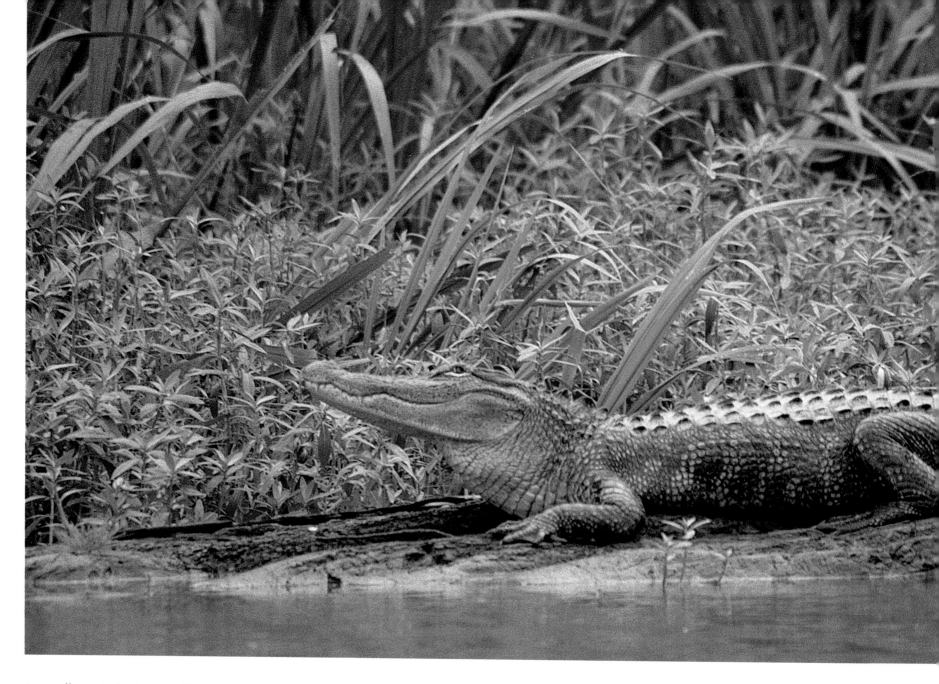

I can tell you, Jack, that the alligator is one beast of which it can be said, that if you've seen one, you've seen them all.

—James Dickey

ALLIGATOR

On the banks of Lizard Creek (where else?), Mobile River, Tensaw Delta, Mobile County, Alabama

Hardly anything seems more Southern than alligators. Folks always remember the first time they saw one in the wild. All of coastal plain Alabama is within gators' natural range, and as they recover from centuries of persecution they'll become more common. Alligators are certainly the top freshwater predator, and we can expect them to regulate the populations of beavers, turtles, and such.

Most gators, while exciting to see, are shy and innocuous. But when they reach ten or eleven feet and weigh about three hundred pounds, the relationship between alligators and humans changes. They begin to wonder if those funny critters on the bank are

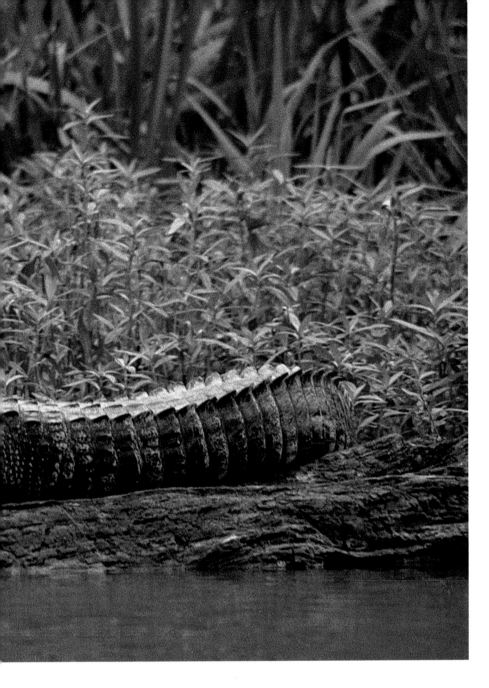

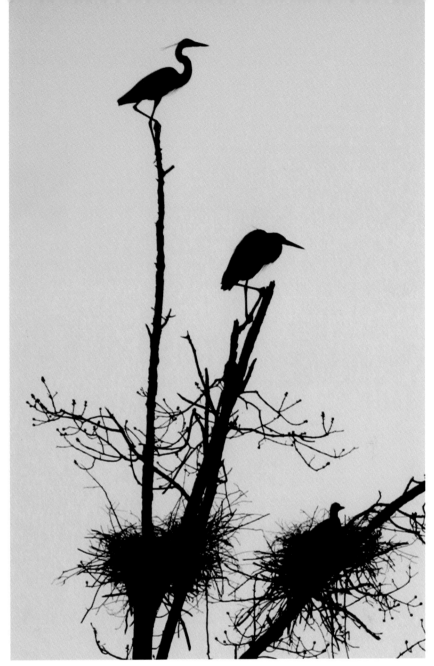

good to eat, leaving us with a bit of a moral dilemma to sort out. It's one thing to agree that the natural balance needs predators, but it's another when we are the potential prey! On the whole, though, it's a better world with the occasional toothy predator than without. Their existence lends a certain validity to the outdoor experience.

SILHOUETTES

Great blue heron rookery near Black Warrior River, Moundville, Hale County, Alabama

Who knows about the private lives of herons? How do they handle the dissonance between the life of a solitary hunter of misty bayous and the chaos of rookeries?

Nesting colonies of herons are a kind of blight. Huge numbers of herons of several species—great blues, great and snowy egrets, little blues and tricolors, and cattle egrets—will nest together for mutual defense and encouragement. They squawk and fuss and fight and raise babies. The smell and the noise are overwhelming. After a few years, the ammonia-rich droppings kill the vegetation and the colony must move. Given all the confusion, who makes that decision?

BLACKWATER BAYOU

Perdido River near the mouth of the Styx River, Baldwin County, Alabama

A good piece of news in recent years has been the push to protect the Perdido River. Named by the Spanish for its "lost" bay, with its changing and evasive natural opening, the Perdido is the traditional boundary between French and Spanish colonies, British East and West Florida, and Florida and Alabama.

The Perdido is a swampy and difficult-to-approach blackwater stream that is worth looking at on a map. It is isolated in the midst of the enormous sandy longleaf pine belt between Mobile and Pensacola Bays. That it has been stuck in the back closet of the consciousness of both Alabama and Florida seems to have been both its doom and its salvation. The lower end has suffered most—the bay by careless development, and the lower part of the river from industrial pollution. But at the same time, the very remoteness of the river's northern end (it was paper company land for many years) has preserved miles of bottomland forest with large stands of Atlantic white cedar. It is a breathtaking canoe ride, but its long, inaccessible runs kept it a local secret until the Nature Conservancy and Forever Wild purchased fourteen miles of the Alabama side in 2006.

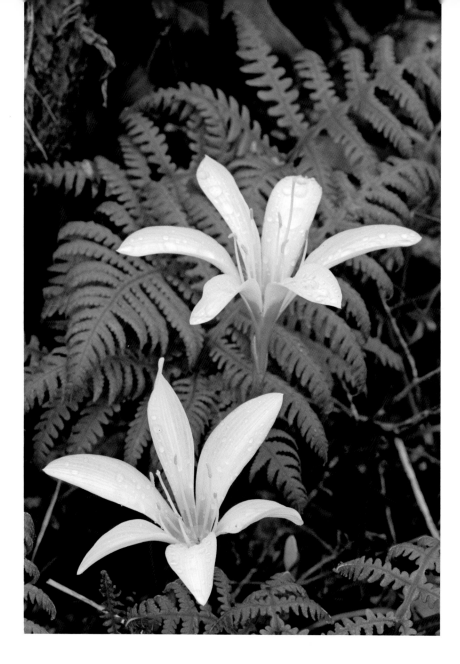

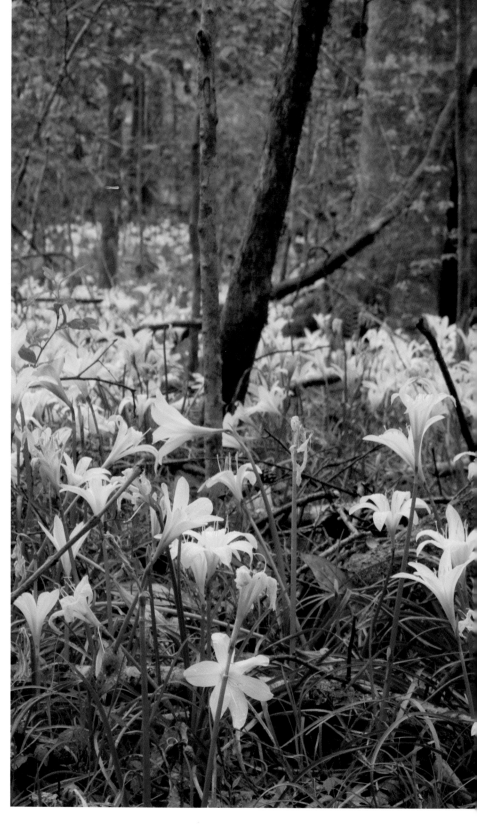

ATAMASCO LILIES

A carpet of rain lilies brightens the swamp along Pigeon Creek, near the junction with the Sepulga River, Butler County, Alabama

It's always a shock to see something like this. You wonder if perhaps a set has escaped from the Disney studio. Any moment now, Snow White will enter, singing to a bird on her finger. Atamasco lilies, also called rain lilies, *Zephyranthes atamasco*, are a showy spring flower of Alabama river bottoms. They are widely distributed but spotty. Though in the lily family, they are not closely related to the shoals and spider lilies, *Hymenocallis*.

Wildflowers are seasonal, and many are very particular about their sites. Some of these needs are very subtle. Orchids form partnerships with specific soil fungi. Some, like beech drops and squawroot, are parasitic upon the roots of other species. Others,

like the endemics in the Bibb County glades, have specific (and rare) soil requirements. Atamasco lilies require moist, organic soils. A healthy and plentiful selection of wildflowers is a sign that a diverse mosaic of soil, moisture, pollinators, and light is in place. If they are in a protected area, it is a sign we are doing something right.

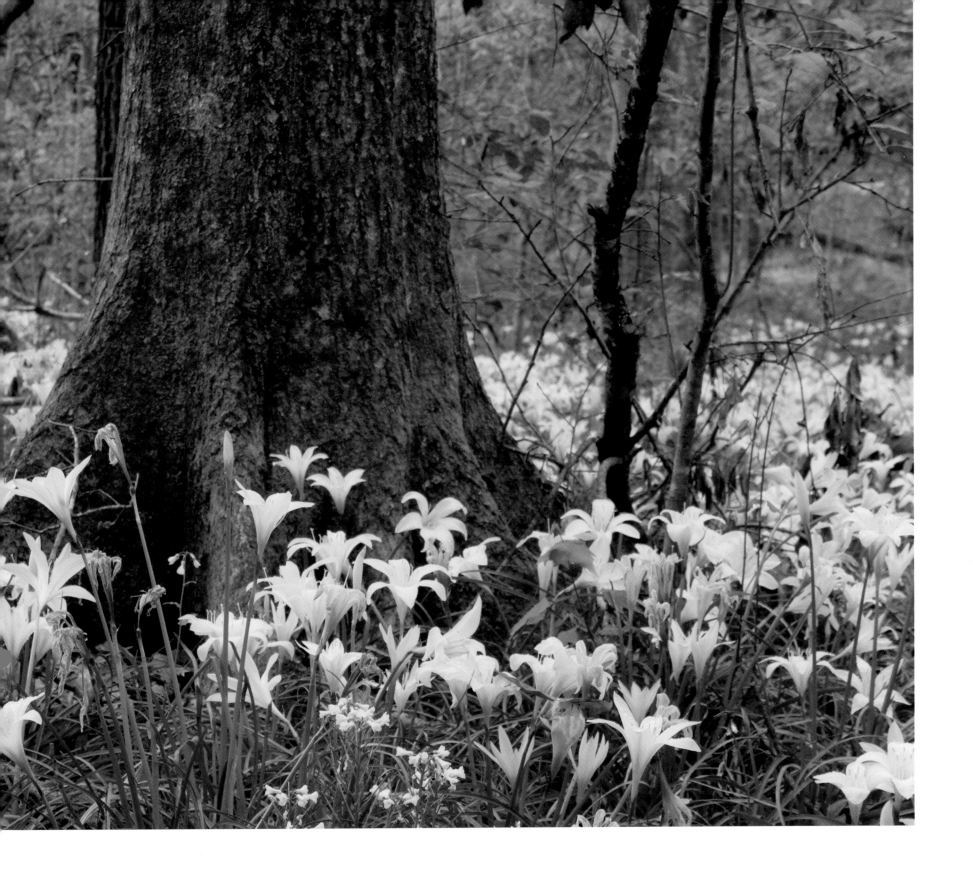

"Oh what a lovely owl!" cried the Wart. . . .
[Says the owl] "There is no owl."
"It is only a boy," said Merlyn.
"There is no boy," said the owl hopefully, without turning around.

—T. H. White

BARRED OWL

Strix varia checks us out at Hurricane Bayou, Tensaw River, Baldwin County, Alabama

"Who cooks for you? Who cooks for you?" says the barred owl. Thank goodness for this variety, or you'd hardly ever actually see an owl. Most owls are strongly nocturnal, but the "eight hooter" is a morning and evening owl that often shows itself in daylight. Barred owls are tremendously vocal and territorial and will often be attracted to even the worst mimic of their call. But they're no fools, and once they have seen that it is you, they won't respond again. Occasionally barred owls get into some kind of dispute and several of them start calling at once. They sound like a bad imitation of jungle-movie monkeys.

As a general rule, for each hawk you see in the daytime there is an equivalent owl at night: big (red-tailed hawk—great horned owl), medium (red-shouldered hawk—barred owl) and small (kestrel—screech owl). Hawks by day, owls by night—it sounds like some kind of dreadful curse on mice.

[The] island . . . is covered with a dense undergrowth of the sweet myrtle . . . The shrub here often attains the height of fifteen or twenty feet, and forms an almost impenetrable coppice, burthening the air with its fragrance.

—Edgar Allan Poe

SUNSET

Live oaks at mouth of Yellow River, Blackwater Bay, Santa Rosa County, Florida

Live oaks are evidence that God provides a remedy for every tribulation—their beauty and abundant shade to counter the blistering summer sun. In areas protected from the regular fires that maintain the pine belt, the coastal plain bottomlands grow a surprising number of evergreens. Southern magnolia, swamp bay, live oak, laurel oak, red bay, wax myrtle, dahoon, titi, smilax briars, palmetto, and American holly lend a tropical look to the lowlands.

When confronted with a sunset framed in live oaks and Spanish moss, it doesn't take a lot of imagination to conjure visions of pirates and smugglers. Indeed, rumors of pirates on the coast abound. One suggests that a certain prominent gentleman of Pensacola was none other than the alter ego of Louisiana's notorious pirate Jean Lafitte, who upon being expelled from New Orleans, recovered his buried treasure one night from the Florabama coast and sailed off into mysterious oblivion.

Why not?

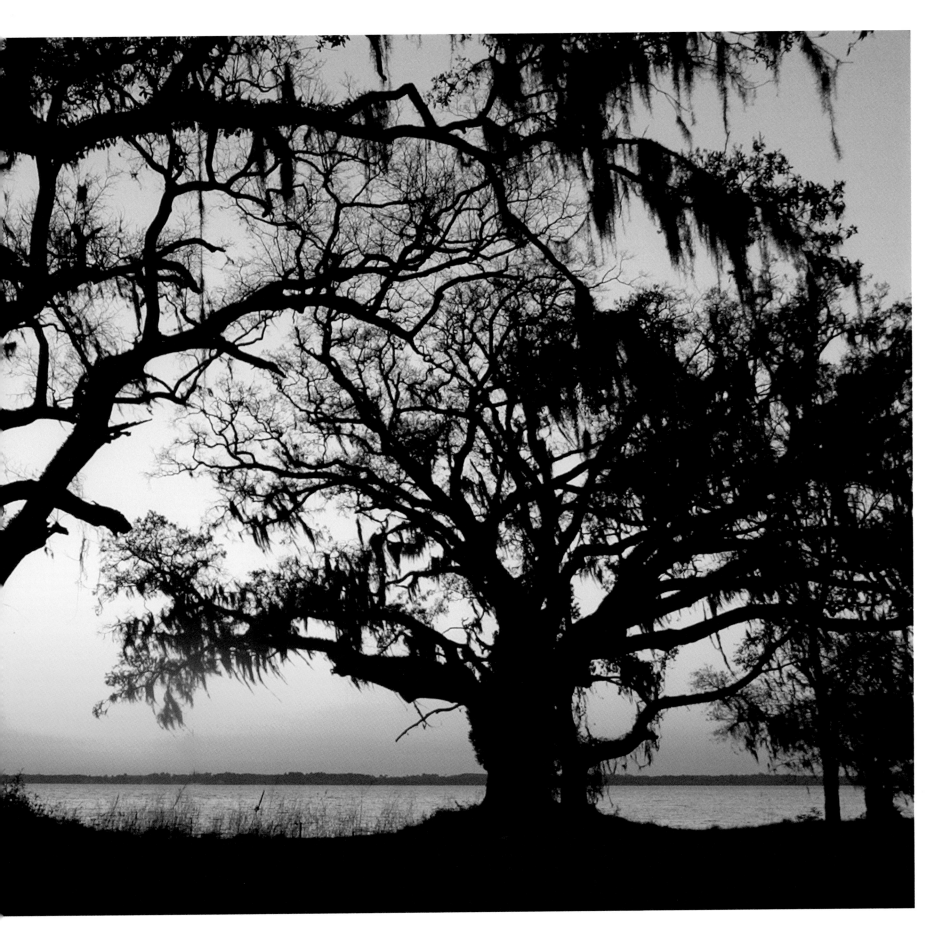

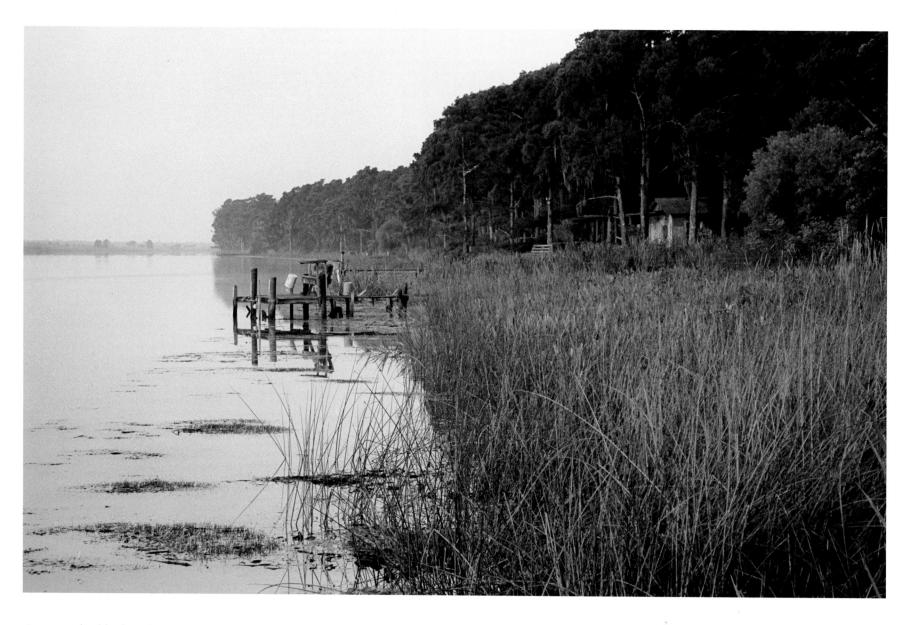

Opposite this bluff, on the other side of the river, is a district of swamp or low land, the richest I ever saw, or perhaps any where to be seen; as for the trees I shall forbear to describe them, because it would appear incredible, let it suffice to mention, that the Cypress, Ash, Platanus [sycamore], Populus [yellow poplar], Liquidambar [sweetgum], and others, are by far the tallest, straitest and every way the most enormous that I have seen or heard of.

—William Bartram

FISH CAMP

Raft River, Tensaw Delta, Baldwin County, Alabama

The quote is from William Bartram traveling Alabama in 1775. He was exploring the Tensaw Delta by dugout canoe. The most accomplished Southern botanist of his day,

when Bartram said the trees were the tallest and most enormous he had ever seen, he knew what he was talking about. His book *Travels* is the first and best book of Southern natural history, and we are in his debt for his description of presettlement Alabama.

It is here in the delta that the Alabama and Tombigbee Rivers join their waters into a vast muddy distributary that has filled most of prehistoric Mobile Bay with a huge and fertile swamp. That the Tensaw Delta has survived to become somewhat protected is a bit of a miracle and a sign of hope. It has been logged and mistreated for generations, but there are still *bears* in it! And alligators!

How much longer until those big trees return?

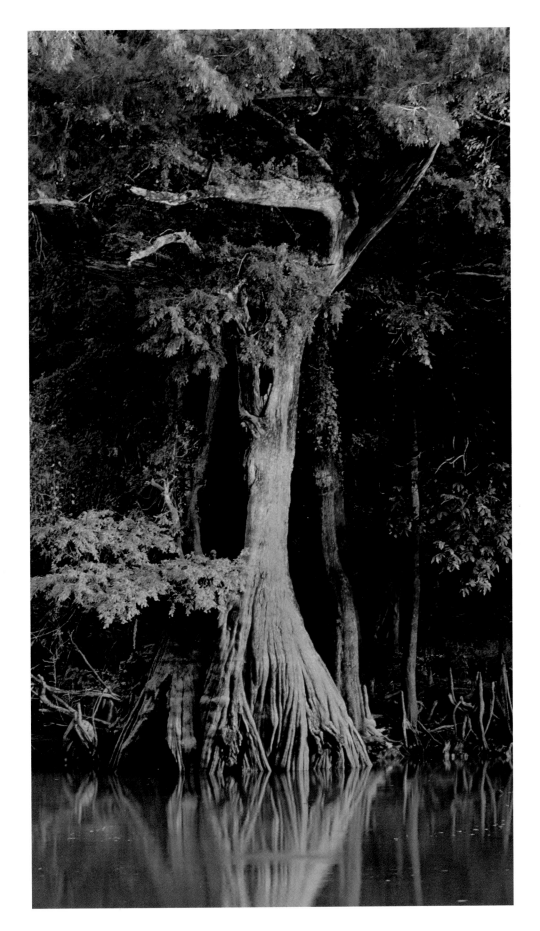

The Cupressus disticha [cypress] stands in the first order of North American trees. Its majestic stature is surprising, and on approaching it we are struck with a kind of awe, at beholding the stateliness of the trunk, lifting its cumbrous top towards the skies, and casting a wide shade upon the ground, as a dark intervening cloud, which, for a time, precludes the rays of the sun.

—William Bartram

OLD MAN CYPRESS

Delta cypress glows in the morning sun near Boatyard Lake, Tensaw River, Baldwin County, Alabama

This old man has stood on his bank for hundreds of years, birds in his hair and bearded with Spanish moss. Large cypresses are virtual time machines. They are the largest trees of eastern North America and among the oldest. Some have exceeded twelve feet in diameter and were more than a thousand years old. This tree may have witnessed the dugouts of the Mississippian builders of the Bottle Creek mounds, the bateaux of the French, Bartram exploring the delta in his canoe, and the Redsticks at war with Andy Jackson. Each huge gray column presents us with an opportunity to approach it with awe. We can see what the Indians saw and touch what the Indians touched.

Alabama's old-growth cypress is mostly gone. The state's ancient trees were logged during the first half of the twentieth century. They survived in Alabama as long as they did mostly because it was so difficult to fetch them out of the deepest swamps. Cypress's real destruction had to await the perfection of mechanized equipment. Many of the surviving large trees are hollow, rejected by the loggers of yore. The heartwood of the sound old-growth trees was essentially impervious to rot and is sometimes referred to as "eternal wood." There are authentic examples of heart cypress water pipes, siding, troughs, and shingles lasting hundreds of years.

Numerous Indian canoes, some five hundred years old and mostly intact, still lie in muddy sloughs, right where they were last parked, intentionally submerged so that they wouldn't dry out and split. A few years back, a drought revealed scores of them throughout the South. Realizing they couldn't preserve so many, the archaeologists just charted them. They're safe where they lie for a while longer.

SEARCH FOR THE IVORY-BILL

Mysterious figure deep in the Choctawhatchee Swamp, Alabama–Florida border

Despite all the excitement about the presumed rediscovery of the ivory-billed woodpecker in Arkansas, the deep swamps of the Choctawhatchee have for many years produced persistent reports of the giant woodpecker, some from folks who should know. The creature in the gillie suit is a biologist, hoping against hope. In her heart, she hopes the rare bird is still there, but eyewitnesses—even professionals—can be fooled, and photographs are hard to come by.

The ivory-bill was the king of southern swamps, but was done in by the wholesale destruction of the bottomland hardwoods around the turn of the twentieth century.

Locals called it a "lord-god," as in "Lord, God! What a woodpecker!" As the biggest and baddest of the woodpeckers, it was never common; it is estimated that it required thirty-six times the home range of the somewhat smaller pileated woodpecker. The size of a large crow, with a call like a toy tin horn and distinctive white markings, the ivory-bill is the holy grail of American birders. It is easily confused with the much more common pileated woodpecker, and in the excitement of the chase the distinctive field marks are hard to verify.

So we wait, trying to ignore the skeptics and stubbornly exercising the virtue of hope. If only the ivory-bill is still out there, perhaps there are other environmental miracles yet to come.

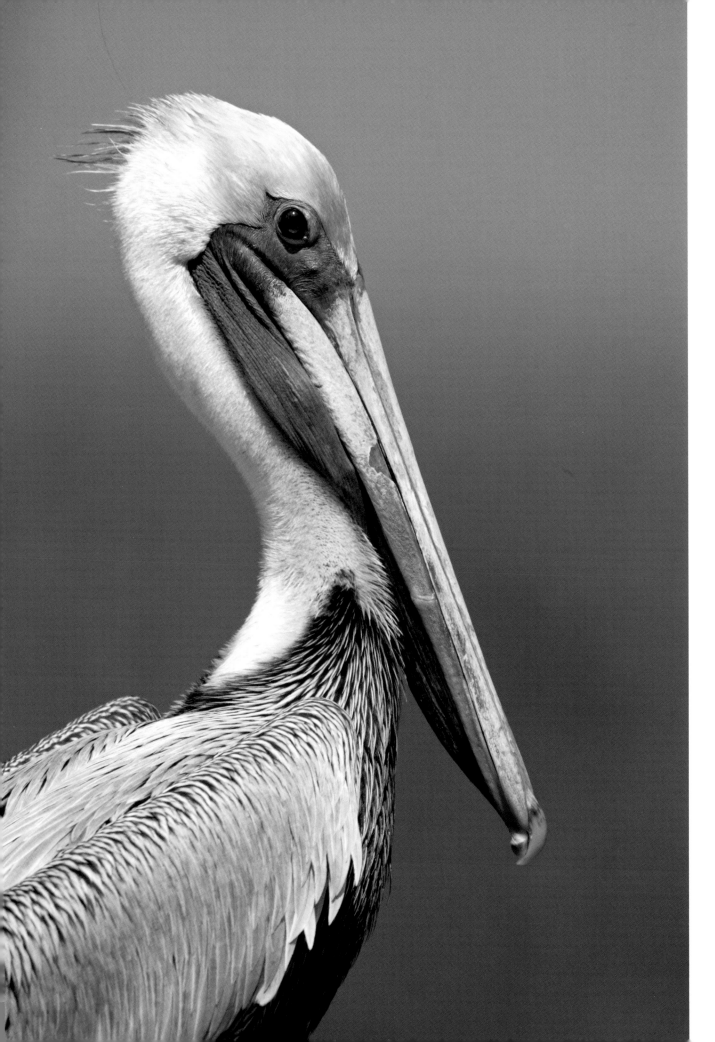

A wonderful bird is a pelican,
His bill will hold more than his
belican.

—Dixon Lanier Merritt

BROWN PELICAN

Adult *Pelecanus occidentalis* in winter colors at Dauphin Island, Mobile County, Alabama

A wonderful bird indeed. To stand and watch this most ungainly of walkers transform into the most graceful of flyers and then suddenly become a fearless fish-kamikaze is a journey into absurdity. If you were suddenly beamed up to the mother ship and tried to describe such a beast, they would accuse you of drinking on the job.

The brown pelican is distinctly prehistoric in appearance. Surely flocks of vanished pterosaurs must have sailed in long vees as well. Another near-victim of DDT, the brown pelican has rebounded amazingly, thanks to heroic measures from the conservation community. It has also benefited from the preservation of undisturbed nesting areas, often, ironically, on islands made of dredge spoil.

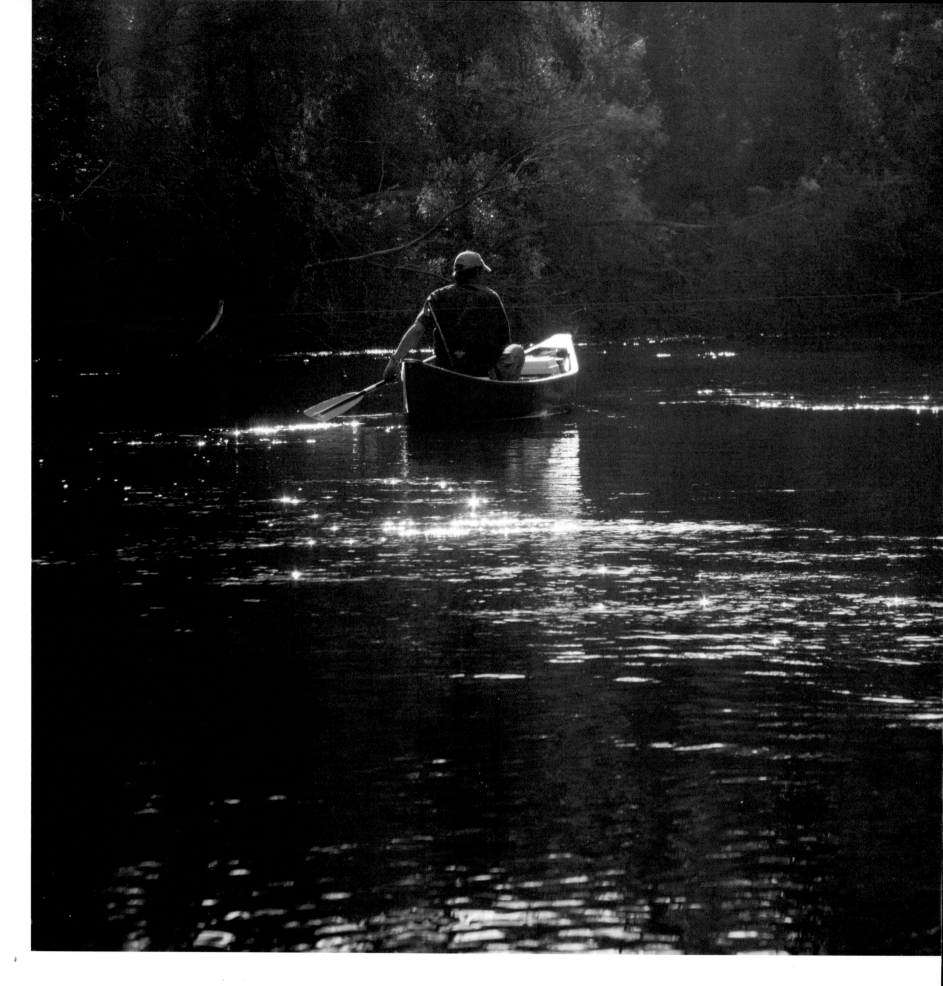

The face of places, and their forms, decay;
And that is solid Earth, was once sea;
Seas in their turn retreating from the shore,
Make solid land, what ocean was before.

<div align="right">

—Ovid, *Metamorphoses* XV

</div>

BLACKWATER NAVIGATION

Perdido River, Baldwin County, Alabama, and Escambia County, Florida

It's lunchtime and you pull up onto a sand bar and take off your shoes. You wade into the water until you can no longer see your toes. The water is clear, the color of iced tea, shading to black in the deep parts. Each year, when you wade for the first time, there's always a child's secret concern that lurking down there, just out of sight, might be that last old slithergadee waiting to bite off your toes. The fact that it hasn't done so yet in a thousand trips is incompletely comforting. You never can tell.

One of the jarring aspects of the coastal rivers is the contrast between their dark water and their brilliant white sand. Sand doesn't get enough attention. Basically it's quartz: sharp-cornered crystals from the eroded granite core of the mountains. Quartz is a lot harder than the other common minerals. In the inland portions of rivers, sand is brown with lots of impurities and little bits of other minerals. The grains are still sharp-edged, freshly recycled from their upland origins.

But down here in the lower coastal plain, the sand is worn and white. The little dark bits are gone, ground to powder and washed away. Now only the glasslike quartz remains and many of the grains are worn and rounded. Quartz is so hard that these rounded grains are not the result of river action. It is the wave action of coasts, tens of thousands of sloshing waves every day, that rounds the white sand of gulf beaches. If we can believe the geologic adage that "the present is the key to the past," then the sandy measures of lower Alabama and the panhandle are old beaches, slowly risen from the sea and crusted with pine trees. Indeed, well inland from the coast, lines of relict dunes are to be found, stranded like whales by the retreating sea.

SALT MARSH

Grand Bay Savanna (Nature Conservancy purchase), Mobile County, Alabama

The Great River of Alabama arrives at the sea. The ceaseless tug of gravity relaxes its relentless downhill pull, and the competing forces of river current and tidal flow contest daily. Distant domes of maritime forests break the horizon, and crabs, shrimp, and baby fish nibble at the salt grass.

Those who have been paying attention are aware that these river estuaries are the nurseries of much of our seafood. But only recently did we begin to realize the degree to which the marshes, swamps, and barrier islands protect us against hurricanes.

It seems unlikely that we can be completely protected from our own hubris when we insist on building on land that is zoned by nature for seaborne disaster. But the coasts are soft shields that give and rebound. Nurture our seafood? Protect our cities? There seems every reason to preserve them—the more intact, the better.

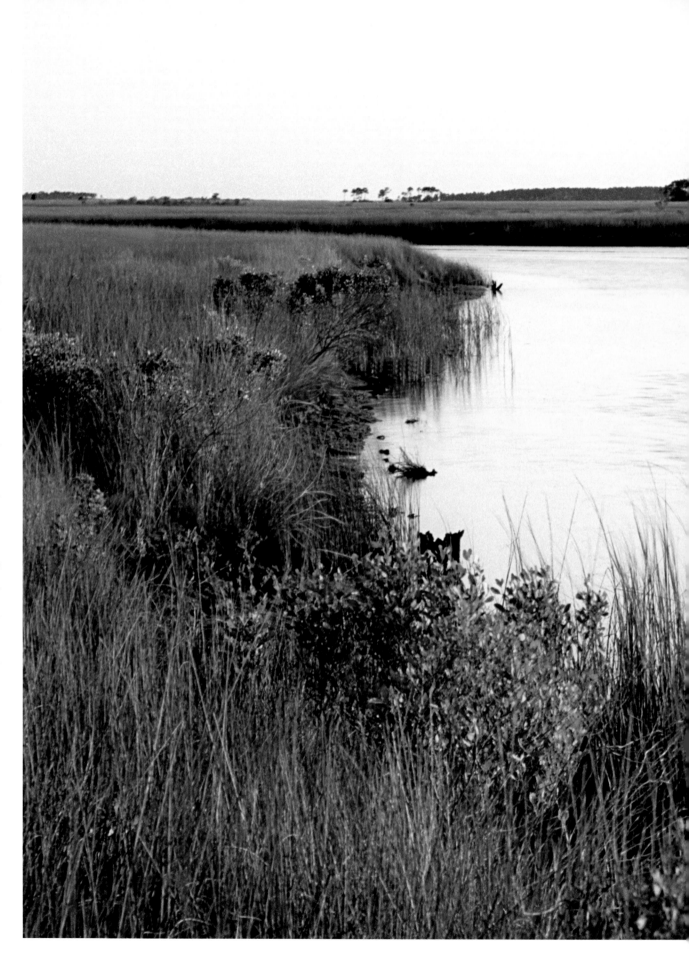

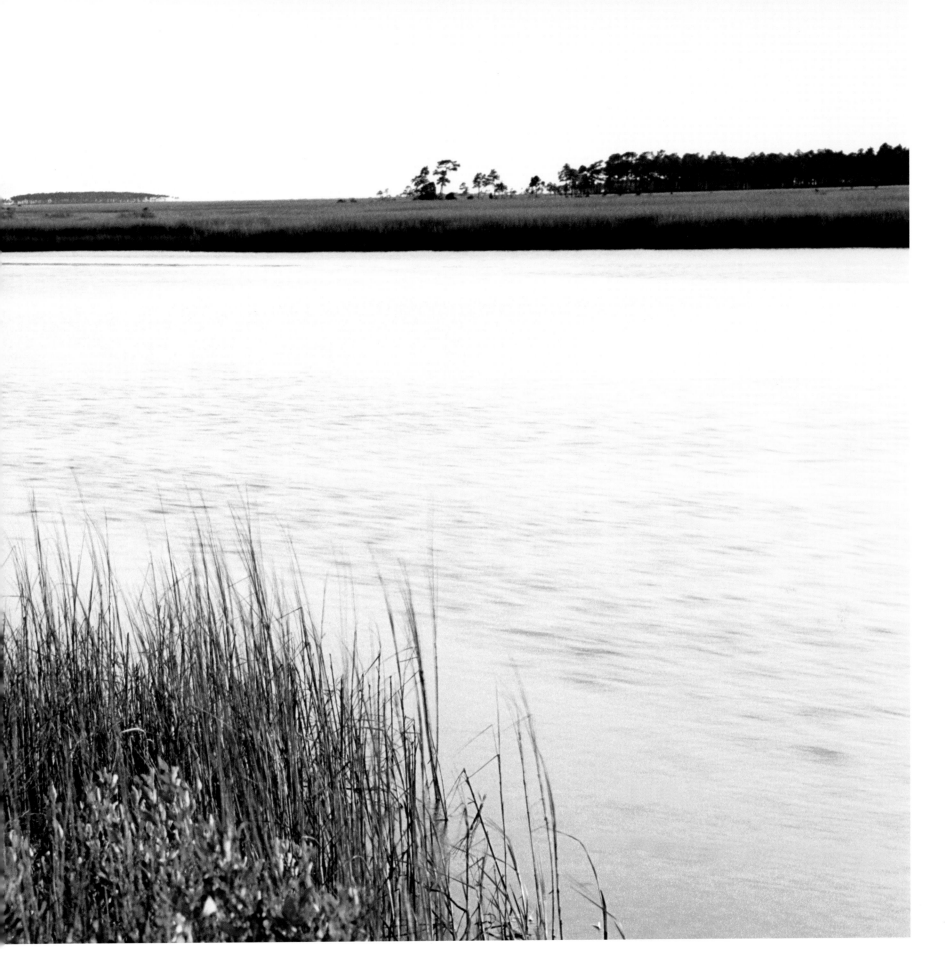

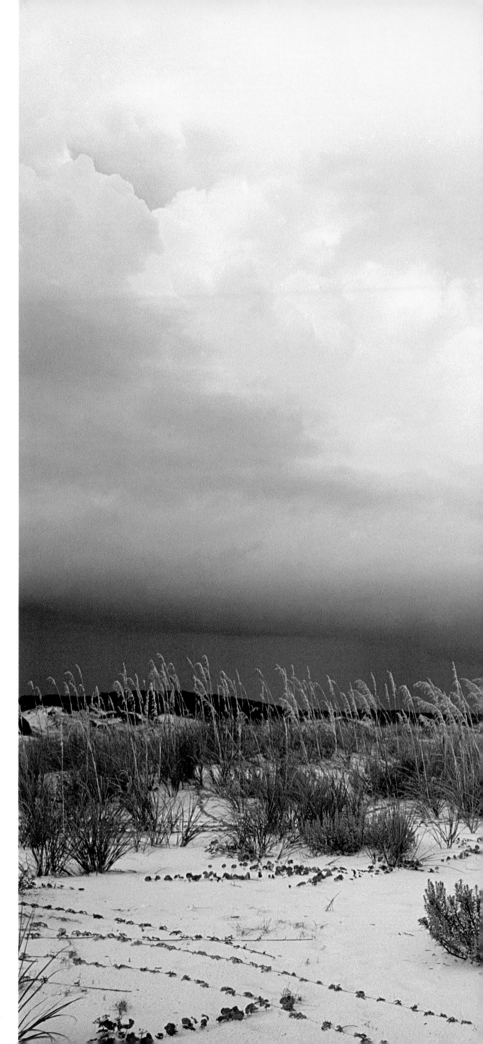

The three great elemental sounds in nature are the sound of rain, the sound of wind in a primeval wood and the sound of outer ocean on a beach.

—Henry Beston

PIÑEDA'S BEACH

Thunderstorm over Fort Morgan Peninsula, Bon Secour National Wildlife Refuge, Baldwin County, Alabama

Every once in a while, if you concentrate, you can see into the past. Here is Alonso de Piñeda's gulf beach, just as it was in 1519 when he explored Mobile Bay. And as he looked east, toward Spain, this is what he saw. No artifact, no track, no contrail spoils the illusion--unspoiled, unpopulated, untracked.

This is one of the ironies of conservation. The notion of seeing it as it used to be is so attractive, but would you really be willing to roll the clock back and remove mankind from the board? Of course not, so we'll just have to keep working on our compromise between use and misuse. It is our duty to know that our children will still be able to seek out such visions in their clean, diverse landscape.

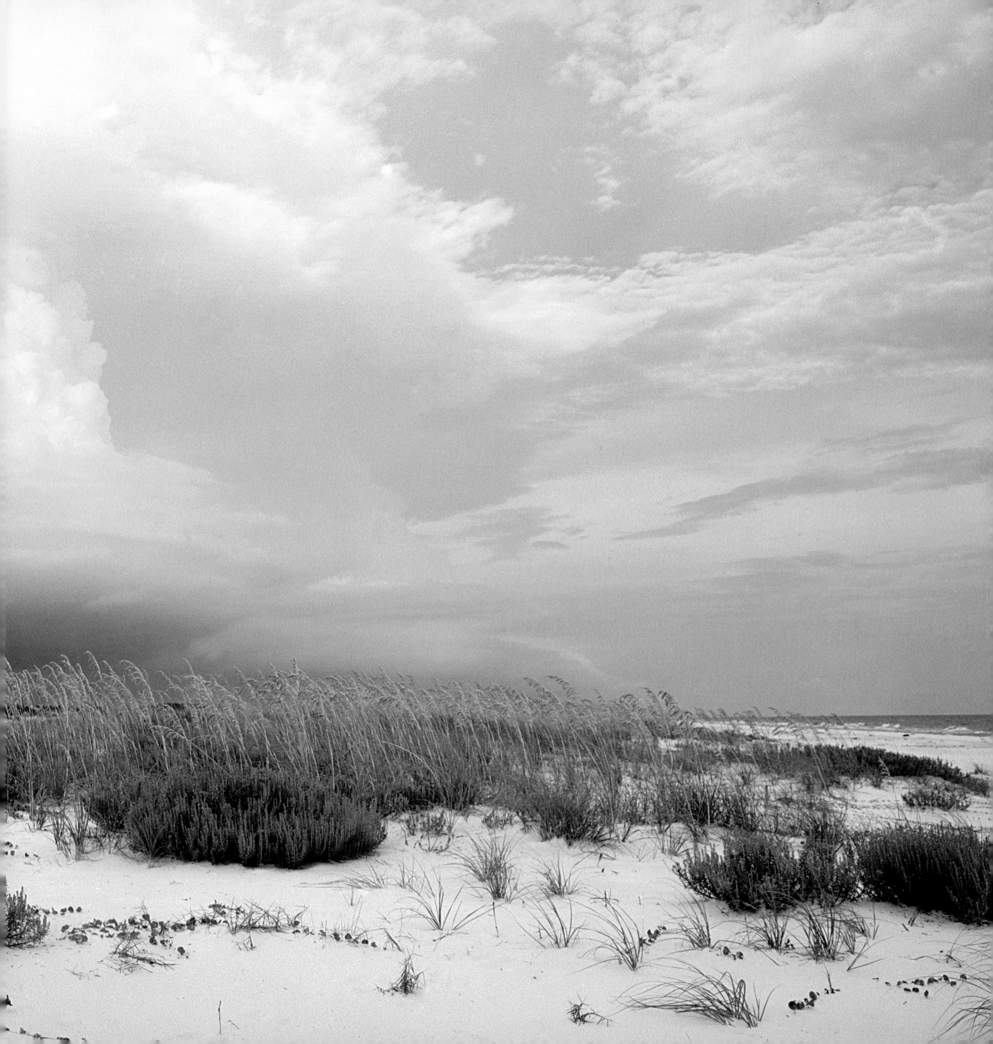

CONSERVATION: COASTAL RIVERS AND TURTLES

THE SAME ICE AGE EVENTS that created the modern Alabama landscape and river terraces did our biological diversity a favor, too. From the Mississippi to peninsular Florida, there are eight sizable rivers on the northern Gulf Coast, and five of them penetrate Alabama. During the glacial periods, when the sea level was down, the seacoast was much farther away and the Gulf Coast's rivers were longer. This tended to isolate those rivers' aquatic animals from other river faunas to the east and west. In hundreds of thousands of years of isolation, the gulf rivers evolved related but distinctly different varieties of fish, turtles, and invertebrate species.

Chris Oberholster of the Nature Conservancy points out that although Alabama's aquatic biodiversity may be difficult to rank, it is certainly world class and comparable to well-known tropical environments. Its fish, turtle, crayfish, snail, and mussel faunas are the most diverse of any state in America. Oberholster also says that even for terrestrial species we rank highly, perhaps fifth, in overall North American species diversity.

Above: **Flattened Musk Turtle,** *Sternotherus depressus,* **in Locust Fork. This is a unique Alabama turtle from the Upper Black Warrior River tributaries. Related to other, more common musk turtles (they all smell bad), the flattened musk turtle seems to have been sat upon by Mother Nature. Its five-inch shell is distinctly flatter than the shells of its relatives. It is an insect and mollusk eater and lives on the bottom of deep, clear rocky streams. It does not seem to be present in lakelike river impoundments, and its numbers are low. The flattened musk turtle is also threatened by overcollecting for the pet turtle trade.**

Turtles are simply everywhere in Alabama. Like its neighbors, Alabama has a big share of the common varieties of turtles, but the state excels in river turtles. The Alabama red-bellied turtle, *Pseudemys alabamensis*, is a unique big-river vegetarian restricted to the Tensaw Swamp rivers of Mobile and Baldwin Counties. It has the unhappy distinc-

Why make such a fuss over a few obscure map turtles? Because the primary food of these turtles, particularly the large females, is mollusks—the same mussels and snails that Alabama is so exceptionally rich in. Is it because of the mollusks that the map turtles underwent their evolutionary spree in Pleistocene times? What effect has the damage to the mollusks in the twentieth century had on the turtles? It is these connections that

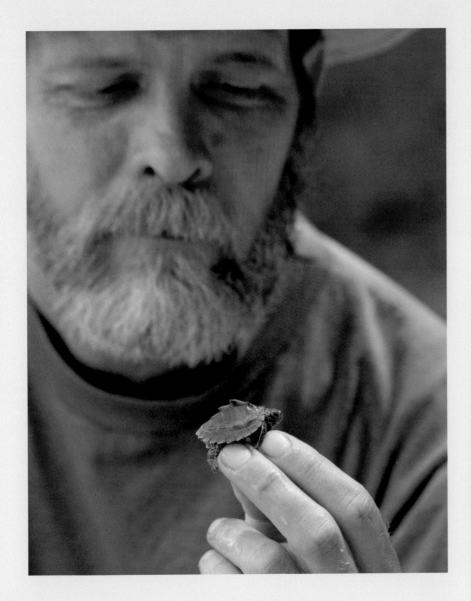

Left: **Jim Godwin of the Alabama Natural Heritage Program and a hatchling Barbour's Map Turtle,** *Graptemys barbouri,* **on the Pea River.** *Below:* **Keith Tassin and Steve Northcut of the Nature Conservancy check a map at a rural gathering spot beside the Perdido River. The broad swampy bottoms of the small coastal rivers are noted for their stands of Atlantic white cedar, reportedly the westernmost stands known. The Nature Conservancy has purchased a large preserve on the Perdido from International Paper Company.**

tion of having the smallest distribution of any North American turtle species. The Alabama red-belly has been listed as an endangered species for twenty years as the lower end of the Alabama river system has degraded and the human population has expanded. One of the many obstacles faced by our state reptile is that the roadkill of gravid, or pregnant, females (the very ones you want to preserve) has reached crisis proportions.

The map turtles are a large group that seems to have rapidly speciated along the Gulf Coast, and Alabama is home to five Deep South varieties in addition to one from central North America. Barbour's map turtle, *Graptemys barbouri*, is restricted to the lower Apalachicola/Chattahoochee River. The entire range of the Alabama map turtle, *Graptemys pulchra*, is centered on the Alabama/Tombigbee drainage of Alabama and adjacent Mississippi. The black-knobbed sawback, *Graptemys nigrinoda*, is restricted to the big rivers of the Mobile drainage: Alabama, Tombigbee, Black Warrior, Cahaba, Coosa, and Tallapoosa.

Above: An incomplete turtle nest on a sandbar. Many species of turtles rely on sun-baked sandbars to warm their nests. If impounded rivers lack sandbars, how does this affect the turtle populations? It is not clear why this turtle nest was abandoned. Map turtles, cooters, and sliders lay ovoid eggs. Softshells and snapping turtles have large round eggs like this one. This is probably a softshell egg. *Left:* Red-Eared Turtle or Slider, *Trachemys scripta elegans.* The slider turtle is a successful general-ist—probably the most common turtle in the state. It eats nearly anything, mostly plants,but does not deserve the reputation of fish eater that has attracted fisher-men's bullets for many years. Baby red-ears were once commonly sold in pet stores until health concerns (and the usual death of the turtle) thankfully put an end to it. The adults lose the red ears. The females grow quite large, and the smaller males court them by stroking their lady friends' faces with their long claws. How sweet!

occasionally give the ecologists and conservationists that wild-eyed look, often when they are trying to explain the profound connections between clean water, free-flowing rivers, and the diversity of such disparate groups as fish, turtles, and mollusks.

The smaller coastal plain drainages of Alabama have been the beneficiaries of at least some good fortune. Away from the Mobile/Baldwin County complex, the thin population of south Alabama has given rivers of the region a bye from the careless development of many of the rivers in the northern part of the state. This is not to say that they are free from damage but that they have managed to avoid destruction until modern times, when a preservation ethic has been increasingly present.

Another piece of serendipity is that big timber companies have owned large tracts of Alabama landscape for many years. Even though their prime objective has been timber production (not always good for natural diversity), at least they have kept the big

Above: **Female Cooter, *Chrysemys concinna*. Cooters are particularly aquatic, leaving the water only to lay eggs. They are able to breathe by merely touching their nostrils to the surface; almost nothing is visible to give them away. Turtles are an extremely old group and are only dimly related to other reptiles. Despite their apparent handicaps they are an extraordinarily successful group worldwide.**

blocks of property together. Some of these big tracts are now winding up as preserves. The new Perdido reserve is an example. Fifty years ago the notion of transferring large tracts of land into the nongovernmental hands of conservation groups was only a dream. Today it increasingly seems like a good idea. Groups like the Nature Conservancy, the Freshwater Land Trust, and the Alabama State Department of Conservation's Forever Wild program now hold thousands of acres in public trust.